Animation: The Mechanics of Motion

focal press visual effects & animation

Debra Kaufman, Series Editor

3D for the Web: Interactive 3D Animation using 3ds max, Flash and Director
Carol MacGillivray and Anthony Head

A Guide to Computer Animation: For TV, Games, Multimedia and Web
Marcia Kuperberg

Animation in the Home Digital Studio: Creation to Distribution
Steven Subotnick

Character Animation in 3D: Use Traditional Drawing Techniques to Produce Stunning CGI Animation
Steve Roberts

Digital Compositing for Film and Video
Steve Wright

Essential CG Lighting Techniques
Darren Brooker

Film Animation
Dan McLaughlin

Producing Animation
Catherine Winder and Zahra Dowlatabadi

Producing Independent 2D Character Animation: Making and Selling a Short Film
Mark Simon

Stop Motion: Craft Skills for Model Animation
Susannah Shaw

Focal Press

Visit www.focalpress.com to purchase any of our titles.

Animation: The Mechanics of Motion

Chris Webster

AMSTERDAM • BOSTON • HEIDELBERG • LONDON • NEW YORK • OXFORD
PARIS • SAN DIEGO • SAN FRANCISCO • SINGAPORE • SYDNEY • TOKYO

Focal Press is an imprint of Elsevier

Animation Exercise 3.2 – Character Types/
 Two Sacks .. 119
Character interaction ... 121
 Animation Exercise 3.3 – Character Interaction 123
Planning a scene .. 124
Props and costume ... 125
 Questions to Ask Yourself about Acting
 in Animation .. 126

Chapter 4 Design .. 129
Before we begin .. 131
Storyboards .. 133
Animatics ... 139
Character design .. 142
Design criteria .. 152
 Questions to Ask Yourself about Design 154

Chapter 5 Animals in Motion 155
Before we begin .. 157
Four legs .. 158
 Animation Exercise 5.1 – Basic Walk Cycle 163
 Animation Exercise 5.2 – Basic Run Cycle 167
 Animation Exercise 5.3 – Advanced Action 167
 Questions to Ask Yourself about a Four-legged
 Animal in Motion ... 168
Birds in flight ... 168
 Animation Exercise 5.4 – Basic Flight Cycle 171
 Animation Exercise 5.5 – Take-off and Landing 176
 Questions to Ask Yourself about Birds in Flight 177

Chapter 6 Sound Synchronization 179
Before we begin .. 181
Bar charts .. 182
Delivering dialogue and carrying narrative 189
Lip synchronization .. 189
 Animation Exercise 6.1 – Lip-sync 197
 Animation Exercise 6.2 – Sound Synchronization 198
 Questions to Ask Yourself about Sound
 Synchronization ... 199

Chapter 7 Technical ... 201
Before we begin .. 203
Dope sheets ... 203
 Questions to Ask Yourself about Dope
 Sheets .. 219
Line tests ... 220

Layouts and field guides ... 221
 Questions to Ask Yourself about Layouts 226
Formats ... 226
Production processes .. 229
 Questions to Ask Yourself about Production
 Management ... 236

Appendices ... **237**
Appendix 1: Glossary .. 239
Appendix 2: Further reading 245
Appendix 3: Further viewing 249
Appendix 4: Useful contacts 251

Index ... 253

Foreword

There's something strange about animators.

Well, plenty if I'm being honest.

They may create the most emotionally charged and outrageous performance you'll ever see on a screen; and yet in person they'll often prove to be shy, retiring and self-deprecating. They're like actors who prefer not to appear on stage and screen. They possess the skill to develop a character over a long period, and then deliver it, fully-realised to an audience – but for some reason they can make do without the daily fix of applause, the flowers in the dressing room and tearful post-mortems in the bar. Though the work is memorable, even unforgettable, the creator is often content to remain invisible and sometimes anonymous. While the viewer knows and loves Homer Simpson, or Wallace and Gromit, or Buzz Lightyear, the person behind the scenes – the artist, the puppet-master who's created that on-screen performance – is hardly ever seen.

Of course, this 'shy, and retiring' routine is all a front. Because what the animator is actively engaged in every day is nothing less than the business of creating life – a job normally reserved for God. Not too much of the shrinking-violet syndrome there! The animator sits down at a drawing desk, or a computer, or a miniature set, and stands up much later (very, very much later quite often) having conjured character, performance, emotion – life itself – out of thin air. A pretty good trick I'd say.

Chris's book is here to guide, inspire and challenge animators. As with acting, which is its first-cousin, animation is crucially a matter of feeling and emotional understanding. But it is also a matter of craft. There are demonstrable, learnable, improvable skills – there are short cuts to embrace, pitfalls to be avoided, conventions to be challenged, rules to learn (and later perhaps to unlearn). Even more importantly, there are new things for every generation to discover. The best possible outcome for a book like this is that it should inspire people – perhaps one of them will be you – to find their own unique animation voice and style.

Peter Lord
Creative Director and Co-Owner,
Aardman Animations Ltd.

Preface

My intention when setting out to write this book was to concentrate on the underlying principles of animation and animation timing that are common to all forms of animation.

The principles of animation that are covered within these pages are never reliant on technology or the latest piece of software. I have seen far too many students fixating on the technical aspects of animation production, how much memory their computer has, if they have the latest version of the modelling software, what render engine they use and the use of collision dynamics, somehow seeing these issues as a substitute for an understanding of animation timing and creativity. It cannot be denied that the technical developments over recent years have dramatically affected the development of the art form, and enabled animators and film-makers to achieve rather stunning results hitherto impossible. This book purposely avoids any detailed discussion about any specific animation software or hardware, as developments in these areas are made at an alarmingly fast rate while the principles of animation remain timeless. There are numerous texts already available that cover such technical issues in great detail, though often these only skim across the principles of animation. This book is designed to complement those texts, not replace them. This text will concentrate on specific fundamental aspects of animation that are central to the art and craft of animation, regardless of which discipline the animator is working in. It covers those principles that all animators adopt when making their characters move: animation timing, overlapping action, follow-through and drag, and squash and stretch. While it also deals with aspects of characterization, design, acting and production management, these subjects are such specialist aspects of production (along with other areas not covered: writing for animation, finance and marketing) that I suggest you seek other texts that specialize in these areas. A number of these appear in the suggested reading list at the back of the book.

Methods for producing 2D classical animation have been documented for quite a long time. The first available textbook, written by Edwin George Lutz, was *Animated Cartoons; How They Are Made, Their Origin and Development*, published in 1920, and interestingly it is still in print to this day. Since those early days, the formation of

major animation studios, particularly Disney with their vast commercial output, has meant that animators had to find ways of passing on their knowledge and skills to a large body of workers who needed to develop skills to a high level. For many years the Disney studios have received a level of criticism for the content of their films, but love them or loathe them (I love them; well – some of them), it would be difficult to deny that this one studio has done more than any other organization in developing the craft of animation. For decades they have provided an environment where top animators can take seriously the analysis of movement, and it was early on in the studio's life that they began to challenge and question what they were doing as animators, and in doing so began to identify 'rules' and guiding principles by which they worked. Most of these principles apply equally to computer animation and stop-frame or puppet animation as well as 2D classical animation, as they are derived from the scientific study of movement, the effect of gravity, friction and force on masses. There are a number of very valuable sources available to the 'would-be' or professional animator today, though I would suggest that there is no single definitive work that will serve all animators in all disciplines. To this end, I have listed a number of texts in the appendices that you may wish to seek out.

As animators we are in an incredibly privileged position in that we now have at our fingertips an incredible source of readily available material for the aspiring animator and professional alike, not only in the form of texts such as this one, but an extensive range of animation of many types, live action video footage, an enormous archive of our cinematic history, ready access to television and the Internet. The early pioneers had nothing of this, yet despite the absence of such material, some of the work they produced was outstanding and to this day is worthy of serious study for those aspiring to achieve great things. I would strongly urge *all* students to become familiar with the work of Winsor McCay. Those early animators gave us some of the most endearing and enduring examples of animation that few have equalled, even today. Some of the work was simplistic, most of it was formulaic, but it still threw up more than a few classic examples that remain worthy of study – *Girtie the Dinosaur*, *The Skeleton Dance*, *Felix the Cat*, *Popeye the Sailor*, the queen in *Snow White*, all stand out as landmarks in animation.

Like it or not, the Disney studio has become the hallmark of animation quality and it is worth briefly contemplating how

this was achieved. While Walt Disney may not have been a great animator himself, there is no doubting his brilliance as a producer, and part of his success was due to the fact that he was quick to exploit the potential of animation by embracing two distinct factors – technology and animation training. This was coupled with an understanding that the medium was fuelled by novelty. His use of synchronized sound in *Steamboat Willie* (1928) did much to place the studio on the road to success. Then again, with the release of *Flowers and Trees* (1932), the studio exploited technological innovation through the use of the Technicolor process that gave it a distinct advantage over its competitors. While this was an important factor in the Disney studio's success, it was Disney's (and the animators' at his studio) desire to improve standards that has really made a lasting impact upon the study and teaching of animation. Instigated in 1932 and run by Don Graham, the drawing classes not only improved the animators' drawing and animation skills, but became the template for animation training for generations to come. Now a new generation of studios and animators has appeared, and the tradition of animation training and development is in the hands of others, though the lineage is there for all to see. The great animator John Lasseter (*Luxo Junior*, *Tin Toy*, *Toy Story*, *A Bug's Life*) first learned his craft as a 2D classical animator at the Disney studio and it is clear to see he has adopted those self same principles within his work, placing the emphasis firmly on characterization, animation timing and performance.

The aim of this book is to build on the tradition of those principles and training initiatives, and it is my firm belief that good training and a firm knowledge of guiding principles are the basis for all good character-based animation. Understanding is everything.

THE EXERCISES

The exercises within the book are only intended to cover the basic principles of animation and many of the animated actions that you will need to master, such as the walk cycle. They cannot cover all the variations that are possible – no book or programme of study could. They are intended to help you develop skills. The amount of effort you put into your work is down to you the individual and the exercises are as easy or as tough as you make them. As with most things in life, the more you put in, the more you get out.

AND FINALLY

Be aware of what you are doing; don't just do things – THINK! Take pride in your work, be professional in your approach, be economic with your efforts and resources – you should not scrimp but nor should you simply throw time and money at the problem. The real solution is to be creative. As technology advances and production processes and methodologies change, you will be increasingly dependent upon your knowledge of the fundamental principles of animation and your own creativity. Neither this book nor any book, for that matter, will make you creative; it is simply intended to assist you with developing your skills and understanding of the principles of animation, and through those help you develop your own personal creativity.

To become a true artist is the work of a lifetime – be in no hurry, grow.

Introduction – Walking with Animators

In the summer of 1997 I had a real problem.

I had just come back from an exhausting trip to SIGGRAPH (the annual CGI conference held by the Association for Computing Machinery in Los Angeles) where I had hoped to find a crew of talented young animators for an exciting new project that I was certain would change the lives of everyone involved with it.

After a gruelling week in which my colleagues and I talked to 219 budding computer animators, we had to admit defeat. Not one of the young hopefuls had any real animation on their showreels – and there was hardly an animal to be seen in all that work. To be brutally honest, most of the so-called animation on the reels was not animation at all, but what we referred to in those days as 'flying logos and dancing products' – the main thrust of commercial digital animation at the time.

In the mid-90s it seemed that there was no communication between the very different worlds of traditional drawn animation and its electronic cousin, computer animation. A few traditional animators had crossed the great divide between paper and pixels – John Lasseter at Pixar was perhaps the most notable – and the newly-fledged CG animation department at Industrial Light and Magic had just produced about 12 minutes of computer animated creatures that had taken the world by storm.

In fact it was precisely that film – *Jurassic Park* – that had inspired Tim Haines, then a producer for the BBC Science series *Horizon*, that the time had finally come when an idea he'd nurtured for many years might finally see the light of day. He wanted to make a six-part television wildlife documentary featuring photorealistic dinosaurs – a project that would need three hours of computer animation, at a far higher standard than had yet been achieved for any television project.

At first I had agreed – I was sure it was in the realms of possibility – but my experience in California was now starting to give me doubts. I was preparing myself to break the bad news to the BBC that perhaps this project was too ambitious for the new medium of digital animation.

As a last resort I posted an email to a CGI user group, appealing for animators, and to my surprise I had several worthwhile replies from people whose reels showed real promise. Two of them were from students at The Glamorgan Centre for Art and Design Technology in Wales, and the animation was impressive – far better than the work I had seen from students previously – so I travelled to Wales to see the college and meet the people responsible.

That's how I met Chris Webster – an irrepressibly good-humoured and lively individual whose enthusiasm obviously inspired all the people around him. He was running a degree course in which students learned all aspects of animation – drawn, stop-frame and digital – over a 3-year period. Finally, I had met someone who was bridging the gap between the pencil and the keyboard – and I was extremely impressed by his results. I explained to Chris my concern about whether my young team could achieve the sort of animation quality demanded by such an ambitious project – but Chris had no such doubts. He persuaded me that we had all the makings of a top animation crew and that we could forge a team of young British animators that would be the equal of any in the world.

He volunteered to give extra coaching to our animation team – both the students and experienced animators alike – to give everyone a firm grounding in the principles of traditional animation, and to show them how to adapt these for realistic creature movement.

Luckily for me, I accepted his offer. So, once a week for several months, Chris got on the train from Wales to London, and spent the day with the newly-formed animation team in a makeshift lecture theatre (our client meeting room), breaking new ground and re-designing the traditional tools of animation for the demands of the digital age. He also spent hours in individual sessions with the animators, explaining the relevance of animation techniques to the particular shots they were working on.

The results of his work speak for themselves. When *Walking with Dinosaurs* went on air after an eighteen-month production schedule, it was an immediate international success, and has now been seen by more than 400 million people worldwide. The young team that he taught are now amongst the most respected in the profession, working as leading animators in countries as far apart as California

and New Zealand, on such features as *Lord of the Rings* and *Star Wars*.

Thank you, Chris, for having the confidence in our young talent and for sharing your enthusiasm and skill with them – and thank you for spreading the word even further with the publication of this book. I'm confident that all its readers will be bowled over by your mastery of the animator's craft – as I was, and still am.

Mike Milne
Director of Computer Animation,
Framestore CFC

Acknowledgements

The following deserve not only my very modest and humble acknowledgement, but the acknowledgement and praise of all those who practise and strive to further the art of animation. They are truly giants on whose shoulders we stand so shakily. We should all thank: Jules Marey and Eadweard Muybridge for their enquiring minds and being such colourful characters. Emile Reynaud for being such a tragic and heroic pioneer of the medium. George Melies and the magic he brought to all our lives. His work remains fresh and inspiring. That great Yorkshireman J.S. Blackton for the first ever animated film. Willis O'Brian for making us laugh, cry and gasp in awe at the sheer brilliance of his work. Yes, I actually cried when King Kong died. Walt Disney and all those great guys at the studio for their part in raising the bar and turning animation into a craft and an art we can all be proud of. We owe a debt to Chuck Jones not only for Bugs and Daffy, but for so much more. Tex Avery for simply being Tex Avery and a particular brand of magnificent madness. John Halas and Harold Whitaker for *Timing for Animation*; I'll bet most of us have a copy of this great book (if you don't own it – buy it NOW!). To Bob Godfrey for inspiring and entertaining my generation with his zaniness. To Ray Harryhausen for making us believe in fighting skeletons and for taking animation to stunning new heights. More recently a big thanks to Richard Williams for all his great work, not just on the screen but through his teaching. To John Canemaker for his brilliant work as a teacher, historian and animator. To John Lasseter for taking the principles of these great animators into the twenty-first century. Last of all, the supreme tribute must go to the greatest animation god of all, Winsor McCay. Words are not enough.

My personal thanks must go to a number of people who have helped and encouraged me in my life as an animator. Perhaps the greatest of all of these is Graham Griffiths, a good teacher, a wonderful person and a great friend, and not a bad animator either. I thank Peter Hodges for all his encouragement and support in my development as a teacher. I need to thank my teachers Derek Barret and Dave Pearce, who helped me to progress as a designer and encouraged me to take up animation. When I entered the industry I had two more great animation teachers, very patient, tolerant and

supportive: Chris Fenna and Les Orton. Thanks guys. Thanks to fellow Beefheart fan Mike Price for all the banter. Thanks to Nicola Marlborough for being just about the best assistant anyone could have and to Duncan Harris for being one of the worst assistants but one of the best friends you could hope to have.

I thank Robin Lyons for his role as producer and promoter of the Welsh animation scene. Thanks to Chris Grace as commissioning editor at S4C, without whom I (and a lot of other people too, let's not forget this folks) would not have had the opportunities to develop as animators. Thanks to Mark Taylor at A Productions for all the times he has taken the mickey over the years. Thanks to Ceri Griffin (sadly no longer with us) and his wife Jude for providing proof that you can be good people and get on in business. To Clennal for all the tall tales of Africa and to Tony Barnes for all the lunacy. To Ric Villeneuve for being Canadian. A big thanks to Mike Milne and the animation crew at Framestore for tolerating me at their studios. A special thanks to Gerald Emanuel for the phone call that started all of this. Thanks to Rob Hamer and all the staff at the Glamorgan Centre for Art and Design Technology, who gave me the opportunity to develop as a teacher. Thanks to all the new friends I have made in the last couple of years at UWE and the Bristol School of Animation, especially Arril Johnson, Kari Nygarrd, Andy, Sophie Harbour, Mark Hewis, John Parry, Dominic Grant and particularly Amanda Wood.

Thanks to Susannah Shaw at Animation Exeter for the helpful contributions to this book.

A big thank you to all my clients over the years, without whom I would never have been able to afford my extravagant lifestyle (yeah, right) or be able to learn and practise my craft. To Ken for always being there over all these years to share a few laughs and a few beers.

I owe the biggest debt of gratitude to my family, for their support, understanding, patience and love over many long years. My wife Pauline, my son Marc, my daughter Rachel and my second son Richard have allowed me to indulge myself in pursuing this strange activity called animation when I should really have been doing more grown-up things.

A huge debt of gratitude is owed to all at Focal Press, but especially Marie Hooper and Georgia Kennedy for all the

support over a very, very long period and showing incredible patience. For pushing, shoving, cajoling and bullying me, and all with caring even loving heart, quite a feat really.

Thanks to Mary Murphy, Gareth Cavanagh and Aurelie Blard-Quintard for help with some of the images for this book.

And last of all, but to whom great thanks must go. I would like to sincerely thank all of my hundreds of students, both past and present, that I have had the pleasure to teach over the years and from whom I have learned and continue to learn so much. I can truly say that I am extremely proud to have known you all (well, most of you) and count myself truly privileged to have taught you. I pray that I can continue to pass on a passion for and a deeper understanding of our art form that I have acquired through this experience to generations of animators to come. Thank you, this book is for you.

I know I have forgotten to mention some people and to some of those I apologize (or not), but you know which one you will be, don't you?

Chris Webster

Chapter 1
Basic Principles

Arcs in Head Turn #1

In order for animation to be believable the action must demonstrate those qualities that we are familiar with in our day-to-day experience. Even the fantastic will become credible if it appears to respect those same laws of nature that we ourselves are subject to. Beyond that, we ask animators to take us on a fantastic journey where the everyday becomes magical and the impossible becomes plausible.

BEFORE WE BEGIN

It has never been easier or cheaper to make animation but, despite this, the choices you must make in terms of equipment and materials have become far more complex. In order for you to film your animation you are going to need some kind of a recording and playback device. If you are going to be making computer animation you may have all this in one package and there are a number of off-the-shelf options available, ranging from the relatively inexpensive to packages costing many thousands of pounds. For 2D classical animation you will probably need a lightbox to work on, a camera with a rostrum stand to film the work and a frame recording/storage device. This may be a traditional film-based system, a video set-up or a digital computer-based system. You may even dispense with a camera altogether if you opt for scanning your drawings directly into a computer using an ordinary flatbed scanner. If you do choose this option you will need some kind of registration system used while scanning in your drawings. If you don't do this the drawings will be unregistered and the animation will be all over the place. Scanning your drawings is time-consuming and while it may be the best way to capture images for the finished animation, it may not be the best option for testing rough animation. For 3D stop-frame animation you will need a camera, a tripod, some lights and the same kind of frame recording/storage device, film-, video- or computer-based system. Recording onto film, video or digitally adds another level of complexity to your choice of kit. There are some very sophisticated and reasonably priced packages on the market that have been developed specifically for stop-frame animation. In addition to the animation packages you will need to consider how you are going to record and edit sound, edit final footage and output animation to a variety of formats. All of your choices will be wrapped up in the reason why you are making animation, the type of audiences you wish to reach and how you intend to distribute your work. The choices you face are so broad and ever changing that it is

beyond the scope of this book to cover these issues in detail. There are, however, many books and magazines available to the professional and amateur alike that give good, up-to-the-minute advice on the specifics of equipment and software to suit all kinds of budgets. It needn't be that expensive and there are several suggested sources listed in the 'Further reading' section (Appendix 2).

TIMING IN ANIMATION

Persistence of vision

Before we get on to the nitty-gritty of animation timing it might be useful to briefly cover the principle that underpins film and animation, and to understand how the illusion of movement is achieved where none is actually present. This marvellous phenomenon is known as the persistence of vision and it is through this that we experience moving images made up of individual frames on a film strip. The secret of this illusion is to be found in the remarkable capability of a part of the human eye, the retina, of momentarily retaining any image it receives. Imagine, if you will, a light being shone into the eye only briefly and appearing on the retina as a bright spot. This bright image would appear to remain for a brief period even after the light had been turned off. It's this slight period of retention or delay that allows for separate sequential images, if seen in quick succession, to appear as a moving image, and it's upon this principle that film and video projection works. Although this phenomenon had been observed in ancient times, it wasn't until the systematic experiments in 1765 by the Frenchman, Chevalier D'Arcy, that it was established that this retention period was approximately one-tenth of a second. The early optical devices that were developed and began to appear in the first half of the nineteenth century clearly demonstrated this effect. What started out as serious scientific investigation soon found a practical application for entertainment through the use of such devices as the thaumatrope, the zoetrope, Joseph Plateau's phenakistoscope and Emile Reynaud's praxinoscope. Variations of these quickly began to appear as popular parlour toys in the homes of the upper classes throughout Europe.

Frames per second

All animators, irrespective of what discipline they work in (2D classical animation, stop-frame animation or computer

animation) and despite what work they undertake (commercial, studio-based or experimental animation), all use the same basic raw material to create their work – time. They use this in much the same way as a painter uses paint or a sculptor uses stone, and while this raw material shapes and defines their work, what they choose to do with it is another matter. The use of time varies from animator to animator, just as paint does with a painter, and it's this varied approach and use of time that helps make the variations in stylistic execution of animation, be it funny or tragic, naturalistic, cartoon or abstract. The basic unit of time we deal with as animators and film-makers is determined by the recording and projection rate of the individual film frame or video image. This rate is commonly known as frames per second (fps).

While these playback or projection rates have varied since the development of cinematography, the standard recording and playback rate for film and video usually equates to:

- Film – 24 frames equals 1 second.
- Video – 25 frames equals 1 second (PAL).
- Video – 30 frames equals 1 second (NTSC).

These figures become critical in achieving the illusion of motion. As we have already established, the persistence of vision retention rate is around one-tenth of a second – much longer than the fps projection rates for film or video. If the projection rate was below that of the retention rate on the retina, the sequence of images would appear jerky and as individual images, and the illusion of movement would be lost. Because animators determine the speed of action of all they animate by creating animation timing, rather than recording movement as in live action, it is possible to achieve all of the variable animation timings they could desire. Working within these normal fps rates does not constrain the creative potential for animation, other than on purely technical issues, and is generally not noticeable to the eye. By comparison, live action film-making depends upon 'recorded' time as opposed to 'constructed' time. The timing of action is recorded not 'created' and is an automated process dictated by the film equipment; therefore, it is often necessary to use other techniques involving variable fps rates to achieve the desired effect. By recording/filming at one speed and playing back or projecting at another, it is possible to achieve slow motion or speeded-up actions.

- Record/film at a slower rate than playback/projection = a speeding up of the action (clouds racing across a sky).

- Record/film at a faster rate than playback/projection = a slowing down of the action (slow motion action for analysis of wing beats of a humming bird).

Timing

Animation timing is the most basic and fundamental aspect of animation, yet it varies greatly depending upon the approach the animator takes. Animation timing, as well as the animated objects and characters themselves, may be stylized or naturalistic according to the effect required. Cartoon animation and naturalistic realism demand very distinct and separate approaches to animation timing. To be skilled in either form takes a great deal of practice and requires an in-depth understanding of the discipline. At its most refined, animation ceases to become a simplistic mechanical act of creating a moving sequence of images and becomes a performance rather akin to acting and, like all good acting, it takes patience and a critical approach to perfect the craft of performance. Most of the animators working in the first quarter of the twentieth century had little understanding of the medium; they had few mentors or contemporaries with well-developed skills and next to no teaching material they could use to help them learn. This, coupled with the incredible commercial pressures to complete the work in order to meet near impossible deadlines, meant that progress was severely hampered. You only have to look at some of the very early attempts by animators in achieving even the simplest of actions to get a sense of the difficulties they faced. Even so, the likes of Winsor McCay, Ub Iwerks, Grim Natwick, Pat Sulivan and others began to shape the medium and pave the way for a score of talented individuals who began to systematically analyse animation timing and formulate the principles we take for granted today. Much of this early development of the medium took place at the Disney studios as the animators sought for ever increasing naturalism within the work.

In order to do the fantastic we must first understand the real.
Walt Disney

This statement of Disney's typifies his search for an increasingly high standard of animation and timing for animation. In order to do this we must understand how things really behave in nature.

As we have already established, there are many approaches to animation and the notion of 'good timing' is entirely wrapped up in and linked to what the animator is trying to achieve. A good dramatic performance demands different acting skills to that of a comic actor, not greater or lesser – just different. Most abstract or cartoon animation has very different qualities to naturalistic animation; therefore, good timing could be said to be somewhat subjective, yet it is animation timing that makes an animation believable, funny, frightening, moving, poetically beautiful or just downright silly. To get it right demands constant practice and to become a master of this art form is the work of a lifetime. In its highest form it is a performance art and, rather like acting, the practitioner should only improve with experience. Some animators specialize in creating naturalistic work that is intended to exactly replicate existing subject matter or at least to make the animated subject move in a totally believable and convincing manner. Many special effects animators deal with these issues on a regular basis. The work in feature films often falls into this category, such as *Terminator II* (1991) and

Figure 1.1 The spacing of the animated images is what gives the animated action its specific timing and dynamic quality. The greater the distance between objects, the faster the action will be. Notice how the feathers in the illustration are grouped closely together. This will give a slower, more floaty type of action, while the drawings of the one-ton weight are more widely spaced, which will give a much faster action. Also notice that the weight drawings appear directly over one another to give a linear movement; the weight would fall straight down. The drawings of the feathers, on the other hand, move in a series of arcs to create the desired action; the feather would move too and fro as it fell to earth, at some points moving slightly quicker than at other times.

Jurassic Park (1993). Other animators specialize in cartoon animation, stretching the boundaries of the believable. Tex Avery was a master of this form of animation and took it to extremes, though since then others have used his techniques and followed on the same path – for example, *The Mask* (1994) and the cartoon series *Ren and Stimpey*. It is exceptional for an animator to be a master of all forms of animation, just as it is extraordinary for a painter or musician to be a master working in a broad range of media or artistic forms. However, the mechanical principles of animation timing are common to all forms of animation, are relatively simple and can be fairly easily taught. It's learning how to apply these principles that takes time!

All animation timing is wholly determined by the sequence of images and their relative position to the preceding and following images as they appear on screen. Fast or slow actions are achieved by the variations in the spatial relationships between the individual images within an animated sequence. It doesn't matter if these images are drawings, 3D models, found objects or computer-generated images, the principle remains the same. Simply put, the closer the subsequent images are to each other in their position on the screen, the slower the action; the greater the distance between the images, the greater the speed of action.

> It is not important what goes on each frame of film; it's the spaces between the frames that are important.
>
> Norman McLaren

ANIMATION EXERCISE 1.1 – FLIP BOOK

Aims

The aim of this first exercise is to develop an understanding of the use of sequential images in the creation of animation and the principles of persistence of vision as applied to flip books.

Objective

Once you have completed the exercise you should be able to create a variety of flip books with animation running at different speeds.

Many of us at one time or another have made a flip book, even if it is just four or five drawings made surreptitiously in the corner of a school book. I have to confess that as a child I used the Bible I received from school. Nice thin paper, lots of it, ideal for animation. If you haven't done animation before, this very basic exercise will give you a feeling for the

principles set out earlier. Flip books are one of the simplest ways of making animation and can be created without the use of a camera at all. More detailed information on recording animation on video and film is covered in Chapter 7. For those of you who have never made a flip book, there are just a few simple points to bear in mind before you begin to make your animation.

Figure 1.2 There are a few basic points to bear in mind when you begin to make a flip book. Basic Point Number 1 – don't use a Bible or any other holy texts. Basic Point Number 2 – you should make your drawings in a landscape not portrait format, so if at some point you decide to record them on video or scan them into a computer you can see them on a monitor in the same approximate format as film and television.

Figure 1.3 Basic Point Number 3 – you should begin your drawings on the last page of your flip book pad with it turned onto the backing card. This page will be your first frame of animation.

Figure 1.4 Basic Point Number 4 – turn over the next page on top of your first drawing. You should be able to see your first drawing showing through the second page.

Figure 1.5 Basic Point Number 5 – make the next drawing slightly different to the preceding one. The rate at which you alter the drawings – that is, the distance between your drawings – will determine the speed of your animation. Remember, the greater the distance between the drawings, the quicker the action; the closer together they are, the slower the timing will be.

Figure 1.6 You should continue to make drawings in this manner until you have either completed your animation or run out of paper. Keep an eye on how your animation is progressing by occasionally flipping the pages and viewing your work. When making a flip book it's important to use the right kind of mark-making tool. Pencils are fine if you use soft ones; too soft and they may smudge and get a bit messy. However, if they are too hard or you make your drawings too lightly you may find that it's very difficult, if not impossible, to view the last drawing through the paper on top. If you use pens you should ensure that they are not the type that will bleed through the paper; these will just ruin the work you have already completed. It might be a good idea to use individual sheets of paper; these can be held together by a bulldog clip. It's easy then to insert extra drawings or take drawings out without weakening the binding as it does on flip books made from notepads.

If at first you keep your drawings simple the animation will appear clearer. As you become more confident you can make animation using more complex images. Remember this is a simple experiment in animation timing *not* in design. Try varying the distance between the drawings as you progress and see what effect that has on animation timing.

Just a suggestion

For those of you who may not know where to begin, you could try one or two of the following as a start.

Figure 1.7 Try animating a simple stick man doffing a top hat.

Figure 1.8 Move a simple shape, a square or a circle, around the page.

The more drawings you use in an action, the longer the animation will take; the closer the drawings are to one another, the slower the action will be. You'll soon gain confidence and find that you will come up with far better and more interesting ideas of your own.

Figure 1.9 Animate a simple boat across the page in one direction and a sun and clouds in the opposite direction.

Figure 1.10 Metamorphosis – changing one object into another over time.

So, we have established that animation timing is primarily concerned with the speed at which actions or parts of an action are completed. However, this is seldom as simple as it seems. Consider, for example, the seemingly uncomplicated action of a person getting out of a chair. This action will entail the shifting of weight and the maintaining of balance throughout, and consist of a number of separate movements, each possessing their own timings, many of which will overlap one another (they will start and end at different points) and all of which are subject to Newtonian laws of motion. Superficially, this basic action relates more to the physical conditions of the scene and takes into account the nature of physiognomy, dynamics, materials and natural forces. Simple!

However, if we then add other considerations of a psychological nature to the mix that relate to acting and storytelling we may get different results. Now let's consider the same action again for a moment, though this time we have additional information. The figure is getting out of his favourite armchair, though struggling somewhat due to the pain in his leg brought about by an injury incurred during a recent accident caused by a very irate neighbour in a long-running feud. He is getting to his feet in some considerable haste, as he has just received the news that he has won a large sum of money on the national lottery. The mixture of pain (the injury), irritation (his neighbour), surprise (winning

the competition) and jubilation (the thought of the money) will create a complex mix of actions. Not so simple.

Before we get to grips with the practicalities of more sophisticated animation timing, we should look at some basics. First of all we should be aware that animation timing may be categorized into three distinct types:

1. Pacing
2. Phrasing
3. Timing.

These three aspects of timing may be applied to the various levels of animated movement within an animated film, and describe and differentiate the distinct action dynamics within a sequence.

Pacing

This describes an aspect of animation timing that is concerned with a series of sequences and how they interrelate with one another and create a coherent whole within a film. As a film progresses its pace will speed up or slow down to create action, drama or tension within a narrative. For instance, the separate sequences that could have preceded the armchair event we have just covered could be paced out something like this:

- *Meeting* – pace is slow and tension is built up as the neighbours talk across the garden fence.
- *Discussion starts* – pace is still slow, though begins to increase as the tension between the neighbours mounts.
- *Argument starts* – pace increases, actions begin to speed up.
- *Argument gets heated* – pace is much faster, both characters increase speed of actions; perhaps this is reflected in the length of each shot.
- *Accident* – pace is very fast as the sequence hits its climax.
- *Post-accident sequence* – pace is very slow, almost stops.
- *Sitting in chair nursing his wounded pride* – pace is slow, though has increased slightly from the dead stop of the accident.

Pacing relates much more to film-making and storytelling than the animation of individual elements within the film, and it's

in such a way that the director manages to involve and manipulate his audience through emotional connectivity.

Phrasing

This category of animation timing is linked to actions that go to make up a sequence and the manner in which they interrelate, creating an overall performance. Most character animation will benefit from varied phrasing as the character undergoes changes either in action or mood.

Once again, let's consider how a character may slow down and speed up within a sequence.

- Initially our character may be sitting relaxed in a chair reading a newspaper.
- On noticing the time, he may have the sudden realization that he is late for an appointment and, in a blind panic, leaps to his feet and heads towards the door.
- He may then stop suddenly in his tracks as he realizes he can't find his car keys.
- Moving quickly about the room from table to cupboard to chair, his actions would increase in speed and become more frantic.
- On finding the keys he would slow down slightly and once again hurry to the door, at which point someone tells him that the appointment has been cancelled; his actions stop suddenly and he gradually relaxes from his frantic state to return once more to his newspaper.

Most scenes will benefit by the varied phrasing of action, becoming much more dynamic and interesting throughout. The intention here is to engage your audience; as the dynamics of the character change throughout a scene, so does our response to his changing circumstances. Each of the separate actions that go to make up the sequence – turning of the page of the newspaper, leaping out of the chair, the search, returning to the chair – are normally completed within their own distinct time frames, some slow, some faster. When each of these varied actions is linked together we create phrasing. Consider it like choreographing a dance sequence. How boring and inexpressive would a dance be if it was all executed at the same pace? While the

Leg Swing - Child

Figure 1.11 Now let us take a look at how this fairly straightforward action can vary. Let's assume that the stride could belong to that of an old man, a young woman or a child – each of these physical characterizations would have its consequences on the timing. An old man's stride may be slow and more even in its timing; he may be quite frail and unsteady on his feet, which may make his movements more circumspect and unsteady. This may result in the stride taking as many as 16–20 frames.

Leg Swing - Young Person

Figure 1.12 A young woman's stride may be quicker. She may be in the prime of her life, strong and in good health. This may result in a more confident and assured action, taking perhaps 8–12 frames. The stride may also be much wider than the old man's, not necessarily because of the height but because there is less uncertainty to her movements.

three separate aspects of animation timing – pacing, phrasing and timing – are closely interlinked, phrasing is more concerned with specific acting and performance issues than overall storytelling, cinematic narrative or the detailed movements of individual elements.

Timing

This aspect of animation timing is the one we begin with when we consider the principles of animation timing, and it's the one that describes the period of time it takes for an individual action to take place. It covers the fine detail of animation. An arm reaching for a glass of water, a head turning quickly in alarm, the speed at which arms and legs move in an animated walk or run, the beat of a bird's wing, all of these separate actions will have their own varied timings. As an animation tutor I am often asked such questions as 'How many drawings are there in a walk cycle?' 'How many separate movements are needed to get a horse to walk across screen?' I have even been asked if a 12-frame run cycle is funnier than an 18-frame run cycle! To these questions there can be only one answer – it depends. And what it depends on is the context in which the animation takes place.

For instance, the movement of a leg as it swings forward during a stride will generally demonstrate a predictable kind of action and timing that will apply to many different kinds of actions. The trailing leg in a stride will start slowly and accelerate as it goes through the stride. As it moves to a forward position it will begin to slow down as it gets to the extended position.

What we can gather from these examples is that it is clearly impossible to state categorically the *exact* timing of any one particular action. Only experience will provide the animator with an extensive knowledge of timing. In the meantime, however, we can make inroads into learning the principles behind animation timing.

Let's take a look at the underlying principles that determine motion and how, as animators, we use these to create various timings.

LAWS OF MOTION

It was Sir Isaac Newton who in 1687 first set out the universal laws of motion in his groundbreaking treatise the *Principia*. In

it he described three laws that underpin all our subsequent understanding of the physics of motion.

First law (inertia)

Newton's first law of motion states that every object that possesses weight will remain static until such time that a force is applied to it. So if an object is at rest it will remain that way until an external force affects it. Once an object is moving it will remain moving in a straight line until such time it is acted upon by an external force affecting either its speed or direction.

Second law (constant acceleration)

The second law states that the motion of an object accelerates in the direction of the force applied to it and that the greater the force applied to an object, the greater the acceleration will be. The greater the mass of an object, the more inertia the object possesses and consequently the greater the force required to move the object.

Third law (equal and opposite action)

Newton's third law of motion states that for every action there is an equal and opposite reaction. This means that if a force is applied to a body, the body reacts with an equal and opposite force on the body that exerted the force.

Cause and effect

So, we have seen that once an object is moving it takes on momentum, which equates to its mass and the speed at which it is travelling. The more momentum an object possesses, the further it will travel and the greater the opposing force needed

Leg Swing - Old Person

Figure 1.13 However, as we can see from the illustrations, there are features that all the walks would have in common. Actions usually start slowly as the object overcomes its inherent inertia, increase in speed to a point where a steady pace is achieved and end by decelerating to a stop.

Inertia

Newton's First Law of Motion;
An object will remain at rest until a force is applied.

Low energy state High energy state

Figure 1.14 This explains how the earth and all the other planets in our solar system orbit the sun; if the sun wasn't there to exert a force (gravity) on these planets, they would simply move out into the depths of space.

Figure 1.15 Simply put – the harder you kick a ball, the further and faster it will travel. Balloons require less energy to move them than tennis balls, which in turn are easier to move than cannonballs.

Acceleration

Newton's Second Law of Motion;
An object accelerates relative to the force applied and in the direction of the force.

The greater the force applied the greater the distance travelled and the higher speed achieved.

Figure 1.16 We can see an example of this in rocket travel in space. The hot gases moving out of the back create forward momentum of the rocket. We can also see this in the recoil of a cannon as it fires a cannonball. Notice that the cannon will move much less than the cannonball because of the comparative mass and inertia of the two separate objects.

Equal & Opposite Action

Newton's Third Law of Motion;
Each action has an equal and opposite action.

Thrust moves in one direction and the rocket moves in the opposite direction

The cannon moves backwards as the cannonball is propelled forwards

to bring the object to rest. This principle will be reflected in the animation timing. A light object may get up to its running speed much more quickly than a heavy object that has to overcome far greater inertia. However, the heavier object may continue to move long after the lighter object has come to rest. Motorcycles accelerate and decelerate more quickly than a large lorry, even though the engine size outputs less energy.

Gravity and its effect on a falling object

Newton also described a universal law of gravitation based, it is said, on his observations of apples falling from a tree.

Basic principles 17

Momentum

More weight = More inertia
More inertia requires greater force to instigate motion in an object

More weight = Greater momentum
More momentum requires greater force to stop an object

Figure 1.17 While friction may not noticeably affect a cannonball rolling along a smooth surface, the action may be slowed a little if it travels over rough uneven ground and may be more quickly stopped if it is rolling across a muddy field, as the friction caused by the mud would be far greater. Try hitting an ordinary party balloon with the flat of your hand and you will observe how quickly it reaches its top speed; you may also notice how quickly it begins to slow down as it moves through the air and meets friction with the air. This peculiar action is due to its size:weight ratio. Its size may be comparable to the cannonball though its mass is much lower. Consequently, it possesses far less inertia and, once moving, less momentum.

Acceleration of a Falling Object

All objects fall at the same rate

Air resistance means that the feather falls more slowly than the hammer

Figure 1.18 It was Galileo who observed that all objects, within a vacuum, undergo uniform acceleration. A large object and a small one, such as a cannonball and a marble, could be dropped from a high building and they would land at the same time. This demonstrates rather beautifully that the effects of gravity are constant and apply equally to all objects, and that all objects accelerate as they fall to earth at a constant speed. The reason the feather lands after the hammer has nothing to do with the effects of gravity, it is friction through air resistance that slows the descent of the feather; a smaller object with the same mass as the feather though with less surface area would accelerate at the same rate as the hammer.

Ball Thrown Vertically

The spacing between the balls begins to cluster at the highest point in the throw as the ball slows down.

As the ball moves downwards the spacing begins to spread as the object accelerates.

Figure 1.19 Notice how the ball begins to slow down as it reaches its apex. The spaces between the drawings get much closer together.

However, it was Galileo who observed that all objects, when dropped, fall at the same rate. An American astronaut on the surface of the moon demonstrated this principle, first set out by Newton, most clearly for the entire world to see on television footage. For this purpose he used a hammer and a feather to illustrate the point; they fell at the same rate and landed together. However, this does not take into account air resistance. Back on earth, the feather will obviously fall at a much slower rate than the hammer due to the effect of comparative friction on the objects.

When a ball is thrown into the air vertically it will initially accelerate proportionately to the force applied to it; it will gradually slow down until it reaches its apex. The height the ball achieves is determined by the force with which it is thrown. Gravitational forces that apply themselves to the ball counter the initial force applied to the ball. This will result in the ball slowing down until all the energy initially applied to the ball is expended. The ball will then stop, albeit for an instant, before beginning to accelerate as it travels downwards again. If it were possible that the ball could be thrown hard enough it would reach such a height that placed it beyond the gravitational pull of the earth and it would begin to orbit the earth.

We can see that the dynamics of a thrown object are not only determined by the force applied to it to make it move in the first place, but also gravitational forces. This gives us a particularly distinctive arc.

A further aspect we need to consider is that objects are a source of stored energy and that the energy can be released in a number of ways. Falling objects release their energy, at least some of it, on impact with the ground in the form of kinetic energy, which is to say they bounce or move off in other directions. We can see clear examples of how the energy within a falling object is expended. The height of a bouncing ball is determined by the height from which it is dropped. The higher the position the ball falls from, the greater the height of the bounce.

SQUASH AND STRETCH

Before you attempt the next animation exercise it would be best to cover the principle of squash and stretch. Squash and stretch is often used in cartoon animation for comic effect and is sometimes used to describe a particular type of

Basic principles 19

Arc of Parabola

While the path of the arc remains constant the spacing between the balls throughout the arc varies as the dynamic varies. Notice how the drawings cluster at the apex of the arc as the ball moves more slowly. The drawings are more spaced out as the ball moves faster.

Figure 1.20 It's a combination of the forces applied to a thrown object and gravitational forces that give objects a curved path.

Rate of Falling Objects

The rate at which objects fall is the same regardless of weight.

A bullet projected from a gun along a horizontal path will hit the ground at the same moment as one dropped from the same height.

Figure 1.21 What is interesting to note is that a speeding bullet coming out of a gun will hit the ground at the same time as a ball dropped at the same time as the gun was fired.

Figure 1.22 Notice how, in this illustration, the drawings are closer together at the top of the arc than they are at ground level. The result of this is that the ball demonstrates variable speed throughout the action. A bouncing ball moves more slowly at the top of the arc. The ball moves quickly upwards after bouncing (the drawings are wide apart) and begins to slow down as it moves towards the height of the bounce (they are closer together). The ball begins to speed up as it falls to the ground again and the distance between the subsequent drawings becomes greater. Remember: the closer the drawings are together, the slower the object moves; the further they are apart, the faster the object moves.

Figure 1.23 Notice in this example the ball bounces at different heights due to the height it falls from. The height of the initial bounce on the highest steps is exceeded by the bounce of the ball falling from a greater drop, as the ball now possesses more stored energy. The subsequent bounces of the ball get smaller and smaller as more energy is lost on each impact with the ground. The horizontal distance between each successive bounce will also be less until the ball comes to rest.

Basic principles 21

Bounce Decay

Height of bounce is maintained as the energy gained during the fall equates to the energy lost on impact with the stairs and during the climb

Energy gained during fall

Energy lost during climb

Energy lost on impact

Height of bounce decreases proportionately to the loss of energy

Figure 1.24 In this example, the height of the bounce remains the same throughout the descent of the stairs. This is because the potential stored energy within the ball remains the same after each bounce on the steps, as the height of each fall between the steps is the same. Notice, however, that once the ball reaches the bottom of the stairs, the energy lost on each bounce results in smaller bounces until the ball at last comes to a halt.

Impacts and Force

The impact of an object hitting the ground is determined by the force; the greater the force the greater the impact

Figure 1.25 For objects that have less potential to bounce than a ball there may be different results. The impact craters made by falling anvils will vary depending on the height from which they are dropped. This is just another example of the varying levels of stored energy within an object being expended.

Squash & Stretch

The ball regains its spherical shape as it approaches the top of the parabola

Height of the bounce declines as energy is lost

The ball stretches as it falls towards the ground and again as it climbs after the bounce

The ball squashes on impact with the ground

The squash on impact lasts for only one <frame before> stretching out

Figure 1.26 Animating a bouncing ball without the use of squash and stretch may leave the animation looking rigid and lacking snap, even though the timing may be correct. Notice how, when squash and stretch is applied to the ball, the particular aspects of the bounce are emphasized. It's important to note that 'squash' is only applied to the ball on impact with the ground and is very quickly replaced with 'stretch' to emphasize the quick action. At the top of the arc the 'stretch' is lost as the ball slows down. It begins to stretch again once it speeds up towards impact with the ground. When excessive squash and stretch is used, the animation will take on a cartoon feel and the action will begin to lose some of its naturalistic properties.

action-based slapstick animation, such as *Tom and Jerry*, *Roadrunner* and most notably in the work of Tex Avery. While squash and stretch is far less associated with animation such as *The Simpsons*, it does not simply apply to a particular type of cartoon animation. Squash and stretch is a technique that, if used with sensitivity, can enhance most of your animation – even the most naturalistic. It's a process whereby the physical form may be manipulated to emphasize a certain action. An object hitting the ground may flatten slightly (squash) before springing back into shape. Fast-moving objects such as a ball being thrown may be elongated (stretch) to emphasize the action. We can see in the following illustrations that when squash and stretch is applied to the animation of a bouncing ball the action is enhanced.

As a general rule you should ensure that the volume of the object you are animating is not changed; it should neither gain nor lose mass. While the shape of the characters and objects may change, they may be flattened or extended; they should not lose or gain volume. This will help the animation to remain in scale with the rest of the environment. Perhaps the most extreme example of squash and stretch can be found in the work of Tex Avery, particularly in some of his masterly pieces of work for MGM in the 1940s, in which he took all kinds of liberties with volume. He used a range of techniques

Squash and Stretch on the Face

Squash and stretch are more evident on the fleshy parts of the face: the jowls, nose and mouth.

Notice that while the head may be subject to squash and stretch the overall volume remains the same

Figure 1.27 Even when animating facial features it is possible to use squash and stretch to emphasize action, which may in turn affect mood and performance. More excessive use of squash and stretch on facial features will give you a cartoon feel that may tend to look less naturalistic. This extreme form of squash and stretch clearly sits well within the cartoon conventions of Avery's work and as such we accept them, but if you tried to do this within an otherwise naturalistic piece of animation the results may be at odds with the rest of the work.

to the extreme, contorting his characters, ripping them apart before reconstructing them, and squashing and stretching them to breaking point, and in doing so practically created a new type of animation that others began to emulate. The more recent film *The Mask* (1994) used the type of animation that became Avery's trademark (they even used the wolf, one of his most famous characters) and set it within a live action environment, though they clearly set the parameters of acceptability through the magical properties of the Mask itself.

When using squash and stretch to achieve naturalistic animation you should take into account the nature and properties of the material you are dealing with. Give careful consideration to the weight and density of the object and allow for any natural flexibility of the material; that way your animation will be believable. It is important to avoid any unnatural rubberizing of objects – unless you are animating rubber. It is easy to overdo it.

Rigidity almost never occurs in organic forms (except boulders and rocks) and is usually only seen in such man-made objects as cars, furniture, bottles, buildings, etc., but if used appropriately squash and stretch can even be applied to these. Even the animation of some of the rigid forms will benefit from a limited application of this technique and, for a more cartoon effect, squash and stretch can bring life and characterization to anything.

Figure 1.28 It's important when you are dealing with materials such as metal or glass to retain their particular rigid properties. Overdo it and you could easily end up with animation that has no snap and lacks credibility! Remember, you may want to rubberize the action without animating rubber.

Squash and Stretch in a Bottle

A little squash and stretch may enhance the action even in objects made from rigid materials

Oops!

Apply too much squash and stretch to an object and it may make the action unbelievable

For example, if your character is a teacup, such as Chip in Disney's *Beauty and the Beast* (1991), squash and stretch will help to give personality. However, if the object is simply a prop it may lose credibility if squash and stretch is applied too liberally – or even at all.

POSE-TO-POSE AND STRAIGHT-AHEAD

There are two distinct processes by which animations are made: pose-to-pose animation (or key-frame animation) and straight-ahead animation. Both are very different ways in which animators approach the making of the work, and both have their unique qualities and specific advantages and disadvantages. The terms straight-ahead and pose-to-pose simply describe the separate processes and the way in which subsequent images are created. Within straight-ahead animation the animator makes the first drawing, or sets the position of the model for the first frame of animation, and then goes on to make the second drawing or set the second position for the second frame of animation. The animation is continually made one frame after the other in chronological order: 1, 2, 3, 4, etc. The images are compiled in this way until the sequence is complete, creating animation in a straight-ahead manner. This process of straight-ahead animation is the only process available to stop-frame model animators as the only way that it can be done is a frame at a time, one after the other. If you recall, this is the way in which you made the flip book animation earlier.

Making pose-to-pose animation (or key-frame animation as it is increasingly known) is entirely different. The animator will

Pose-to-pose & Straight-ahead Animation

Straight-ahead Animation

[1] [2] [3] [4]

— — — Time Line — — — — →

Pose-to-pose Animation

[①] [2] [3] [④]
Key Inbetweens Key
Drawing Drawing

Straight-ahead animation drawings are made in sequential order: 1, 2, 3, 4, etc....

Pose-to-pose animation is made by creating Key Drawings first. These illustrate the important positions within an action and are followed by creating Inbetween drawings.

Figure 1.29 Straight-ahead animation is created by making one frame after the other in sequence. Key-frame or pose-to-pose animation is made by creating the important moments of an action first and subsequently creating the frames in between these moments.

Key Frames Breaking Down a Sequence

Keys — Inbetweens that determine animation timing

Figure 1.30 The individual key frames are created in order to outline the sequence by breaking it down into a series of poses. The principal advantage of pose-to-pose animation is the capability it allows for the addition or subtraction of frames within the sequence. Changes to animation timing are easily achieved using this method.

make the first drawing or set the model for the first frame of animation (this applies to CG and not stop-frame animation). Once this has been done they create the next drawing or set the model for the next frame of animation depending upon a key moment of the action. The important aspect of pose-to-pose animation is that this drawing or position does not need to be frame 2. This can be almost any frame within the action and is determined by the nature of the action. Subsequent drawings are made of key moments of the action (hence the term key frame) without the necessary frames in between the key frames. So, for instance, an action of a figure throwing an object may be broken down into just a few key positions, picking up on all the major transitions of the action.

Advantages of pose-to-pose animation

The advantages of pose-to-pose animation generally outweigh the disadvantages; it's a very efficient way of producing animation, lending itself to an industrialized approach, and is the reason why this is the favoured method used in most commercial animation. One animator can create the keys while others can make the inbetweens based on the animator's timings. Using this method it is possible to sketch out an entire sequence using rough key drawings, enabling the animator to construct the entire action. From these, with practice, it is possible to make a fairly reliable assessment of the development of the action without having to create all the drawings. Using key drawings it is also possible for animators to more easily synchronize key moments within an action to pre-identified frames that appear on the dope sheet. This is most important when animating dialogue. This is covered in more detail in the chapters covering lip-sync and dope sheets. It is also easier for an animator making classical 2D animation to keep the characters on model and to ensure that proportions do not change throughout the sequence.

Disadvantages of pose-to-pose animation

The disadvantages are that the animated action may at times, in the wrong hands, appear to be a little stagy, stiff, and have the appearance of being constructed and somewhat unnatural. For some forms of cartoon animation this may not be a problem but become part of the stylistic approach. However, for more naturalistic actions, particularly in those actions that have many complex elements, each with its own specific timing requirements, it may actually become more difficult to break down each element into keys and inbetweens. The disadvantages of pose-to-pose animation are sufficient to warrant a mixed approach to animation, using both straight-ahead and pose-to-pose within a single sequence.

Advantages of straight-ahead animation

The great advantage of straight-ahead animation is that it encourages a liveliness of approach to the animation. It is unencumbered by an overstructured approach to the animation, you can go with the flow. This is very useful for actions that have a lot going on, with separate elements having their own timings. Trying to structure such actions

using keys may kill the action stone dead. Straight-ahead animation may often allow for a more creative approach to animation timing and surprise you with happy accidents, those moments when apparently, quite by chance, you create something more wonderful than you first intended.

Disadvantages of straight-ahead animation

This puts a great deal of added pressure on the animator, as corrections cannot easily be made by adding frames within an existing sequence. Straight-ahead animation can lack structure by its very nature and demands a good deal of concentration on the part of the 2D classical animator, something that is an everyday occurrence for the 3D stop-frame animator. Using this method, making one drawing after the other, it may be easy to allow drawings to change proportion throughout a sequence, gaining or losing mass. The difference does not have to be very great from one drawing to the next, but taken over many drawings this difference may well become very noticeable. It is also more difficult to hit specific points within a sequence and there may be a tendency to allow the duration of specific scenes to grow or shrink, which may cause more difficulties for the director trying to keep to the initial timing of the animatic.

KEYS AND INBETWEENS

More and more drawings or, in the case of computer animation, additional frames are made in this fashion – mapping out key moments of the sequence until the action is completed using key frames alone. At this stage the sequence is completed with key frames with no frames in between the key action. The sequence is initially broken down into individual poses; subsequent animation is then added to get the action from one pose to another pose – hence the name. You will notice that there are initially far fewer drawings of frames within the sequence than the equivalent using straight-ahead animation. In order to complete a sequence of pose-to-pose or key-frame animation properly, it is necessary to add the frames that appear between the keys. These drawings or additional frames are known as inbetweens – because they appear in between the key frames. Once these are added you will notice that the number of frames for each of the sequences is the same, or very nearly.

It is standard practice in 2D classical animation to illustrate animation timing breakdown with the use of a small chart or

Figure 1.31 The individual key frames are created in order to outline the sequence by breaking it down into a series of poses or points within an action. In this case it is a simple ball rolling down a slope. The two key frames are positioned at the beginning and end of the action, in this case Key Drawing A and Key Drawing B. It's at this stage that the animator creates the animation timing chart that describes not only the number of drawings in the sequence, but also their spacing throughout the sequence.

Figure 1.32 Animation timing breakdown.

grid. These are used to indicate key drawings and the inbetween drawings that appear between them.

We've seen how we can create key frames and inbetweens, and we've seen how to make fast and slow actions by positioning drawings closer together or further apart. Now we need to take a look at how to vary the timing of an animation to create the dynamic required. To create variable timing we need to vary the position of the inbetweens in relation to the keys. Let's take another look at that bouncing ball.

This kind of variable timing is achieved by varying the distance between drawings. As these timings appear in relation to key frames, they are known as either 'slow ins' or 'slow outs'. In some computer software packages you will find this exact process described as 'ease in' and 'ease out'. Being trained as a classical 2D animator, I prefer the more traditional term, but either will do. But first of all, let's look at a constant speed to put the variable timings into context.

Making Keys & Inbetweens

① The first Key Drawing **A** represents the start position of the action

② The second Key Drawing **B** represents the end position of the action

③ Both Key Drawings are used to create the Inbetween. Key Drawing **A** sits on top of Key Drawing **B**

④ The Inbetween is drawn between the two Key Drawings

Figure 1.33 Once the key frames are completed, it is necessary to add inbetweens to the animation to complete the sequence. It's this spacing of the separate inbetweens that creates the animation timing.

Slow out

A 'slow out' describes an action that progressively accelerates out of a key frame. These timings are usually seen at the beginning of actions as the inertia of an object is gradually overcome. The greater the inertia an object possesses, the longer it will take to build up momentum, which may result in a more pronounced slow out action.

Slow in

A 'slow in' action describes movement that decelerates towards a key frame. Slow ins are typically used as an object slows down before coming to rest. An object with little mass and momentum will shed its kinetic energy more quickly than a heavier object and will slow down more quickly. Typically, such objects will have shorter 'slow in' periods than heavier ones.

Basic Sequence for Making Inbetweens

Key Drawing ①

To make this simple action using Pose-to-pose animation the following sequence would be used

2

3

4

Key Drawing ⑤

1. Make Inbetween Drawing # 3 using 1 & 5
2. Make Inbetween Drawing # 2 using 1 & 3
3. Make Inbetween Drawing # 4 using 3 & 5

Figure 1.34 The manner and order in which inbetweens are made is fairly standard and is pretty straightforward. Complex animation timings can be achieved quite simply if the proper structured approach is taken. *Step 1*. Checking the animation timings marked down for this sequence, we can see that there are three drawings that appear halfway between our two key drawings (1 and 5). We can see in this instance that drawing 3 is halfway between the two keys. This is known as a breakdown drawing; as its name suggests, it breaks down the action. So this is the first drawing of the sequence to be made other than keys. Placing key drawings 1 and 5 on the lightbox, we then make drawing 3, which appears halfway between the two as per the animation timings. *Step 2*. Having made the first breakdown drawing, we can now go on to make the rest. Using the first key drawing 1 and the breakdown drawing 3 just made, we can create the next inbetween, in this case drawing 2. Once again, you will notice on the animation timing chart that this drawing appears halfway between key 1 and drawing 3. So by placing key drawing 1 and drawing 3 on the lightbox, we can then make drawing 2. *Step 3*. The next process to complete the short sequence is to create the final inbetween (4). To do this, follow the same process as before, making drawings that appear halfway between two other drawings (keys or inbetweens), take key drawing 5 and the inbetween you have just completed (3) to create the next inbetween (4). By breaking the timing down in this manner we can mostly achieve all the animation timing we desire simply by positioning drawings halfway between keys, breakdown drawings and other inbetweens. Occasionally, it is necessary to make inbetweens that appear a third of the way between keys. These are usually a little trickier to make, though once you have more experience they are very useful in creating the exact animation timing you require.

Figure 1.35 We can see from the chart that the spacing between each of the drawings is at equal distances from each other. Such spacing will create a constant speed throughout the action, making for a most unrealistic bounce.

Timing - Constant Speed

Path of action

Basic principles 31

Figure 1.36 The spacing of the drawings in this chart will result in an action that speeds up as it progresses from the first key drawing – this is known as a 'slow out'. It's given us some variation in timing but it's not what we are looking for and gives us a very unrealistic action.

Figure 1.37 In this example the ball will begin to slow down towards the end of the action – a 'slow in'. This is still an unrealistic action for a bouncing ball.

Figure 1.38 We can see that in this illustration we have both slow in and slow out actions, and notice where they are. We have a slow in as the ball moves towards the middle key (drawing number 6) and a slow out as it moves from the middle key to the end key. This will result in the ball decelerating as it moves from the first key towards the middle key (slow in) and it begins to speed up as it moves away from the middle key towards the third key (slow out). The variable timing on this action will give the desired result, a more realistic and believable action, as we saw in the earlier example.

The frames that go to make up both slow in and slow out actions are known as cushions. More cushioning is added to extend the acceleration or deceleration periods of an action.

A word of warning! I have seen examples in some texts on animation where the terms 'slow in' and 'slow out' have described the exact opposite to what I have laid out above. I have even noticed that in some computer packages the terms 'ease in' and 'ease out' are the opposite of what I have described. The principle remains the same, so whatever you decide to call your timings shouldn't be too much of a problem unless you are working in a team with different traditions. The timing breakdown I learned and practised over many years in a number of studios is based on the model I present here and is also offered this way in a number of other texts by professionals – basically, if it's good enough for the master animator Richard Williams (and he learned it from the Disney master animators), it's good enough for me!

ANIMATION EXERCISE 1.2 – BOUNCING BALLS

Aims

The aim of this short exercise is to extend your understanding of animation timing, pose-to-pose animation and the variable dynamics of objects.

Objective

On completion of the exercise you should be able to create a series of animations with variable timings.

In order to understand the basic principles we have covered so far we need to put them into practice. The following animation exercise will give you a chance to play around and discover these things for yourself. Animation, rather like riding a bicycle, is learned through experience, not simply by reading about it. Also remember that animation skills are transferable skills; if you develop a good understanding of dynamics, a sense of animation timing and performance within one medium you will be able to carry these over to another medium with little additional effort. That is why many of the major CG animation studios are keen to employ people with solid 2D classical animation experience. You may find that this exercise will be much simpler to complete using 2D classical methods than 3D model animation, as you won't have the added difficulties of dealing with suspending the bouncing balls in space.

It is important to remember that the object of these animation exercises is concerned with movement and timing, *not* good draughtsmanship or design, so for the purposes of *all* these animation exercises you should keep your images as simple as possible. You should consider all these animation exercises as an opportunity to develop basic animation skills upon which

you can build, regardless of the specific animation discipline you work in. Also, as a general rule, naturalistic animation is more difficult to achieve than cartoon animation, so for this reason you should try to make all your animation within these exercises as naturalistic as you can. This makes cartoon animation sound simple – it isn't, it's just that the discipline involved in creating dynamics that emulate the real thing can be more easily and honestly assessed.

You should try to animate three different types of 'ball' bouncing down a set of stairs – so the exercise is in three separate parts. The three 'balls' are:

1. A tennis ball
2. A cannonball
3. An inflated balloon.

The aim of the exercise is to extend your understanding of timing in animation and the different and distinct dynamic properties of the separate 'balls'. You will find that each of the 'balls' will

Bouncing Ball

Drawing of steps to act as a stage

Path of action sits on top of steps

Figure 1.39 Draw a set of steps seen in profile as the 'stage' on which all your animation will appear. This drawing should be placed on a lightbox first, all subsequent animation being done on separate pieces of paper placed over this initial drawing. You may find it helpful to make, on a separate piece of paper, a path of action that each of the balls will make. These will act as a guide when you begin to animate. Obviously they will vary from one another because the actions of each type of ball will vary.

move in very different ways, though they will all be subject to the same laws of motion we have discussed. Each of the different balls will build up momentum. The level of this momentum is dictated by the object's mass; the more mass an object possesses, the more momentum it will build up. A heavy object such as a cannonball will take a lot more effort to move but, once moving, takes a lot more stopping than a tennis ball, for instance. These factors will help to give each ball its own very distinctive movement characteristics. Do not concern yourself with animating in perspective for this exercise, that is just another level of complexity that you don't need right now. You might want to try that once you have completed this successfully.

Figure 1.40 The first animated ball falling down the steps should display the characteristics of an ordinary tennis ball. Notice how the bounces are very similar to one another as they descend the steps and get smaller once the ball reaches the bottom.

Figure 1.41 Notice that the path of action for the cannonball has much less bounce in it than the tennis ball. The second animation should reflect the realistic action of a cannonball. Notice how the cannonball bounces much less than a tennis ball on each of the steps. However, the cannonball would continue to roll much further than the tennis ball once at the bottom of the steps. Ths is due to the amount of momentum an object with more mass has built up.

Balloon Path of Action

The bounce may be a little irregular due to shape of balloon

Figure 1.42 Your third piece of animation should demonstrate all the qualities of an inflated balloon. On this path of action there is more bounce than the cannonball, though the action has more drift than the tennis ball. The bounce remains quite quick, though the fall through the air is slower due to air resistance. Notice how the path of action may vary slightly between bounces. This is due to the air resistance such an object with low mass and large surface area will encounter. Once the balloon reaches the bottom of the steps, the bounces quickly lose height and there is little forward movement. The momentum is quickly lost due to the lack of mass and large surface area.

Once you have completed your animation you should make a thorough analysis of your work before attempting any alterations. Animation isn't learned by simply doing animation; it is learned by reflecting on the animation you have completed. It isn't enough to make a good piece of animation, it is necessary to understand what makes the animation good so you can repeat it. At this stage you may learn just as much from making an unsuccessful piece of work as one that works first time. Indeed, it is more likely, as it will force you to analyse your work much more closely. Remember, it's through constant practice and analysis that you will improve your skills.

Now that we have covered the basics of animation timing we can move on to take a look at some of the more involved and complex aspects of animation that, coupled with your understanding of animation timing, will continue to test your new-found skills.

OVERLAPPING ACTION, FOLLOW-THROUGH AND DRAG

Overlapping action, follow-through and drag are aspects of animation that are interrelated and are all very often evident within a single action. To fully understand how these operate as separate principles, one must become aware of this relationship. Follow-through and drag describe separate types of action

and while they are not the same, they do affect each other and occur within the same movements.

What is overlapping action?

Animating the motion of inorganic objects can be tricky, but animating living things is far more complex. Generally, the movement of the different parts of a living creature do not occur at the same time; things start, move and stop at different points and move at different rates. In order to achieve this lifelike action it is necessary to create time lags between these separate actions making the movement of the individual elements overlap. We call this overlapping action. Overlapping action describes these variable actions within an object and how some elements of an object start, continue and end their movement in relation to others. Overlapping action is often down to the complexity of the structure: the various materials it's made of, the nature of locomotion, the effects of natural forces upon the different parts (hair, arms, clothing and solid objects), the way in which these parts are connected, and a whole host of other variables.

An object, even one with a low degree of complexity, will demonstrate varying levels of dynamics throughout its structure during its natural motion. The separate parts of things nearly always move at different times and at different speeds. Animating a character as complex as a horse, for example, will by necessity demand a high degree of variable dynamic actions due to the nature of its physiognomy and the complexity of its mode of locomotion. A fish, on the other hand, may demonstrate far more simplistic actions. You will find that the main area of action in a human during locomotion often comes from the hips and that other parts of the body will follow. You should note that this is *not* a strict rule and many variations on this are possible, and it's these little variations in actions that will make your animation convincing and create the performance you are trying to deliver.

Staggered timing

It is important to remember that the separate things that make up a character – head, body, arms, hips, hair, etc. – should not start and end their actions at the same time or move at the same rate. The animation shouldn't appear as a mechanical action, unless you are animating machinery. Animators are usually after achieving a lifelike action, even in abstract cartoon animation, and only machinery or perhaps

Overlapping Action in a Simple Turn

The action begins in one part of the body and then flows throughout the figure

The head has completed the turn before the rest of the body

The head begins to move first

This action is followed by the upper torso

Subsequent movement in the hips precedes movement of the legs

Figure 1.43 In addition to considering the timing of the separate elements that make up an action, such as a head turn, the animator needs to think about the overall timing of the figure and all its separate actions. This will give you phrasing of the action.

soldiers on parade should move in this linear fashion. In the same way as the separate elements should not start and end their actions at the same time, they should not wait until other elements have come to rest before they in their turn begin their movement. This would give the overall animation a very unnaturally stiff action, a sort of stop–start quality.

Using pose-to-pose animation or key-frame animation, it is possible to break down a complex action into separate, more easily managed stages, which simplifies the process of making overlapping action. As animators begin their work, they will add layer upon layer of animation timings to the separate elements of the action. We can break this process down into primary, secondary and tertiary actions according to how they affect and are affected by the overall movement.

Primary actions

Primary actions are those actions that are central to any given movement. As an example, let's consider a fairly straightforward walk cycle. In such an animation, the action will be driven by the leg and hip movement of a walking figure. All other actions, such as swinging arms, bobbing head,

Walk Cycle - Primary Action

Primary action within a walk is from the legs; the action of the arms is a secondary action that assists the movement

The movement within a walk is not dependent upon the secondary action of the arms

Figure 1.44 The primary action of a man walking is the movement of the legs; the arm swing is a secondary action. The primary action of the man walking while carrying a box is seen to be the movement within the legs; this continues though the secondary action of the arm swing is no longer there.

etc., may be dependent upon or be a result of primary actions and, while they may assist the primary action, they will play little part in initiating the action. Imagine a man walking while carrying a large cardboard box. The arms will no longer swing, though the walk itself will not be affected in any fundamental way. In a walk the animator may begin with the legs and hips as primary action before moving on to animating the arm swings and movement in the upper torso.

Secondary actions

Once primary action is completed, the animator may go on to animate the secondary actions that assist the primary actions. These movements are those that are usually linked to primary actions and make for more efficient movements, such as the

Basic principles 39

Run Cycle - Secondary Action

The arm swing acts as a secondary action that assists the movement of the run cycle

Contact Point Passing Position Stride

Contact Point Passing Position Stride

Without the secondary action of the arm swing the run is still possible but appears unnatural

Figure 1.45 A running athlete will be assisted by the secondary action of the swinging arms. However, it is perfectly possible to execute a run with little or no arm movement, though such a restricted action will appear, in most cases, unnatural.

swinging arms in a walk cycle, and while such actions affect the overall movement they are not essential to its completion. The arms and hands could be animated separately to produce a particular gesture or movement. Actions such as these may be synchronized independently to hit other 'marks' within the scene.

Tertiary actions

Tertiary actions are actions that are simply the result of the primary and secondary actions, and are often the movement of those things that are simply attached to the main figure. These types of actions are often used for appendages or costume details, and are perhaps best exemplified by such

Tertiary Action

The action of garments usually has little direct influence on the movement of the figure. A very heavy cloak may impact upon the primary action of the walk.

Figure 1.46 The action of the cloak we see in this illustration is as a result of the primary and secondary movement of the figure. The cloak will obviously be subject to the natural laws of physics and the exact nature of the movement will also be determined by the material the cloak is made from. More substantial material such as a heavy woven cloth will move very differently from lighter fabric such as cotton or silk.

things as the flapping ears of a running dog, the tail of a galloping horse or the ribbons on a dress. Such actions are usually of little consequence to the movement of the figure. If the tertiary action is associated with additional elements such as a costume or a carried object, the weight and size of these elements may begin to determine the primary and secondary actions. For example, a heavy full-length cloak *may* result in the figure leaning forward slightly during a walk, while a figure walking with a large heavy sword on their hip may compensate for the weight by leaning slightly to one side. Lip synchronization often, though not always, falls into this category. This aspect of animation is covered more fully within the section covering sound synchronization.

It is important to have an understanding of these different types of action and how they interact in order to create a believable whole within any movement.

For animators to be effective and efficient in their work, it is necessary for them to prioritize their efforts and the categorization of actions can help in this. Whenever possible, animators should initially concentrate their efforts on the primary action, and only when that is satisfactory should they go on to add secondary and tertiary actions and any additional refinements. This is one area where the art of

3D stop-frame animation is fundamentally distinct from either 2D classical or computer animation. Model animators do not have the luxury of creating layers of animation one over another; everything, including lip-sync, must be executed at the same time. In this regard, model animation has much in common with puppet plays. Model animation is more like a live performance than the constructed actions associated with other forms of animation. One could compare stop-frame animation to the complexity of a live performance by a symphony orchestra. In order to make a coherent performance it is necessary for every instrument to be played in perfect synchronization and harmony. Such 'live' performances often possess vibrancy and energy, and remain open to improvisation and the happy accident that may be 'worked out' in other 'constructed' forms of animation where changes can be made and actions reduced or elaborated upon.

OVERLAPPING ACTION CASE STUDY 1 – LIFTING A WEIGHT

We can analyse overlapping action by using the relatively simple action of a figure lifting a heavy object.

Figure 1.47 Here we can see overlapping action in figures in motion. The rate and order in which a movement begins are dependent upon the inertia within a figure or part of a figure, the momentum a figure gains once an action is undertaken, and the use of muscles and flexible joints throughout the figure.

Figure 1.48 Start position to bending down.

Figure 1.49 Bending down to lift.

Basic principles 43

Figure 1.50 Lift to stretch.

Figure 1.51 Stretch to end position.

OVERLAPPING ACTION CASE STUDY 2 – GETTING OUT OF A CHAIR

We can analyse overlapping action by using the relatively simple action of a figure getting out of an armchair as a case study.

Figure 1.52 As a man raises himself out of a chair, the first action may be to move the upper torso forward slightly, placing his hands on the arms of the chair for support while bending the head slightly upward to keep it level, countering the downward tilt of the torso. The next movement will come from the hips as the bent legs begin to straighten out. The arms will straighten out in order to add thrust to the upward movement. The whole upper section of the body will begin to rise and move forward as the legs continue to straighten. During this process the arms will be readjusted to aid balance, bending at the shoulders, elbows and wrists. As the figure is almost upright, the torso will regain its vertical aspect, the neck adjusting for the continued balance of the head. A short step may be taken, one leg lifted slightly and moved forward in an attempt to balance the figure as it takes into account the momentum the forward motion has built up.

On the face of it, animating both of these actions appears to be fairly straightforward. However, we can see that it involves a number of individual actions, each demonstrating its separate and distinct dynamics and timings, potentially creating animation as complex as a performance by a symphonic orchestra.

Of themselves, the separate movements are reasonably uncomplicated, and if we approach the animation in a sensible and organized way, we can achieve a continuous naturalistic action throughout the sequence, changing as the nature or the direction of the movement changes.

> Animation is just doing a lot of simple things – *one at a time*! A lot of really simple things strung together doing one part at a time in a sensible order.
> Richard Williams

What is follow-through?

Follow-through actions are those actions that continue after the main instigating factor behind the motion has either come to rest, changed direction or ceased to influence other elements of the object or figure. It sounds complicated – it isn't.

Once a moving figure has come to a halt, certain aspects of the figure (such as the arms) or any loose items (such as clothing) may sway forwards and then backwards at a decreasing rate until they themselves finally come to rest. However, it isn't only at the end of actions that we see evidence of follow-through action. Consider for a moment the action of animals in motion. The tails of many animals are subject to follow-through action; the floppier the tail, the more likely it is that the follow-through action will be greater.

Follow-through action is also clearly evident in such things as clothing, dresses, coats, and in long hair.

Costume

Overlapping action is also clearly evident in cloth, drapery and other appendages of costume design. Long flowing sleeves, dresses with full hems and coat tails, in fact anything that is free moving and attached to the primary source of animation, will be 'dragged' behind the figure and subject to the same wave action principles that are seen in flag cycle animation.

46 Animation: The Mechanics of Motion

Figure 1.53 A good example of follow-through action may be seen in the long floppy ears of a dog as it runs along. The upward movement of the head will result in the ears moving upwards also. As the head starts to move in a downward direction the tips of the ears will continue for a short while on their upward journey. The action will follow through. As the head of the dog continues downwards, the tips of the ears will begin to move downwards (they are, after all, attached to the dog's head). As the head reaches the lowest part of its action, all parts of the ears will now be moving downwards, following the action of the head. As the dog's head begins to rise once more, the tips of the ears continue to move downwards, even though the part of the ear that connects it to the dog's head rises with the rest of the head. As the dog comes to rest, the ears will continue to move until they have expended all their kinetic energy and they in their turn come to a halt.

Follow-through Action in Dog Ears

① ②
As head moves up the ears continue downwards, swinging round as they come to the end of the follow-through action

The head begins to move down though the ends of the ears move upwards

③ ④
Head moves downwards and the ears reach the top of the follow-through action

⑤ ⑥
Once the head begins to move upwards the ends of the ears begin to fall downwards, swinging forward once they reach the extremity of the downward action

Figure 1.54 In this example we can see overlapping action on the head and hair, follow-through action on the hair and drag as it is affects the end of the long hair.

Follow-through Action on Hair

Drag Drag
The hair begins to drag as the head is turned

Drag Drag
As the head comes to a stop the hair continues to move forward

Having lost forward momentum the hair begins to move backwards with the ends displaying more drag

Basic principles 47

Figure 1.55 In the animation of material we see overlapping action, follow-through and drag, demonstrating the principles of wave action that are evident in a flag cycle.

Overlapping Action, Follow-through & Drag

The principle of a wave action that applies to a flag cycle also applies to the animation of hair, long ears, tails, skirts etc.

Overlapping Action, Follow-through & Drag

Overlap on hand as the wrist starts the action followed by the finger

Drag on the edge of the finger

Drag is clearly demonstrated on the sleeve throughout this action

The hand stops and the sleeve continues to move in an overlapping action

Follow through action on the cuff once the sleeve has stopped

Figure 1.56 The cuff on the sleeve clearly demonstrates the principles outlined above, as does the rather cartoon-like action and drawing of the hand.

The movement of the garment is dependent, as you would expect, not just upon the style and type of clothing, but upon the nature of the material itself. Thick drapery will move in a very different manner from that of a fine silk dress. Heavy cloth as used for a cloak will remain relatively still in all but the strongest of air currents, either as a result of a strong breeze or the vigorous actions of the figure wearing it, whereas a garment made from silk may flow and undulate in the lightest of air currents.

Drag on Facial Muscles

Drag on the jowls means that they lag behind the rest of the head as it moves

The jowls continue to move a little even after the head has come to rest; the action follows through

The arc in the head movement is most evident in the line of action of the nose.

Figure 1.57 In this example we can see evidence of drag as a result of variable inertia. The jowls on the face are left behind slightly as the head begins to turn.

What is drag?

The inertia that a figure possesses will be overcome at different rates throughout the figure as it begins to move. Some elements of the figure will begin their motion before others and be the prime source of animation, such as the legs. Other aspects of the figure will make little contribution to the generation of motion within the figure as a whole (depending upon the nature of the action), such as the head, the hands, hair, etc., and as such may well move after the primary source of motion. Drag may be a result of some kind of friction resistance (air or water) or as a result of variable inertia within a figure.

This delayed action of part of a figure may be subject to a force known as drag. Drag, by its very nature, will result in the varied timing we have just described as overlapping action.

How does drag affect an action?

All objects are subject to the effects of drag; how this manifests itself outwardly will vary with the nature of the object, its shape and its material properties. A solid object, such as an arm, will be subjected to the natural effects of drag, as will the long flowing hair on a girl's head.

Drag During a Walk

Drag on arm throughout the movement

Drag on foot as it rises from floor

Figure 1.58 We have already seen how appendages attached to a figure in motion may continue to 'drag' behind the source of the primary action until a change of direction occurs. This will result in the following through of the action of the secondary object as the appendage continues its motion until its energy and momentum are lost and it finally comes to rest. Drag may also affect feet and hands during a walk.

However, they will behave in distinct ways. The hair will trail behind the principal object of motion (the head), and flow, bounce and ripple as the air moves both along it and through it. The arm, being a more solid structure, while subjected to the same laws of physics, will not be affected in the same way and demonstrate very different outward signs of drag. In a typical walk, for example, the wrist may bend, causing the hand to trail slightly behind the forearm on the forward movement of the arm. On the backward movement of the arm, the wrist may bend in the opposite direction, slightly throwing the hand forward, though this is not likely to be so exaggerated as to make the hand appear to 'wave'. This is less likely to be a result of air resistance than of variable levels of inertia.

QUESTIONS TO ASK YOURSELF ABOUT OVERLAPPING ACTION, FOLLOW-THROUGH AND DRAG

When animating there are questions you should bear in mind regarding the principles we have covered.

Q. Is the action naturalistic or stylized?

Q. Would the object behave like this in nature? Is it subject to the laws of nature?

Q. Does the overall animation have varying dynamic properties running through it? Does the action overlap?

Q. Will the object you are animating begin to move in its entirety at the same time?

Q. Will all aspects of the object you are animating stop at the same time?

Q. Do the secondary objects within your animation follow naturally on from the primary animation and do they possess their own varied timings?

Q. Is the apparent weight of the object reflected in the nature of its overlapping action?

Q. How will the object's material affect the level of overlapping action?

Q. Is the flexibility of the material properly illustrated within your animation?

Q. How does the structure of the object suggest the level of overlapping action running through it?

Q. Are there any loose garments, long hair or other objects in your animation that will be affected by drag?

Q. Is the level of drag and follow-through appropriate to the effect you desire?

Q. Does the drag affect the limbs of the figure you are working with and if so how appropriate is that to the suggested weight of the figure?

ARCS AND CURVES, AND LINE OF ACTION

Arcs and curves

In nature things seldom move in straight lines and most naturalistic actions follow a series of very often complex curves and arcs. Linear motion is not very often witnessed in nature; such actions belong much more in the world of mechanization. You should bear this in mind when making either cartoon or naturalistic animation; just because you may be creating cartoon-type animation it doesn't mean you should ignore the way things move in nature. Your audience will buy into what you are doing if your animation conforms (more or less) to natural laws of motion and they recognize the way things should move. However, there are times when you may wish to give your animation a linear motion as a result of design or aesthetic considerations, but this is a different matter entirely. John Kricfalusi used this approach to great comedic effect in the *Ren and Stimpey* series, taking a direct route from key to key, often ignoring arcs and slow ins and outs to achieve a very snappy action, with all the emphasis placed on the keys and not on the movement.

Basic principles 51

Arc in Arm During a Walk

Note the drag on the hand during the swing forward

Arm swings forward in an arc.

Figure 1.59 The motion of an element of a figure may take its movement from the restricted nature of the action – the motion of a forearm being constrained by the fixed position of the shoulder and elbow will result in the arcing of the hand as it moves along its spatial plane.

Arc in Arm During a Throw

The non-throwing arm also describes an arc during the action

The action of a throw starts from the ankles

All elements of the figure throughout the throwing action describe motion in a series of arcs

Figure 1.60 In this throw you can see that the arm describes a very definite arc. The position of the inbetween drawing is not obvious from a simple animation breakdown. If the animator were to be literal about the breakdown, the result would be very different and totally unbelievable.

This does mean that the keys have to be particularly strong and interesting. Linear action will result in more punchy actions and on occasion you may wish to disregard what would happen in nature and take a little artistic licence (after all, that's what you're there to do) to give the action more power.

Complex animation that has many separate components, such as in a figure running or a horse walking, will describe many arcs throughout its various elements, which on the face of it can be most confusing. Just remember the work you did for the bouncing ball animation and the arcs described there. Treat each of the elements separately, starting with the primary animation and moving on to the next stage; apply the arcs to each of the elements in a structured way. Once you have done this, go back and check on your animation as a whole, making amendments as necessary.

Arcs in Head Turn #1

Figure 1.61 When animating a head turn you will find that you get a much more satisfactory result if you arc it slightly. The linear head turn looks unnatural and stiff.

Line of action

Creating a line of action is really only appropriate for animators making 2D classical animation, who have the luxury of building their animation through a series of individually made key frames, though animators making other forms of animation may find it useful to bear the principle in mind when planning a sequence. The process of making a line of action entails creating a single line that runs through the figure on each of your rough key frames describing the dynamic flow throughout a sequence. Using the line of action you are able to strip your rough animation bare of detail and concentrate on the main thrust of animation. This will assist you in making solid, vibrant key frames that are focused on the essential aspects of the action. Once you have achieved good strong keys you are more likely to create clearer, more easily read animation with stronger action.

Once the overall flow of motion has been achieved, it is then possible for you to further animate the details. You should

Basic principles 53

Arcs in Head Turn #2

Head arcs downwards and round

Head arcs upwards and round

No arc in head turn looks a little unnatural

Figure 1.62 You may wish to make the head turn without arcs. Let's consider for a moment that your character is in a spooky house. She is alone and afraid and she has just heard a strange noise behind her. While she is frightened to turn around, she still needs to check it out. She may turn her head round to face her fear in a very slow and linear manner.

study closely the work of Preston Blair, such as the hippos and crocs sequence in Disney's *Fantasia*. For detailed reference of his methods on this particular issue you should study his book, *Cartoon Animation*.

I have used the line of action method when teaching life drawing to animation students to great effect. With a little practice they are able to cut through non-essential detail to describe the essence of an action. This has proven to be

Line of Action

Figure 1.63 The line of action depicts the general direction of movement and shows the thrust of the dynamic. It illustrates the overall motion and not details. Using this method may prove useful when animating fast and dynamic actions. It may be less useful when making slower, more deliberate actions or animating close-ups of heads, hands, etc.

a very useful technique when drawing figures within the environment.

CYCLE ANIMATION

What is cycle animation?

Cycle animation can be a very effective and economic way of making animation, particularly for repeat actions such as walks, runs, flag cycles, etc. It describes a way in which animation runs on a seamless loop, with the action returning to its starting point. Once again, this is only really applicable to 2D classical animation and computer animation.

Wave cycle

The principle behind the wave cycle is really very simple and may be applied to a wide range of animations. If done well it can create some elaborate actions to very good effect.

Figure 1.64 The aim of cycle animation is to create a sequence that can be repeated over and over seamlessly. Cycle animation is often used on actions that support the main action with a sequence – perhaps supporting characters in a crowd scene, flags waving in the distance, water cascading down a waterfall. Cycles are sometimes less effective if they are used for the main subject of a sequence – the audience sees the cycle. Of course, this is not always a major concern, particularly when creating limited animation, and can even be used to good comedic effect.

Figure 1.65 More advanced cycles may involve separate actions that can be linked together to create a more elaborate action, giving the illusion of more complex full animation.

Interlocking Cycles

More elaborate interlocking cycles can be made to give the illusion of full animation

Flag cycle

The principles behind a flag cycle are exactly the same as those in the wave cycle, though the complexity of the actual animation is likely to be determined by the complexity of the actual flag.

Walk cycles use the same kind of repeat animation but, as you will gather, are far more elaborate than wave cycles. These will be covered in much more detail in the section on figurative animation.

Basic principles 57

Figure 1.66 In the example above we can see the wave is moving from left to right. We simply take two aspects of the wave – the peak and the trough – and in between them to the next peak and trough animating Point A to the right until it becomes Point B.

Figure 1.67 Using the animation breakdown as illustrated we need to animate from the first drawing in a cycle back to the first drawing. The animation would then be repeated from drawing 1 through to drawing 1. Notice that, in this instance, drawing 5 is the same as drawing 1. I have included drawing 5 as a guide only. If we included both drawings in our sequence we would find that the animation would 'stick' slightly. Effectively, we would see the same drawing twice, slowing the animation down at that point. It is therefore necessary to discard drawing 5 to avoid this.

Figure 1.68 Basically, the flag cycle uses the same principle as the wave cycle – peaks and troughs moving seamlessly from a given start position back to the starting position.

A repeating animation cycle showing the eddies marked X as they progress along the flag

Figure 1.69 The animation within a flag cycle is created by an action brought about by the movement of air along the surface of the flag's material, creating creases, ripples and folds. This interaction of air and material forms complex eddies within the air currents.

Wind Action Along a Flag

Eddies

As the wind blows along the length of the flag eddies are formed in the air currents along both surfaces creating a series of curves

Flagpole

Eddies

Eddies

Eddies

Wind

ANIMATION EXERCISE 1.3 – FLAG CYCLE

Aims

The aim of this short exercise is to extend your understanding of timing, key frames and inbetweens, and to practise the technique of cycle animation.

Objective

On successfully finishing this exercise you should be able to create a series of key frames and inbetweens, and complete a seamless piece of cycle animation.

For this exercise you should create a short animated sequence of a waving flag in 2D. This should be made using a limited number of key frames and inbetween drawings that operate on the principle of cycle animation. The number of drawings for this cycle will obviously vary according to how fast or slow or complex we want the animation to be. Making an elaborate cycle animation may require many drawings, but for this simple exercise we will use far fewer. You will need to make between four and eight separate drawings to create a successful animation flag cycle. They should be made using the same principles covered earlier in the section on key frames and inbetweens. Remember: the more drawings you use, the slower the animation will be; the fewer drawings you use, the faster and more simplistic the action will be. When you have finished the animation you should shoot it in sequence, i.e. 1 through 8 and subsequently 1 through 8 again, creating a seamless animation sequence.

When filming your animation cycles to test your work, you should shoot the cycle three or four times. This will enable you to analyse your work more thoroughly and ensure that the first and last drawings work together to complete a satisfactory animation cycle. It's at the point where the cycle joins up that most problems occur.

Setting up the Flag Cycle

① The flagpole is drawn to one side of the page; this enables the flag to sit in the centre. This will be the 'stage' upon which the animation will move

② The first flag drawing should accurately 'fit to' the flagpole

③ The first flag is used as a guide for all the subsequent drawings

Figure 1.70 Draw a flagpole as part of the 'stage' on which all your flag animation will appear. Position the pole just off-centre, allowing your animation to occupy the centre of the frame. This drawing should be placed on a lightbox, just as you did with the bouncing ball animation, and all your animation drawings should be done on separate pieces of paper placed on top.

Let's try making another cycle, though this time working in perspective. First of all, we should look at how we make perspective animation drawings. When animating an object moving in perspective – that is, moving away from and towards the viewer – a whole new set of problems are encountered. How is the speed of a moving object affected? How does the scale of the drawing alter? How do we alter the 'timing' of our drawings to illustrate a complex movement?

60 Animation: The Mechanics of Motion

Figure 1.71 You should attempt to create the illusion of the 'wave' in the flag being made by an unseen breeze travelling the length of the flag horizontally.

Figure 1.72 You should start by making a key drawing for the start position of the animation, but remember because we want the flag to work as a cycle this drawing will act as both the start and end positions of your animation. Make a timing breakdown for all your inbetweens – in this instance we will go for a constant speed throughout the action, so the inbetweens will be evenly spaced.

Flag Cycle - Breakdown & Timings

Figure 1.73 As you can see from the breakdown chart we have just made the first and last drawings the same. The drawing that appears halfway between the two keys – in this instance drawing 5 – is known as a breakdown drawing. This needs to be made before the subsequent inbetweens can be drawn.

Flag Cycle - Inbetweens & Timings

Figure 1.74 Once you have completed the breakdown drawing we can move on to make the inbetweens. Following the same process we covered for the bouncing ball, we start by using key 1 and our breakdown drawing 5 in order to create inbetween 3. Make sure you work on top of your initial drawing of the flagpole so you can trace all the flag's edges to the pole. At this stage you should keep the flags really simple. Keep it blank – don't get tempted into drawing unnecessary detail or making your flag too fancy. We can do all that later.

To animate in perspective using 2D classical methods requires a good deal of skill and a little understanding of geometry. As a figure moves towards the camera, it not only appears to get larger, the spaces between the drawings also appear to become greater.

Perspective Drawing # 1

The railway sleepers appear to slant towards the horizon and the vanishing point. The angle increases the further out from the central line of sight they get.

Seen sideways on, the rail tracks appear as horizontal lines with the telegraph poles as verticals.

Figure 1.75 We can see in this illustration that the poles are evenly spaced. Using a grid system makes it easier to control animation in perspective.

Perspective Drawing # 2

The perspective between the two poles is described by the two red lines that converge at the 'vanishing point'.

Vanishing Point

The distance between the poles is the same though the equal division of the space creates a false perspective

Vanishing Point

The correct positioning of the poles is achieved by drawing lines from the top of one pole to the bottom of another. The lines converge at the halfway point between the two.

Vanishing Point

Vanishing Point

Figure 1.76 Seen in perspective, the poles not only appear to get larger, the distance between the poles seems to increase the closer they are to camera. Notice how the perspective lines on the grid help us to position the poles in their proper place.

Basic principles 63

Perspective Walk

Seen flat on in profile the strides of the walk appear to be evenly spaced

When seen in perspective the stride appears to widen as the figure approaches the viewer

Figure 1.77 In this walk cycle we can see how the stride appears to widen, though the use of a grid (as shown in the previous example) would help us to keep the figures in proper perspective.

ANIMATION EXERCISE 1.4 – AEROPLANE CYCLE

Aims

The aims of this exercise are to further develop your animation skills and understanding of animation timing as it applies to perspective animation and to understand how animation works in perspective.

Figure 1.78 For this exercise you should attempt to animate, in perspective and in a repeatable cycle, a paper aeroplane flying around a figure of eight pattern. Before starting to make any animation drawings you will find it helpful to make a path of action guide for your plane. Place the path of action guide on the peg bar to sit underneath your animation drawings. If you make marks on the path that indicate the position of the plane along the path, it not only gives you the position of the aeroplane, but also gives you your timings. It should be easy to flip the drawings to continuously refer to the guide as you make your animation.

Basic principles 65

Elevated Path of Action

Evenly spaced action throughout the rotation will result in a constant speed

Seen in perspective the images closer to the viewer appear to move faster

Figure 1.79 It would be easy to assume that as the aeroplane moves away from the camera (the front of the path) it will slow down as the drawings get closer together. This is an illusion. As we can see from the elevated path of action, the spacing is constant throughout the action. We get the impression of increased speed when objects are close to us. Anyone experiencing a speeding train moving across a landscape will get the impression that it is moving quite slowly. If we were to stand next to the track we would get a more realistic and perhaps frightening impression of its true speed.

Objectives

On completing this exercise you should be able to complete a seamless piece of cycle animation that involves the use of perspective drawing.

As before, your animation should work on a cycle – that is, the last drawing should link up to the first. Keep your drawings simple. Concentrate on animation timing, do *not* make overelaborate drawings. Your aeroplane can be a simple triangular shape if you wish; it needn't be an F111 complete with pilot, bombs and afterburner to be a successful piece of animation!

You should make a line test of your animation, making thorough analysis of it before altering your work. Be sure to slate all your work by shooting a piece of paper with the title, your name, date and take number, taking care not to go over any other work. That way you can keep a good record of all the work you have done and track the progress you are making.

Chapter 2
Figurative Animation

Walk Cycle

When animating you need look no further than the human figure for inspiration and challenge. If you can master the human figure in all its forms you can master anything.

BEFORE WE BEGIN

In the first chapter we covered some of the basic principles of animation which we will be dealing with during this chapter on figurative animation. At this point it might be useful to place these into context before going further by looking at the nature of animation. I have broken animation down into four categories of movement in an attempt to understand animated movement more fully.

THE FOUR 'A'S OF ANIMATION

- Acting
- Animation
- Action
- Activity.

This hierarchical system describes the various levels of animation that can be achieved with the lowest at the bottom and the highest at the top. I have set out below an explanation of each of these categories, starting with the lowest, activity, and moving to the highest, acting.

Activity

This category simply describes the most basic form of movement we may witness and is the lowest form of animation. These movements are not associated with anything in nature at all and in this regard are completely abstract. An example of this would be of an image being at a particular point on the screen at any given moment and subsequently at another point on the screen the following moment. We can see examples of this in text rolling across a screen in a title sequence. Even though some of the objects that move in such a manner may display variable dynamics (they may move faster or slower at various points), they remain abstract and are not associated with any particular object that we recognize as being capable of independent movement.

Action

This category describes movement that can be attributed to specific objects such as we have covered in the previous

chapter. The animation you made in the exercises there described the *action* of a bouncing ball or the *action* of a paper aeroplane. The fundamental difference between Action and simple Activity is that in an object's *action* we understand that a type of movement may be associated with certain *known* objects, under certain *known* conditions and subject to the *known* laws of nature. For instance, we recognize the action of wind blowing through the leaves of a tree, the waves on the sea or the fall through the sky of a shooting star. These things do not *intend* to move this way, they simply do so as a result of the natural laws of nature and their own particular properties.

Animation

This describes the kind of dynamics that arise from *within* the subject matter. This can be seen in such things as a salmon leaping out of the water as it heads upstream to spawn, a humming bird collecting nectar from a flower or a dog scratching for fleas. All of these examples intend to undertake these actions. The key to this categorization is that the motivation for such actions comes from within the subject itself. While the humming bird, the fish and the dog are all still subject to the laws of physics and external forces, the manner in which they move is determined by their physiognomy and the particular motivations that instigate the action. Motivation for these separate dynamics may be as varied as the type of movements themselves; migration in order to breed, the search for food, or simple irritation. Whatever the motive for the movement, it has been an *internal* motivation; animation comes from *within* the subject – they *intend* to move that way.

Acting

This describes the highest level of animated movement. Not only are the movements subject to the laws of nature, with the route of the movement coming from within the subject (the subject intends to move), there are clear psychological reasons for these movements. It's called performance! In this type of movement we experience the inner feelings of the subject of the animation. We can not only see what the characters are doing, but experience what they are thinking and feeling. This level of animation not only deals with variable dynamics, but the variations in mood and temperament necessary to build characters with personality.

This is the most difficult task that faces any animator and is central to creating engaging narratives.

Before we begin to tackle figurative animation we need to understand the task that is ahead of us. Naturalistic figurative animation is perhaps the most challenging and demanding aspect of animation. The development of your animation skills should continue throughout your career as an animator, no matter how high you rise in the industry or how respected you become as an independent film-maker. It's through naturalistic, figurative animation that these skills will be most severely tested. Why is this? Naturalistic animation of recognizable animals and humans is difficult to achieve because we all understand how people, dogs, cats, horses and the like are supposed to move, as we witness such movements first hand on a regular basis. As a result, our expectations are high and as such audiences are much more difficult to convince. Most of us can tell if a naturalistic figurative animation looks 'right' or not, you don't need to be an animator to do that; however, it's only through serious study that we can dissect the movement in detail and determine *why* things look right or wrong. It's learning how to dissect such actions and discover the animation principles within them that is the purpose of this chapter.

As kids we may have developed the skills necessary to draw a funny cartoon horse or to draw figures in a particular cartoon style, perhaps slavishly copied from superhero comics. This is OK and I imagine that's how many of us got started on the long road to art college, but it doesn't help us much to develop the necessary skills to become a creative animator. At that stage it's rather like seeing a dog balancing a ball on its nose – not a great trick, but you are amazed it can do it at all. If you are going to develop the skills of an animator you are going to have to learn more than simple tricks in order to get by. Figurative animation and the exercises set out in this chapter give ample opportunity to explore and practise all those basic principles covered in the earlier chapter.

Let's start with the basic animation of a walk cycle, though we will see how even this most fundamental action can be a complex issue, before we progress onto various types of runs and then move on to cover in some detail the use of weight and balance in animation.

WALKS AND RUNS

In the previous chapter we looked at creating the first two levels in the four As of animation: activity and action. We are now going to tackle the next level – animation itself. We are going to make movements that involve the illusion of intent; the figures we make move should look as though they possess the motivation for the action and that purpose instigated the action.

Walks

The approach to creating a believable walk cycle is wrapped up in a wide range of issues related to physical and psychological conditions, and we will be looking into some of these later. There are simple step-by-step processes that you can undertake in order to achieve a fairly naturalist walk cycle and we will see that a fairly straightforward mechanical approach to a walk cycle will give you satisfactory results if all you require is to get a character from A to B. However, you should bear in mind that any naturalistic animation, no matter how simple, will demand a great deal of skill and observation on the part of the animator.

I was once on my way to discuss this very problem with the talented group of animators who created the *Walking With Dinosaurs* animation and the whole notion of characterization through a walk was going through my mind. As I made my way through the London underground system at rush hour, I observed the very thing I was going to discuss that day. Three people with very different types of walk just happened to appear as if on cue. A young woman walked quickly past me, obviously in a hurry to get to work. She walked confidently through the crowds, though she wore ill-fitting fashion shoes which had the double effect of throwing her body forward slightly and making her very flat-footed. Immediately on passing me, we were both delayed by the slow progress of a couple of commuters, one a rather large lady who rolled from side to side as her bulk shifted over the supporting leg. Her arms extending out at her side in an exaggerated manner only enhanced the effect. Her head pivoted slightly from side to side to counter the quite extreme to and fro action of her body. Her partner happened to be a rather tall and slender gentleman who had the appearance of being in ill health. He tried not to move too much, looking as though any extra vibration would disturb his already perturbed internal organs. He stooped slightly and held his head down to stare at the

Figurative animation

floor, as if uncertain of his footing. He almost shuffled along in a very stiff manner. Each of these actions had their own distinct qualities and were a result of different conditions, some external (the shoes), others physical (weight), still others psychological (uncertainty). The girl bobbed up and down, the large lady wobbled from side to side and the frail man moved stiffly with very little up or down movement at all.

It is easy to see evidence of all kinds of characterization through a walk. Consider for a moment the very famous and stylized walks of Groucho Marx, Charlie Chaplin, Mae West and Frankenstein's monster. These are all instantly recognizable to the audience and clearly demonstrate the character within the figure.

Basic walk cycle

Simply standing up in a balanced manner demonstrates what a wonderful piece of engineering the human body is. Supported on relatively tiny feet, a tall figure is continuously balanced against the forces of gravity that would overbalance

Basic Human Figure Construction

For the purposes of the animation exercises keep the figure simple. Construct your figure based on simplified shapes. Do not include any unnecessary details

Use crosshairs on the front of the head and chest to assist in aligning the figure correctly

Keep the hands and feet simple

Indicate the position of the shoulders, elbows and knees with circles

More detail can be added once primary animation is approved

The adult figure should stand approximately 8 heads high

The use of a little shading or colour will help your drawings to read more clearly and create a sense of 3D perspective

Figure 2.1 Keep the design of your characters fairly simple and add no unnecessary details. Remember, the exercises are about animation, *not* design. If you base your drawings on a naturalistic figure and try to keep the proportions correct, you will find it easier to complete believable animation.

Basic Human Figure Construction

Using a simple figure illustrating limited elements of 3D form will enhance the clarity of the animation

A simplistic stick man figure will create difficulties in reading your animation

Figure 2.2 Your figures will be more easily read as animation if they possess some volume. Analysing stick-men type characters can become a little difficult once the lines are seen in motion, particularly in complex movements or actions where elements of the figure cross one another.

Walk Cycle

Figure 2.3 Notice how, in these drawings, we have the full set of movements that go to make up a full walk cycle. We can see how the body rises and dips at certain points throughout the action. As the leg swings forward and the figure is supported on one leg (the passing position), the body rises; as the leading leg makes contact with the ground (the stride), the body is lower. There are very few instances throughout a walk cycle where the body achieves complete balance. For the most part the figure is in a state of controlled 'unbalance'. A mistake I have noticed many inexperienced animators make (particularly when animating models in 3D stop-fame animation) is to attempt to create a balanced figure for each of the drawings or model positions throughout the action. This results in some very strange actions, with the weight of the figure moving backwards and forwards in an exaggerated manner throughout the walk.

us and leave us in a heap on the ground. We constantly shift our weight on these two very small feet to stay upright; not only that, but we can do this on one leg (hopping), on the move (running and walking), on slippery surfaces (ice skating), in a strict rhythmical coordination with others (dancing) and while moving objects with the feet (playing football). These activities, based on our ability to balance, make the human body seem almost miraculous, but it's the very act of unbalance that we exploit in order to do all of these. Walking has been described as controlled falling and when we analyse a simple walk we can see it's exactly that. From a very early age we learn how to throw our weight forward (or backwards) in a controlled manner and purposefully become unbalanced. It's this unbalance, driven by the forces of gravity, that provides the momentum for such elaborate movements. If we were to take no action at the moment of unbalance we would simply end up face down on the floor. However, we have learned the trick that if we swing a leg forward timed to coincide with the forward movement we can not only stop ourselves falling flat on our face, but we actually take a step forward. If we then use the energy from the controlled fall, we can go on to make a second controlled fall, and then a third and a fourth – it's called walking.

We can break the basic walk cycle down into two key positions: the stride and the passing position. From these, we

Figure 2.4 The stride is the position that demonstrates the leg outstretched as the leading foot makes contact with the ground and the trailing foot moves upwards onto the toes. The length of the stride will vary between walks and will be determined by various factors, as we shall cover in other examples. Notice how, when the left leg is forward, the left arm is placed backwards to achieve balance. This creates a counter-rotation of the hips and the shoulders.

Walk Cycle: Figure Dynamics

Figure 2.5 The passing position is the frame whereby the leg moving forward in the cycle passes the leg that supports the body. When the figure is at the passing position the figure is balanced on one leg only. Notice how, when the left leg is thrown forward, the left arm moves backwards and the right arm is thrown forwards. When the figure is in the passing position the figure raises slightly as the supporting leg moves toward the fully upright position. These two positions alone, the stride and the passing position, form the basis for the walk cycle.

Walk Cycle: Keys & Inbetweens

Figure 2.6 Once you have all the drawings completed for the cycle, it is easy to notice how the body rises and falls throughout the cycle. We can see how the head and the hips rise at the passing position as the supporting leg is straightened. The figure then moves downwards during the stride, due to the angle of the legs.

Figurative animation 77

Walk Cycle - Front View

Stride Passing Position Stride

Figure 2.7 We can see in this illustration of the figure viewed head-on that the figure twists at the hips and the shoulders throughout the walk cycle and the counter-rotation of the hips and shoulders. The right shoulder is in a forward position when the right side of the hip is in a backward position.

Timing a Walk

1 3 5 7 9 11 13
Slow Out Slow In

The stride speeds up as it goes through the passing position

Figure 2.8 The more drawings or frames you have within the walk cycle, the slower the walk will be. As the walk becomes slower, the length of stride will shorten. Conversely, if the length of the stride remains short and the speed of the walk becomes fast, you will get a very strange kind of fluttering or shuffling type of walk.

can develop the other frames that are needed to complete the cycle.

Once the stride and passing position have been created, it is a simple matter of flipping these two drawings or positions to create the next two needed for a complete cycle. Notice how, in the last illustration, the two stride drawings are fundamentally the same, though the one on the left has the left leg thrown forward while the right-hand drawing has the right leg thrown forward. You can make the second passing position drawing in the same manner.

The number of inbetweens needed to complete the cycle will be determined by the type and speed of walk you wish to achieve.

ANIMATION EXERCISE 2.1 – BASIC WALK CYCLE

Aims

The aim of this short exercise is to extend your understanding of animation timing and to develop an understanding of the basic principles as they apply to a walk cycle.

Objective

On completion of the exercise you should be able to create a short animated sequence of a basic walk that works within a repeatable animated cycle.

A few tips before starting the exercise:

Design

Design should not be an issue within these exercises and you should keep your drawings simple, with little or no detail. There should be no colour or shading unless absolutely essential and only in order to allow the animation to read more clearly.

Film language

Film-making is not an issue within these exercises. Remember, you are not telling a story but are attempting to complete a short animation.

Drawing

Work quickly though not hurriedly. Try to achieve consistent volume and weight within your characters. Do not concentrate your efforts on making beautiful drawings; rather you should be attempting to achieve beautiful animation. Do not overwork your drawings. Rather than rub out mistakes you should discard your drawings; this will help you keep up the creative flow.

Animation

Map out your animation timings on your key drawings, indicating clearly the number of inbetweens you initially expect to create. Try to time out the action by going through the motions yourself using either a stopwatch or a watch with a second hand. Do not forget the basic principles of animation.

Double Bounce

Contact | Squash | Passing Position | 2nd Squash | Contact | Squash | Passing Position

Figure 2.9 To achieve a slightly more exaggerated and comic effect, you may choose to give the figure a little extra bounce. Notice how the figure is squashed between the point of contact and the passing position, a natural response as the knees act as a kind of shock absorber. In this example there is an additional squash added at the point between the passing position and the stride (contact); this position acts as a kind of anticipation to the stride and makes the whole action rather exaggerated. It is for this reason that I have chosen a rather more cartoon-like figure to demonstrate this unnatural and more cartoon-like walk.

A Happy Walk

Very upright stance throughout with chest thrown out and head back

Big swinging arm movement

Extreme rotation of shoulders

Wide stride

Exaggerated squash gives added bounce to the movement

Very positive action with fairly rapid movement throughout with plenty of snap to the action

Figure 2.10 Once again I have chosen a more exaggerated character to illustrate this point. The happy walk may result in a bouncier type of movement with a longer stride and a more upright aspect. The arms may also have a more pronounced swinging action to them. In this instance I have omitted the double bounce.

Depressed Walk

Walk cycle is slow with many more drawings or images making up a full cycle than in a normal walk

Slow, shuffle-like motion with very short strides. Very little swing in either the hips or the shoulders

The supporting leg during the passing position does not fully straighten

Figure 2.11 Such a walk will typically show the figure having a slumped posture. The much slower pace of this type of walk will affect the timing of all the separate elements. The stride will be much shorter and the timing far slower than within a standard walk cycle, though the dynamic progression (timing breakdown) may have a similar profile, with the slow ins and outs being in the same place. There may also be much less rotation of the shoulders, which will result in less exaggerative movement on the arms. Notice also how the foot barely leaves the ground through the passing position.

An Old Person's Walk

Head angled downwards

Very slow uncertain movements

Body thrown slightly forwards with a flat action throughout

Arms extended for balance

Legs remain slightly bent

Stride Very short steps Passing Position Foot slides across the floor Stride

Figure 2.12 An old person's walk may appear to be a lot more uncertain than a younger person, possibly as a result of unsteadiness on the feet. The overall timing will be noticeably slower and there will be very little bounce or up and down movement throughout. Consider how people that are uncertain on their feet use their arms during a walk; they may no longer be used as a secondary action swinging backwards and forwards, but may be outstretched slightly, perhaps to assist balance or to give additional confidence in anticipation of a fall.

A Young Child's Walk

Arms held out for balance

Very confident movements with tiny quick steps

Arms held quite rigidly with little backwards and forwards secondary action

Stride
Short legs mean a low centre of gravity

Passing Position
No squash on supporting leg between contact and passing position

Stride
Lift on leg is quite high

Figure 2.13 A very young child's walk may also demonstrate uncertainty, though this is more likely to be from lack of experience. When children walk at speed you may notice that they move with their arms outstretched as an aid to balance. There will be no evidence of the swinging-type action of arms countering the movement of the legs that you see in adults. The walk has a lot of bounce in it, perhaps most noticeable when children begin to run. Because the legs do not cushion the contact of the foot with the ground in the same way as adults do, there is a jolting of the head as a result.

Overweight Walk

Shorter strides with greater movement from side to side
Less swing in the arms than in a normal walk cycle

Figure 2.14 You may notice in such a walk that the body is thrown back slightly, creating a centre of balance that is further back than is evident in a less heavy person. This is done in order to counterbalance the extra weight. You may also see this in heavily pregnant women; the additional weight at the front of the body results in the figure leaning back and curving the spine, which sometimes results in back strain. This may be accompanied by an increased sideways motion, swaying from side to side slightly to shift the weight more centrally over the supporting leg during the passing position.

82 Animation: The Mechanics of Motion

Walking with a Heavy Weight

When carrying a heavy object on one side of the body the body leans to account for the added weight

Body moves from side to side to position weight over the supporting leg

Body is thrown backwards to account for additional weight of object

Figure 2.15 This is a very similar walk to an overweight walk. There may be adjustments in posture to accommodate additional weight, with an increase in sideways movement to counter the additional weight during the passing position. The body is thrown backwards. You may notice that there is less bounce in such a walk and if the weight is extremely heavy you may see a kind of shuffle as a consequence.

Figurative animation

The Sneak

Body moves forward as weight is shifted from the right leg to the left

Shift of weight and centre of gravity

Body shifts forward with weight fully on left leg

Weight supported on toes

Very little movement in arms

Body moves backwards as the leg moves forwards

Weight directly over supporting leg to maintain balance

Body back as leg is extended

Leg is raised high

Figure 2.16 An exaggerated sneak (usually reserved for more cartoon-like animation) will result in the body being thrown forwards and backwards, shifting the weight first over the trailing leg and then over the leading leg. This comes from the combination of the wide length of the stride and the slowness of the movement. In order to remain balanced throughout such a movement, the body weight must be constantly shifted over the supporting leg.

Confident walk

The arms may swing a great deal

The shoulders rise and fall alternately

The walk is very quick with wide strides

The supporting leg becomes 'locked' during the passing position phase of the walk

Figure 2.17 In a fast confident walk the body may be thrown forward slightly, the stride will widen and there may well be a greater swinging action on the arms. In this example the stance is very upright, though this is not necessary to achieve a confident look.

Walking Through Snow

The arms are held further away from the body to assist with balance

Increased backwards and forwards motion of the torso

Strides are wider than in a normal walk

A far higher lift of the leg through the passing position

Figure 2.18 There are similar aspects of the sneak in this particular walk, with the body being shifted back and forth to remain balanced. Notice how the legs lift much higher off the floor as the foot is lifted out of the snow, moved forward and placed in the snow at a place further forward. It's easier and more efficient to move the foot up and down out of deep snow rather than trying to push the foot through the snow and encountering resistance. You may notice a similar kind of walk when people begin to walk from the beach into the sea; at first, the shallowness of the water does not affect their walk, though as they get in deeper they will begin to lift their legs higher. Once they are in the water so deeply that this is no longer effective, they revert to a more normal walk, though leaning forward slightly as the water takes their weight.

Animate the character moving in profile either from left to right or right to left. Don't concern yourself with the difficulties of perspective animation at this stage.

1. Make your first key drawing of the first stride position.
2. Make a similar drawing with the opposite arms and legs thrown forward.
3. Using the two stride keys, make the passing position drawing.
4. Make a similar drawing of the passing position with the opposite arms and legs thrown forward, just as you did with the stride.
5. Decide upon the animation timing and draw this on your key drawings, remembering to clearly indicate the slow ins and slow outs.
6. Make the inbetweens using the same process as described in the previous chapter.
7. Remember that the animation should work as a cycle.
8. Shoot your animation.

While this will give you the basis for the walk, it really does only cover the bare bones. Once you have mastered the basic principles you could attempt to create a more individualistic walk cycle through a series of animation exercises based on the examples here.

The number of different types of walk is almost endless and we have only just touched upon the topic; however, the basic principles remain the same. In order to get exactly the kind of walk you want you must try to imitate it, and through doing it yourself gain more understanding of the exact nature of the animation. If we choose to, we can observe such actions every time we go outdoors and as animators that is exactly what we should be doing. Using texts such as these, completing exercises and constant practice will help you to develop skills, but learning through observation will give you a much deeper understanding of the dynamics of the human figure.

Runs

You will notice that many of the basic principles covered in a walk cycle also apply to the run. We can break down the action into a few simple positions to create the cycle, just as we did with the walk.

The variations on the run, as with the walk, are almost infinite and the examples illustrated here are very limited. With only a couple of exceptions we have covered the animation of a single adult character in a fairly realistic manner. Once you start dealing with figures of different ages and sizes and within different environments and under different conditions or cartoon animation, the options are limitless.

Figure 2.19 Just as in the walk cycle, the run can be said to be a condition of controlled unbalance. The one major difference between the run and the walk is the period within the run that the figure actually leaves the ground. This occurs slightly after what we termed as the stride within the walk. For an instance there is a period where neither of the feet support the figure; in effect it leaps through the air in a series of bounds. In the run cycle this is known as the suspended phase.

Run Cycle - Key Poses

Figure 2.20 The stride in this case is the period whereby the figure is about to become unsupported and enters the suspended phase. The passing position remains fundamentally the same as in the walk. The passing position is the frame whereby the leg moving forward in the cycle passes the leg that supports the body. As in the walk cycle, it's these two positions that form the basis of the cycle. Notice once again that as the left leg moves forwards the left arm moves backwards. Also notice how a running figure in the passing position, unlike the walk cycle, lowers slightly (squashes) as the supporting leg acts as a shock absorber. The figure then moves toward the fully upright position.

Run Cycle - Timing a Run

① Stride ③ Suspended Phase ⑤ Contact Point ⑦ ⑨ Passing Position ⑪ Stride

Figure 2.21 The timing of a run, rather like that of a walk, will be determined by the effect you are trying to achieve. The same general approach to animation timing is taken, with slow ins and outs appearing in the same place. While this may be varied to create other results, it is a good starting position to get a general understanding of the process.

Figurative animation 87

Run Cycle - Front View

Contact Point Passing Position Inbetween Stride Suspended Phase Contact Point

Figure 2.22 In this front view we can see how the figure moves from side to side slightly as it is placed over the thrusting leg of the stride and the leading leg at the contact point.

Run Cycle : The Jog

The stride is narrower in a jog than in a normal run

There is less arm movement in the jog than in a normal run

Passing Position Suspended Phase Stride Passing Position

Figure 2.23 Jogging is generally less quick than the run. There is often just as much up and down movement as in a run but the strides are much shorter, though the backwards kick of the foot may be rather high. You will find there is much less rotation of the shoulders and the swinging action within the arms is much reduced and limited to short backwards and forwards action, usually keeping the hands in front of the body.

The Sprint

As the run commences the figure is angled downwards; the stance becomes more upright as the run progresses

Figure 2.24 It is often the case that a fast run is animated with the figure leaning forward, but you only have to look at video footage of sprinters to notice the upright gait of the athletes. The stride is often very wide on a fast run and the arms may swing in an exaggerated fashion, moving well in front of the body on the forward action and trailing behind the backwards position. A figure may in fact lean forward a great deal when beginning the run, particularly if starting from blocks, and it may well lean heavily into the finishing tape, but for the most part it remains fairly upright.

Cartoon Runs
Movements within a cartoon run are exaggerated and extreme

Some runs demonstrate a forward thrusting dynamic
Others show the figure leaning backwards slightly

Figure 2.25 A fast run cartoon style may incorporate not only an acutely angled figure, but the arms may also be extended out in front of the character. All manner of variations are possible to create a comic effect.

Figurative animation

ANIMATION EXERCISE 2.2 – BASIC RUN CYCLE

Aims

The aim of this exercise is to extend your understanding of animation timing and to develop an understanding of the basic principles as they apply to a run cycle.

Objective

On completion of the exercise you should be able to create a short animated sequence of a basic run cycle.

Once again you should animate the character moving in profile from either left to right or right to left. Perspective animation can be rather complex and you should only attempt this after you have mastered the run cycle and gained confidence.

1. Make your first key drawing of the first stride position with the figure positioned as it is about to leave the ground.
2. Make a similar drawing with the opposite arms and legs thrown forward, as you did with the walk cycle.
3. Make the passing position drawings in the same manner as above.
4. Make similar drawings of the suspended phase with the opposite arms and legs thrown forward, just as you did with the stride and passing positions.
5. You now have the basic building blocks for your run cycle. Decide upon the animation timings and draw these on your key drawings. Ensure that the slow ins and outs are clearly indicated.
6. Create the inbetweens using the same process as described in the previous chapter.
7. Remember that the animation should work as a cycle.
8. Shoot your animation.

WEIGHT AND BALANCE

Weight and balance are two key factors in making believable animation. When dealing with an animated dinosaur of 50 tonnes or so, the animator's job is to ensure that they display the kind of dynamics that make them look like they weigh that much. Conversely, animating a butterfly fluttering across a meadow needs equal attention to detail. To maintain the suspension of disbelief the animator must ensure that the former must not float and the latter should not plod. Coupled with weight, the animated characters must display that they are fully in

control of their weight through continuous balance. The weight and, to a large degree, the timing of the animation will create the necessary balance within the animation of a character. However, we cannot approach these aspects of animation in isolation and we must constantly be applying all the other principles of animation covered in the previous chapter. It's the very issues of weight, balance and timing that we recognize and relate to on a daily basis and make the animation believable – even if we see neither dinosaurs nor butterflies on a regular basis.

Weight

All animated figures, either naturalistic or cartoon-like, should possess weight in all their actions, which will vary depending upon the physiognomy of the character. How they use and deal with this weight may be dependent upon a number of other variables, such as age, their current mood, motivation and their overall psychological make-up. In addition to these factors, the figure may be subject to external forces such as gravity and affected by the load they are carrying; the actions of a deep sea diver or an astronaut on the surface of the moon will be very different from those of a figure on earth under normal conditions.

Balance

The balance of a character in motion may be linked directly to the intrinsic weight of the character. A very large figure may move in a certain manner as a result of their bulk. The age of the character should also affect the balance they display; a toddler will demonstrate a distinctive set of actions that are easily distinguished from those of a fit and healthy adult or the unsteady progress made by a frail old lady. Balance may also be dependent upon external factors such as the nature of the environment the figure is negotiating. A figure walking along a flat, even and solid surface will demonstrate a separate set of actions to one walking on an icy road or up a steep hill or along a tightrope. Carrying a load will also affect the nature of balance; a briefcase being carried by an adult may not result in any noticeable adjustment to the posture, though the same object carried by a young child may have extreme effects on balance. The size of an object as much as the weight may affect the balance of the figure carrying it. A large, fairly light object such as an empty wooden crate may necessitate more of an adjustment to the balance than a small heavy object such as a cannonball.

Centre of Gravity

The location of the centre of gravity of an object relative to its support will determine the stability of balance

Stable - Low energy state

Standing here is safe

Unstable - High energy state

Standing here is not safe!

Figure 2.26 The location of the centre of gravity of an object relative to its supports will determine its stability. The closer the mass of an object is to the floor, the lower the energy state of the mass and the more stable the object becomes.

Centre of Gravity

The weight, density and shape of an object along with the material it is made of will determine the nature of the lift, the animation of the lift and its timing

In all lifts the object, no matter how heavy, will impact upon the balance of the figure lifting it

Figure 2.27 The attitude of the figure must take into account its centre of gravity. This will change once the figure takes on additional weight as it picks up a heavy object. For all intents and purposes we can assume that this additional weight now belongs to the figure. The amount of shift necessary will vary depending on the weight of the object and its distribution. An object held in front of the figure will result in the figure having to shift backwards to accommodate the centre of gravity.

Lifting

A lifting animation incorporates a complex series of movements that necessitates the shifting of the centre of

Balance and Weight

The figure looks unbalanced as the weight is at a distance from the centre of gravity

The feet are positioned well away from the centre of gravity making this lift seem implausible

The figure's attitude makes the object look very light

The posture of this figure makes the object appear to have considerable weight

The feet are spread apart and straddle the centre of balance

The centre of gravity of both figure and object shifts throughout the lift

Figure 2.28 By comparing the illustrations here we may assume that the first ball is a very light beach ball, in which case the balance is correct. We may also assume that the second ball is extremely heavy and the resulting shift in the figure relocates the centre of gravity. If the first ball is not a beach ball but is also heavy, then the posture is wrong. This is *not* a matter of the strength of the figure, it is a matter of balance. No matter how strong a person is, they must shift the body to place the mass centrally over the point of balance, otherwise they will simply fall over.

Character Construction

The physiognomy of a character will be determined by its construction

The type of character you work with and its construction will determine the nature of the animation, including balance

All figures, regardless of physical type or strength they possess, incorporate a lifted weight into a balanced attitude around the centre of gravity

Figure 2.29 The physiognomy of a figure will determine the nature of the lift and the balance achieved. All figures, regardless of physical type or strength, will incorporate the lifted weight into a balanced attitude around the centre of gravity – or fall flat on their faces.

gravity throughout the lift. The very act of a figure moving to lift an object will mean a shifting of balance; once the figure has taken on the additional weight it will have to realign itself in order to accommodate the weight. The position of the weight, its shape and even possibly the material it is made of may be determining factors in the way balance is maintained during the lift and once the object is supported.

Throwing

Throwing actions also incorporate a series of movements that illustrate the shifting of the centre of gravity. The timing of the throw will be subject to the same principles covered earlier and the exact nature of the throw will be determined by the type of object being thrown, as well as the identity of the thrower. Very young children and some adults tend to throw in a very distinctive way, with a swift downwards action of the arm moving from over the shoulder downwards across the body and very little movement at the elbow. This is a very different action than we can expect to see from an experienced baseball player throwing a ball for example, or a skilled athlete throwing a javelin or putting a shot.

Strong Poses Enhance Clarity

Successive parts of the body are used in the lift as the sack is shifted upwards by degrees

Hands — The sack is kept directly over the centre of gravity

Forearm/back/knees — The back is kept straight during the lift

Back/legs/arms — The body is angled backwards to counterbalance the sack

Upper arms/shoulders — The upper torso is bent forwards to keep the sack aligned over the centre of balance located between the feet

The knees are bent in order to keep the back straight

The knee moves forward slightly to counter the backward motion of the upper torso

The legs are straightened as the lift is completed and the stride is widened to assist balance

Figure 2.30 In this sequence there is an almost constant shift in the character as it lifts a heavy sack. At almost every point throughout the lift, balance is maintained in this manner. At the beginning of the action, even before the sack is lifted, the figure is aligned almost directly over the sack in anticipation of the need to place the additional weight at the centre of balance. We can also see in this illustration how strong poses for the key positions enhance the clarity of the action. Animation is much easier to read if you have strong, clear shapes in your key images.

The Shift of the Centre of Gravity During a Lift

The centre of gravity is shifted as the figure adjusts its stance in accordance with the weight being lifted

The figure is positioned over the weight at the beginning of the lift to place the weight as close as possible to the centre of gravity. This will maintain balance throughout the lift

The feet are spread further apart to assist in balancing the figure with additional weight

Figure 2.31 The size, mass and shape of the object being lifted will affect the nature of the lift, its animation and its timing. All objects, no matter how heavy, will affect the balance of the lifting figure by varying degrees. In this sequence the figure is positioned over the weight in order to more closely align the centre of gravity. The feet are placed further apart once the object has been lifted to assist in the balancing of the figure. The wider apart the supports are, the more balanced and stable an object becomes.

Timing a Lift

The timing of a lift will be determined by the weight of the object; kittens are not heavy, anvils are. Timing will also be determined by the ability of the figure to lift the object

The arms may provide the lift when the object is a light one. The feet remain close together to maintain balance

When lifting a light object the back is used and is bent throughout the lift

When lifting a heavy object the knees are used and the back remains straight throughout the lift

The knees may provide the lift when the object is a heavy one.
Feet will be wider apart for balance

Figure 2.32 The timing of the lift will be determined by the weight and the nature of the object. The same principles apply to this action as were covered earlier in the section on the Newtonian laws of motion. Kittens are lighter than anvils and, as a consequence, have less inertia to overcome, so the lift will be faster.

Figurative animation 95

Throwing Action - Key Frames

Figure 2.33 The four keys demonstrate how the balance changes throughout the sequence during this throwing action. The arc of the throw is a major constituent of the action, with the hand coming from waist height, extending above the head and ending up across the body almost at knee level pointing at the ground.

Dynamics of a Throw

Figure 2.34 In this example we can see that, at the beginning of the throw, most of the weight of the figure is supported by the trailing leg; as the throw progresses the weight is shifted forward and is supported by the leading leg. The action of this throw does not start with the arm or hand. It begins at the ankles. They pivot, moving the entire body forward; this movement progresses through the knees to the hips. The body is swung forward, followed by the shoulder, then the arm and finally the hand and fingers. This creates a whiplash type of action that flows through the entire body. As the throw develops, the figure needs to move the trailing leg forwards through the passing position and into a new forward position, as in a stride. During a more dynamic and energetic throw, the figure may gather so much momentum it is necessary to take one or more additional steps after the javelin has been released to regain balance.

Dynamics of a Throw

Body moves backwards as arm is raised in anticipation

Body begins to rotate as the upper torso moves forwards

Throw begins by pivoting at the ankles as the body moves forward

The weight is shifted onto leading leg

Arm arcs high over the head during the throw

Body arcs downwards as the arm reaches its most forward position

Body rotates as the throwing arm moves forward

Trailing leg swings forward as the figure takes a step

Body fully rotated, head held upwards and looking forwards, throwing arm across the body and pointing downwards

Figure 2.35 In this animation, as with the javelin throw, the non-throwing hand is held out in front of the body at the start and swings backwards as the throwing arm moves forward.

Dynamics of a Shot-put

Figure 2.36 During this throw, the bulk of the body plays a far more important role as it helps to lift the shot upwards. At the outset of the throw the figure has bent knees, so as the knees are straightened the shot's inertia is overcome and momentum gained. The non-throwing arm is once again held outwards away from the body to assist in balance and pulled backwards during the throw to provide a counterbalance to the throwing arm and to assist with the upwards thrust of the shot.

Pushing

During a push the weight of the figure may be utilized in order to induce movement in the object. Pushing a small object may simply require a limited amount of force, perhaps coming from the hand or the arm. With larger objects it will be necessary to increase the force in proportion to the object's mass in order to overcome its inertia; this may necessitate the increased use of one's own body weight. Newton's third law of motion states that every action has an opposite and equal reaction. Effectively, if one pushes an object in a given direction there are opposing forces that 'push' in the opposite direction.

Figure 2.37 The weight of the figure may be utilized to apply the necessary force to achieve movement. The figure can lean into the push at an acute angle simply because the mass of the object is such that it 'supports' the figure. If this was a lighter object it would quickly move away from the figure, an unbalanced state would occur and the figure would fall over.

Balance During a Push

The weight of the figure itself can be utilized in an effort to move an object. The amount of weight (force) needed to be applied in order to make the object move is proportionate to the amount of inertia the object possesses

The angle of the figure will become more upright once the object has begun to move. Less force will need to be applied to maintain movement once the inertia has been overcome and momentum gained

Pulling

As with the push there is clear evidence here of the third law of motion; the arms are pulling in one direction and the feet applying thrust in the opposite direction. Similarly, a figure engaged in a pulling action may achieve a position that appears unbalanced though is in effect supported by the mass of the object being pulled.

QUESTIONS TO ASK YOURSELF ABOUT WEIGHT AND BALANCE

- Q. Is the action naturalistic or stylized?
- Q. Would the object behave like this in nature? Is it subject to the laws of nature?
- Q. Does the overall animation display the sense of weight that is appropriate to the object?
- Q. Does the object float?
- Q. Does the object look balanced throughout the action?
- Q. Is the centre of gravity in the right place?
- Q. Does the centre of gravity shift throughout the action to accommodate the weight of the figure and to maintain balance?
- Q. How does the physiognomy of the character affect its balance?
- Q. What other factors impact upon the balance of the object or character?

ANTICIPATION

Almost all actions are preceded by an anticipation of that action. We can see this anticipation in the throw, the push and the lift that we have just covered. In some instances it is a

Balance During a Pull

The centre of gravity shifts as part of the weight of the figure is counterbalanced by the weight of the object being pulled

The angle of the figure moves towards the horizontal as more weight (force) is applied. The feet are placed further from the centre of balance relative to the figure. As the weight moves the figure moves towards a more upright position

Figure 2.38 Notice how the figure leans over in an increasingly acute angle as the strain is taken up. The centre of gravity shifts to such a position that if the object was no longer there the figure would fall over. The mass of the object acts as a counterbalance to the weight of the figure until such a point that the backwards thrust applied to the ground increases to a high enough level to overcome the inertia of the object and the object begins to move.

physical requirement of the action. In order to jump upwards it is necessary first of all to move downwards by bending the knees. Anticipation also helps the animator to communicate clearly to the audience what is going to happen next. Often, there is no physical need to undertake an anticipation of an action; we do it simply as a result of thinking about something before we do it. We may lift our hands upwards slightly before we reach downwards to lift an object off the floor, though there may clearly be no physical reason for this. Adding anticipation to an action strengthens the action and adds clarity to the movement; however, if it is overdone it may result in a very staged and exaggerated, cartoon-type action that is reminiscent of the silent movies. Before the advent of sound, actors would often exaggerate their actions to make them more easily read. Chaplin was a master of this. Though far from being a simple pantomime figure, he mastered the technique and was able to use just the right amount of exaggeration to enhance the action, adding clarity and

Anticipation Within a Throw

Underarm

Recoil Anticipation Throw Follow-through

Overarm

Recoil Anticipation Throw Follow-through

Figure 2.39 In these examples you can see how the arm has to move backwards first in order to provide the forward thrust of a throw.

keeping the action subtle. This gave him the scope to cover a huge range of emotions without recourse to dialogue, and for this reason alone he is worthy of very serious study.

Anticipation prepares your audience for what is coming next and if done well it won't give the game away.

Takes

A take is a kind of anticipated action that is generated not by premeditated preparation for a movement but more by

Figurative animation

Anticipation During a Punch

Recoil Anticipation Punch

Figure 2.40 As in the throw, the punch can only be delivered if an anticipated action precedes it. The arm moves backwards before moving forward for the blow.

Anticipation Within a Leap

Recoil Anticipation Thrust Jump Anticipation of contact

Figure 2.41 In this case the entire figure anticipates the move. In order to jump forward from a standing position, the figure squats down in readiness for the spring upwards. In this way, energy is stored within the legs during the anticipation and then released during the jump.

surprise experienced by those doing the take. This can be quite subtle or it can be extremely exaggerated for comic effect.

An argument in support of life drawing

To understand we must see and experience. Sight is a facility most of us possess; to see is a purposeful act of investigation. One way we can develop the skill of perception is through life drawing. The act of drawing will not only improve your mark-making skills and develop a facility with a range of media, it also forces you to observe your subject very carefully.

The Take

Figure 2.42 In this example we can see the starting position is the figure at rest. It then moves down in anticipation of the take (squash). This is followed by the extreme position of the take (stretch), instigated by an event that causes any number of reactions: surprise, fright or joy. The completion of the take is when the animation settles into its final position. This need not be limited to the face and the head, it can affect the entire figure. Laurel and Hardy were masters of the take and double take, which often involved total body movements including grabbing their hats, ties or even one another.

I had a group of students studying computer animation who demonstrated a deep reluctance to attend any of the life drawing classes provided for them, while their colleagues working in 2D or 3D animation would show up regularly. Their concern was that they couldn't draw too well and they didn't see the relevance of life drawing to their studies and their practical work. Their stance was: why should they learn to draw, they were working in computer animation after all, and that stuff was for the traditionalists not techno whiz-kids. I met up with a few of these students at a studio where they were working shortly after they graduated and they were somewhat coy about letting me know that they had arranged life drawing classes of their own. It turned out that the old boy with the pencil was right after all. Do not become despondent if you are not confident in your drawing skills; this does not mean you will not be a good animator. There are many first-rate computer animators and stop-frame animators who are not comfortable with drawing, but what they do have is a profound understanding of how things move, behave and perform. Performance is the thing. Life drawing, in this instance, is only a means to an end, the end being observation and understanding. If you can get this same level of understanding through any other method, studying films,

The Double Take

Squash Stretch

Figure 2.43 The double take works along the same principle as the take, though there is a second anticipation position before the reaction position. This is often used in more cartoon-like animation for comic effect.

observing people and animals in motion, making videos or taking photographs, then that is the way forward for you. There is no one way.

> It is my business to know things. Perhaps I have trained myself to see what others overlook.
> (Sherlock Holmes, in *A Case of Identity* by A. Conan Doyle)

One final thing: it may sound obvious, but it is important to have a clear idea about what you are trying to achieve in an action long before commencing animation. Your ultimate intention should be to make your characters look like they *intended* to make the movement and that the motivation for the action comes from *within them*. The hand of the expert animator becomes invisible; they no longer animate, they allow their characters to give a performance and the characters become so believable that they begin to exist as real entities. If you don't believe me – just ask Bugs Bunny!

Chapter 3
Acting

Character Interaction

Animation leads to performance and performance is at the heart of the story. The animator's main aim should be to become invisible, leaving only the character and the performance behind.

BEFORE WE BEGIN

In the previous chapter we looked at the issues and complexities of figurative animation and placed that type of dynamic action into a context within the four As of animation. While those aspects of animation covered in that chapter and the exercises set out were challenging, the subject of the chapter was clearly placed within the 'animation' level of the four As of animation. We looked at how all the motivation for the movement came from within the figure and that one of the main aims within the animation was to make the figures appear as though they *intended* to move. We also covered the problems associated with the creation of believable figurative animation and we went on to discuss why the animation of familiar objects and figures is difficult simply because we are so familiar with them, we observe them regularly. In this part of the book we will begin to look at character interaction and the much more difficult task of acting. Achieving believable animation utilizing acting becomes even more difficult because we not only recognize how things move, but we also relate to how characters think and feel.

The one thing you must realize from the start is that you will not find simple, off-the-shelf solutions to your acting problems. Nowhere will you find a set of movements or expressions that can be used as some sort of acting kit, using this or that predetermined action to express sadness or anger or delight. Individual characters may develop recognizable traits over time just as Bugs and Daffy have, but to construct believable emotions and to connect with an audience the acting must be done for real, there is no faking it. I once set my students an exercise whereby they all had to complete a short sequence of animation using the same characters and the same voice track; they even had to use the same layouts. The results were quite remarkable. Each one of them managed to complete a separate and quite distinctive performance based upon their own understanding of the characters, their approach to the scene and their own acting abilities.

Acting

The meaning of the words is determined and changed through the individual performances of the characters

The same word or phrase takes on a different emphasis in all these examples

Figure 3.1 In the illustrations set out here, the real meaning of the expression 'I love you' varies in each of the examples. The first really does mean it; the guy does love whoever he is talking to. The second really says 'I'm sorry'; perhaps he has had a night out with his friends and returned home late after missing a planned dinner with his in-laws. The third means 'Don't leave me, I can change and mend my ways'; things have got that bad. The fourth has more menacing overtones that create a tension between the words spoken and the meaning. In this case it may mean 'I am going to kill you, and no one will ever find the body'. This juxtaposition of the words and how they are delivered and the real meaning creates a chilling tension. Consider how, in the scene in Tarantino's *Reservoir Dogs* just prior to the torture of the policeman, the psychopathic villain turns to his captive and calmly considers his suggestion that even torture will not get information out of him as he knows nothing: 'Torture you? That's a good idea. I like that. Torture you.' As I say, chilling.

CHARACTERIZATION

The task ahead of us now is to look how we impart character and personality to our animation, and how we create in them shifting moods and a temperament. Characterization does not start with the physical appearance, it starts on the inside. It's not simply the *visual* design of great animation characters that makes them believable. How well they are drawn or how well crafted the modelling is does not make them real to us. However, there is no doubt that the physical appearance is important and there can be no denying that it adds appeal, which is vital when trying to reach, and sell to, an audience. It's the fact that the characters demonstrate the kind of traits we recognize in ourselves and in others that brings them to life. The reason Chuck Jones made such wonderful Bugs Bunny movies wasn't because he could draw the character so well, it was because he understood Bugs, he knew Bugs and, for all intents and purposes, he *was* Bugs! That is obviously overstating it, but he did know how to *act* as Bugs, that's for sure.

The manner in which 'characters' act is fundamental to the medium of animation, be they cartoon rabbits, elegantly drawn figurative characters, 3D objects, typographical or other graphic symbols or elements. The key to successful character animation lies in the believability of those characters. No amount of elaborate animation or skilful drawing will give the characters lasting appeal; this can only be achieved through well-thought-out design, which includes psychological design as well as physical design. By itself, a physically interesting or attractive design is not enough; the psychological make up of a character is what interests an audience most. It's this that demands the viewer's emotional involvement. For a truly successful solution both elements – good design coupled with a well-crafted performance – are necessary. If the designer doesn't know and believe in the characters and the animator fails to emotionally engage with his subject, then an audience has no chance and the character will remain unconvincing. As good as it is, the naturalistic animation of the dinosaurs in the BBC's *Walking With Dinosaurs* series or the feature *Jurassic Park*, for example, remains limited in performance as it is restricted to the characters more or less eating or being eaten. Acting involves much more than this. Let us consider for a moment the animation of Gollum in the *Lord of the Rings – The Two Towers* (2002) and *The Return of the King* (2003). Here we

have naturalistic animation of a very unnatural character. Yes, Gollum is human in form but abstract in as much as he is beyond the natural bounds of the human figure (he actually takes on the form of a quadruped), yet what a performance the animators achieve. Using the performance of actor Andy Serkis as reference material, the animators rotoscoped the actions to achieve a remarkable *psychological* performance. This is far more than simply illustrating movements that portray basic instincts. As Gollum and Smeagol argue with one another for dominance, a full range of emotional stresses and tensions come to the fore; in turn we are amused, frightened and disgusted by this creature in torment, the audience is left completely captivated and the suspension of disbelief is total. This does beggar the question as to whether what we are seeing here is live action or animation. My own opinion is that it does not matter. What does matter is the performance. The animators, and in this case the actor too, have become invisible and what we are left with is Gollum, or Smeagol, or both.

The performance is the thing

John Lasseter of Pixar, responsible for such great films as *Toy Story* (1995) and *Monsters Inc.* (2001), said that there are three important aspects of a film: the script, the script and the script. And it is true. A good idea (if good enough) will be able to stand alone; there are a number of films that are first rate that have less than great animation in them – the idea carries it. However, no amount of great animation will save a bad idea. Couple a good idea to a good performance of a good script and you have the recipe to make a film truly great. Consider the following:

Good idea + Bad animation = Good film

Bad idea + Good animation = Bad film

Bad idea + Bad animation = Stinker

Good idea + Good animation = Write your acceptance speech

Acting, the highest and most difficult level of animation, is at the heart of all character-based animation. Giving a performance is what drives any film. If the script is the most important aspect of the film, then it's the performance that brings the script to life.

Your characters should not simply move, slavishly illustrating the script, they should perform – display mood, temperament and emotions. They should allow us in; we should know not only what they are thinking, but also what they are feeling! How else can your characters illicit from your audience the response you intend.

Remember, as an animator you are an actor. Instead of getting in front of a camera yourself or treading the boards in front of an audience, you are sending your creations out there on your behalf – but make no mistake it is *your* performance they are turning in.

In order to get the most out of your characters you must:

- Know your characters
- Empathize with your characters
- Become your characters.

Perhaps one of the greatest performances given in the medium was the defining moment when Woody and Buzz Lightyear first met in the feature film *Toy Story*. The full range of emotions is there for all to see. As Buzz finds himself on a strange planet cut off from his command centre, he is confronted by what appears to be an alien species, Woody. Woody introduces himself and tries to get over the initial nervousness at the possibility of being ousted from his prime post as Andy's favourite toy. He also has to deal with embarrassment as he tries to reason with Buzz and establish that the best position to be in (on top of Andy's bed) is the place that rightly belongs to Woody. Buzz's fear abates when he notices Woody's sheriff's badge, as he recognizes a fellow law enforcement officer. All in all, this is a magical sequence achieved not only by the performances of voice artists Tom Hanks (Woody) and Tim Allen (Buzz Lightyear), but by the masterly handling of the animation.

Dialogue

Many character animation performances depend upon the abilities and craft of the voice artist. Genius is definitely an overused term, though in the case of Mel Blanc it is totally appropriate. He was not only able to create a wide range of comical voices, he brought to life some of the greatest animated characters we have ever seen and in doing so gave a whole generation of movie fans those most irascible,

lovable, petulant, greedy and human characters: Bugs Bunny, Daffy Duck, Elmer Fudd and a host of others. Great animation cannot save a poor voice performance, although it's perfectly possible that the performance may well be of an acceptable standard. However, there is nothing more certain to kill a first-rate voice performance stone dead than poor animation. This is not simply an issue of sound synchronization, it's a matter of bringing both elements to life, making them greater than the sum of their parts. The voice and the animation together create performance. Animators usually make character animation working with a recording of the voice performance either on tape or disc as reference material. Some productions even go as far as to video the voice artists as they record the voices and encourage the artist to stand while delivering the dialogue. This not only aids the voice artist to project their voices better in a physical delivery of the lines, but it encourages them to make accompanying gestures and even to put in a full physical performance at the time of recording, including facial expressions. Using this kind of footage for reference may assist animators in the task of making the animated performance. Even though a good voice track may underpin character animation, dialogue is by no means necessary to create believable, moving and memorable performances. Rudolf Valentino, Harold Lloyd, Charlie Chaplin and Buster Keaton managed to transfix their audiences with outstanding performances for years without ever saying a word. In animation terms, Chuck Jones's Coyote never utters a sound while his arch enemy Roadrunner merely says 'beep beep'; silence doesn't seem to be an obstacle to those guys.

Motivation and objectives

The motivation of a character is the vital aspect of a script that drives the acting and enables a performance. As individuals and as groups, we react and undertake an action because something drives us to it and in undertaking that action we aim to achieve something by those actions – we have an objective. There is normally a reason we do what we do. We strive to achieve our goals because we are driven to achieve them, even if it's a simple action of making a cup of coffee. In most situations motivation starts in the head with a thought, not in the body as a physical action; there are exceptions to this, however, such as purely physical reactions to external forces, such as sitting on a drawing pin. Thinking leads to emotion and emotion leads to movement and action.

In order that your audience fully understands and appreciates the motives of your characters, it is important that you understand not only your characters' objectives, what they are trying to do, but also their motives and the personal psychology that is the cause of these drives. A character's motives and objectives need to be clearly understood by the audience, though not necessarily immediately, otherwise the actions may appear to be random and nonsensical.

Empathy

In order to create believable animation and deliver a convincing performance you must connect with your audience, and the only way to do that is through your characters. In order to achieve this, the audience must connect with the characters, and the only way to do *that* is through empathy. Before your audience can empathize with the characters, *you* must understand them and empathize with them. This doesn't mean you have to agree with their morals or even like your characters, it's enough that you understand what makes them tick. I suspect that in order to achieve the best performance there will be a little crossover; the things that make *us* tick will appear within the character and we may gravitate towards those elements within the character that we recognize and see within ourselves, even the ones we would rather not admit to. You must learn to take advantage of that and exploit it to the full, just as Chuck Jones did with Daffy Duck. Daffy isn't exactly the most gracious of characters you could meet; however, he is one of the most endearing, not despite his human frailties, greed, envy and pride, but because of them.

Physical acting

Much of the physical acting we see in animation depends much less on the outward display of subtle actions driven by complex thoughts and emotion than on pantomime, which it usually incorporates in some form or another, though it is not necessarily limited to this. Perhaps the greatest exponent of physical acting was Charlie Chaplin, who managed to express a broad range of emotions through his particular brand of mime. Genius as he undoubtedly was, his acting often appears somewhat crude by today's standards, simply because his acting was so dependent on the physical, limited as he was by the medium of the day. The physicality of animation acting is most evident in cartoon animation, where

the impossible becomes the norm. This approach can be seen clearly in the work of Tex Avery and John Kricfalusi. This kind of acting is heavily dependent upon body language and strong key poses, often holding a single drawing for many frames. Tex Avery was a master of this technique. He would take a strong, highly exaggerated key drawing and hold it with little or no action at all. While Kricfalusi's characters have a far stronger and more defined personality than most of Avery's characters, they still depend on their believability through the physicality of the animation to express all their emotions, which are often very limited in range. While this approach to animation is a perfect vehicle for fast slapstick physical comedy, it can be limiting if a more profound statement is sought, though in the wrong hands this type of physical acting will ultimately fail to convince. And there is nothing worse than unfunny comedy!

Psychological acting

This type of animation is far less dependent upon the physical performance normally associated with slapstick cartoon animation. Psychological acting and the actions that result from it are expressive of thoughts and emotions, and often entail much less dynamic movement. The animation and portrayal of thoughts are often far more difficult to handle than physical actions. The incremental movement of the figure within this type of action demands more refined work, involving far less differentiation between frames. This can be very demanding work for the animator and means far more physical control of the drawing or the model to maintain smoothness of action. The animation timing is usually far more crucial in this kind of acting, while the phrasing of the animation is central to the success of the sequence. A good example of this can be found in Disney's *Bambi* (1942). The scene in which Bambi as a little fawn realizes he has lost his mother to the hunter's gun demonstrates supreme control on the part of the animator. On hearing the news that 'Your mother cannot be with you any more, Bambi', the youngster is quite motionless, staring up to camera as the snow falls slowly around him. He then does little more than slowly lower his head and lowers his gaze, and although the action appears simplistic we are left in no doubt of the intense sorrow he feels and we share with him the realization that he is now alone in the world. And that's the key: we *share* his feelings. But it's not simply the speed at which the head is lowered that generates this feeling, it is the phrasing of the

whole sequence; it's the relationship between the words being spoken by the Prince of the Forest and the resultant action of Bambi that is most poignant. It does not depend on complex movement, it depends upon subtle phrasing and animation timing. The scene also depends for its success upon the use of sound, colour and cinematography, all of which are masterly.

It has been said that the villain is more interesting than the hero, and there is plenty of evidence to support this. It is certainly true to say that the animator has a harder task to bring to life a character that has less psychological complexity to them as they have less to work with. Consider the example of the Prince and the Evil Queen in *Snow White* (1937). The former is a vacuous, love-struck young man with few discerning characteristics that would set him apart from other princes, while the latter is a complex character, beautiful, narcissistic, envious, devious, malicious and deceitful, and a psychopathic killer to boot. Yet there is an element of compassion within her (she is, after all, keeping Snow White in her household, albeit as little more than an ill-treated servant) that makes her rich pickings for the animator capable of animating such a character.

TEMPERAMENT AND PACE

Character animation is determined by psychological factors as often as it is by any physical constraints or conditions. The shifting emotional tensions within the animation should be reflected in the dynamic of the sequence and the phrasing of the animation. The pace of the animation is established before the animation begins, and is determined by the storyboard and the recorded voice track. Your animation should always be in keeping with the storyboard and the dynamic of the sequence set in the animatic or story reel. Both storyboard and animatic will establish the narrative dynamic of the sequence, while the animation and voice track will add the performance which reflects that dynamic.

A slow-moving sequence intended to add tension and suspense to a sequence or display tenderness, sadness and loss will be totally ruined if the animation timing is at odds with these aims. If Bambi moved too quickly or made the wrong kind of action in the sequence we covered earlier, the illusion would be broken. Conversely, if the dynamic calls for a series of quick shots to generate excitement, danger, fear or

comedic effect, this may be totally ruined if the animation timing is too slow and the pace too lethargic. The work of Tex Avery depended heavily on the speed of the action. His characters ran riot across the screen, exploding into pieces, elongating into improbable proportions, chasing one another, hitting lumps out of one another and generally creating a surreal pandemonium. Slow this down with inappropriate timing and phrasing and not only will the gags be killed stone dead, but the design of the characters and their psyche will be totally misread and become inappropriate. As energy levels rise within the animation there is an increase in pace and tempo. As the energy levels lower so the animation phrasing becomes slower. These high points and low points throughout a sequence, determined by the script, provide a kinetic contrast, a kind of choreography of emotion that will keep your audience interested. If the sequence moved at a continuous breakneck speed or plodded along relentlessly at the same pace, then the audience would lose interest. It is interesting to compare the early Daffy Duck in *Porkey's Duck Hunt* (1937), where he makes an appearance as a two-dimensional bundle of lunacy, and the far more sophisticated Daffy of later years, *Duck Dodgers in the $24\frac{1}{2}$ Century* (1953), once he had been developed and was better understood by the animators. They are like totally different characters. The first is capable of no more than demonstrating deranged madness, while the second is a fully developed personality able to cope with a full range of emotions and situations. Acting in character animation does not necessarily mean having your characters behave naturally. The main aim in acting is not even to be believable, it's to express emotion, to elicit pre-considered results, to take your audience on an emotional journey. In order to do this, you must understand what you are trying to achieve *before* you begin.

For the exercises in this chapter you should keep things as simple as possible. You can always add more complexity to your animation once you have mastered the basics. Characterization and personality are not dependent upon the simple surface details of a figure. Consider the creation of Peter Lord and David Sproxton – Morph. You couldn't get much less detail in a character, yet in the hands of the highly skilled animators at Aardman Animations, Morph demonstrates all the emotions that are common to us and that we recognize in our everyday life – excitement, frustration, sadness and joy.

ANIMATION EXERCISE 3.1 – TEMPERAMENT AND PACE

Aims

The aim of this short exercise is to start to develop basic acting skills within your character, to animate an expression of temperament within a character and to illustrate mood change as a result of an external event within a short sequence.

Objective

On completion of the exercise you should be able to create a believable animation that demonstrates characterization and basic acting through mood change.

Make your animation using a single, very basic character and avoid complicated details of costume or props; we'll get onto those issues a little later. Don't try to animate a figure that has inbuilt animation difficulties – for example, a figure with any kind of physical peculiarities such as long flowing hair, a broken leg or a character that is frail, overweight or very young. Keep it simple!

1. Create a simple character; this can be either naturalistic or cartoon-like. Do not make the character either overdetailed or too abstract, as this will create additional problems that have nothing to do with acting and will just get in the way of your animated performance.

2. Consider the mood of your character at the start of the sequence and the mood you wish to instigate. Your character should show disappointment, express anger, show longing, loss, sadness, joy, etc.

3. Plan out your sequence through a series of thumbnails. Don't get involved in complex perspective animation. You should animate the sequence in one shot; don't use cut-aways or close-ups.

4. Before you begin to animate act out the sequence, in front of a full-length mirror if you have one. Go on, try it!

5. Do not use dialogue for this exercise.

6. If you are working in 2D or with computer animation, create a set of key frames picking out the most important aspects of the sequence.

7. Time out your animation and shoot a key pose test according to your timings.

8. Once you are happy with the key frames make the inbetweens.

9. Shoot the final sequence.

Some thoughts on possible actions

I've suggested a couple of actions that might make for mood change within your animation just in case you're stuck for ideas, though I'm sure with a little thought you will be able to come up with far better ones.

- *Depression to excitement.* A man is walking along slowly, depressed. He spots something on the ground. He stops in his tracks and takes a closer look. It's a gold coin. He looks around anxiously to check that nobody is around to see him lift up the treasure. Excitedly he picks up the coin and hurries off.

Temperament and Pace
Finding a Coin

Slow steady walk - boredom

Figure stops suddenly - surprise

Bends down to get a closer look at what it is - uncertainty

Quickly looks around to see who may claim the coin - inquisitiveness

Stops and looks at the coin - constrained excitement

Looks away and slowly places foot over coin - anxiety

Quickly bends to reach for the coin - nervousness

Moves off quickly before anyone can claim the coin - guilt

Figure 3.2 The temperament and pace of the character should shift throughout the sequence. This will add a dynamic not just to your animated action, but to the pacing of the film as a whole; it will add interest, high points and low points contrasted against one another to create a kind of emotional choreography.

- *Calm to surprise and then embarrassment*. A figure walking along trips and stumbles, then regains balance and attempts to remain dignified and act as though nothing has happened.
- *Tiredness to surprise and then anger*. A figure gets out of an easy chair in which he has been dozing. As he gets up he turns and stubs his toe; he grabs at his foot in pain, perhaps hopping on one leg. Angrily he turns to the chair and gives it a swift kick, causing him to stub his toe once more.
- *Happy to shock and then to fear*. A figure is walking along and for no apparent reason an anvil drops into shot, narrowly missing him. Startled at this, the figure looks up in time to see more dropping all around him. Abject terror is the result!

This exercise should have given you an insight into the possibilities of character-based animation. It's what all the great animated performances are built upon. Hopefully, with practice (and a lot of it) you will just get better and better at this, and once you have gained confidence you will be able to breathe life and *personality* into your own creations. All that is left to do now is for you to practise your craft for the next 20 years or so. Simple!

ANIMATION EXERCISE 3.2 – CHARACTER TYPES/TWO SACKS

Aims

To create two distinct personalities within two inanimate objects that have the same physical appearance. To demonstrate mood change through the varying actions of two characters.

Objective

Once you have completed this short exercise you should be able to animate characters with distinctive personalities that are independent of physical appearances.

1. For this animation exercise try using two flour sacks as the characters for your animation. While in appearance they should be similar, in temperament they should not. Each of the flour sacks should demonstrate their individuality and distinct characteristics in all that they do, or endeavour to do.
2. The first sack should be eager, confident, bright and energetic, while his companion, the second sack, lacks confidence, demonstrates apprehensive behaviour, and is generally somewhat less enthusiastic and dynamic.
3. Animate them making their way across the screen together. The exact nature of their movement is left to your discretion.
4. They stop as they find their way barred by a narrow, although very deep and perilous, chasm.
5. They assess how they are to proceed and finally attempt to jump across.

6. You should undertake to animate this sequence demonstrating both physical and emotional interaction between the sacks.

7. The final outcome of the sequence is left to the discretion of the animator.

8. The animation sequence should not be dependent upon dialogue or soundtrack.

Character Types

Character recognition is even possible using non-figurative objects that define emotion, mood and personality.

Figure 3.3 The separate sacks display differences in characterization and personality, not through their physical appearance but in the manner they behave.

9. You should make thumbnail drawings to map out the action.
10. Make the animation in the same manner set out in the previous exercise.

Some thoughts on possible actions

- Perhaps the second sack takes some persuasion from the first one before leaping the chasm to safety.
- Perhaps in order to persuade his less than brave companion, the more confident sack leaps to and fro across the chasm in a more and more elaborate and flamboyant manner.
- Perhaps as a result of his lack of confidence, the second sack falls to his death.
- Perhaps the faltering actions of the sack result in his companion falling.
- Perhaps one of them slips, being saved at the last moment by his companion.

CHARACTER INTERACTION

Acting generally comes from some kind of interaction, either with other characters, objects, creatures or our environment. We respond less readily to characters' individual actions in isolation; it's only when characters are placed within an environmental or emotional context that we become more interested in them and it's interaction that provides the interest. The dynamic of an animation that involves interaction between two or more characters will shift throughout the sequence, at one point the action being led by this character and supported by another and then subsequently being led by the second character and being supported by the first. This shifting dynamic narrative is what makes for engaging acting. It provides a contrast in performances through different types which enhance the narrative. Any script that was delivered with performances that were similar in pace and tone would result in the narrative becoming flat and unimaginative. Many great screen events have been dependent upon dynamic and sometimes fiery partnerships. Consider, if you will, the various partnerships and the performances these partnerships have achieved: Fred Astaire and Ginger Rogers, Richard Burton and Elizabeth Taylor, Laurel and Hardy, Bugs Bunny and Daffy Duck, Tom and Jerry, and Roadrunner and Coyote.

The role of the animator is to direct the eye of the audience and focus the attention on the most pertinent and interesting aspects of a scene. Character interaction is not a simple matter

Character Interaction

Figure 3.4 In the scene we have described, we see that the action is being driven by one character while the dialogue is being delivered by a second. The true meaning of the narrative can only be realized by the combined action and dialogue. The individual performances on their own are interesting, but seen together they create a tension both unspoken and without explicit action, illustrating the true text.

of I talk and move, you keep still and quiet, you talk and move, I keep quiet and still. This is very unnatural. Characters' actions should overlap as the dynamic shifts between the two. It is important to remember the passive characters within the scene and to keep your characters alive. Overanimate them and they can distract from the main thrust of the scene, underanimate them and they can appear like wooden blocks, which in itself can become distracting. It is also not necessarily the character delivering the dialogue that is the one you want your audience to be watching. One character could be delivering the dialogue while the other does the movement, perhaps in response to what is being said. His actions could be more revealing about the inner emotions and thoughts than the dialogue. Consider a scene with two characters within a medieval court talking together in whispers discussing the

problems facing the king. The first character, a loyal subject of the king, is seen in mid-shot talking openly about his concern for the king and the pressures he is under, not only from his neighbouring enemies but those within the palace plotting to overthrow him. The second character, seen in close-up facing camera and with his back to the first character, reaches out and picks up from out of shot a dagger tipped with a deadly poison. He looks over his shoulder towards the first character before secreting within his cloak the assassin's blade.

ANIMATION EXERCISE 3.3 – CHARACTER INTERACTION

Aims

The aim of this short exercise is to extend your understanding of character interaction and the development of personality. To explore the animation of a shifting phrasing between separate characters of different physical types.

Objective

On completion of the exercise you should be able to animate two characters of different physical types working together in a single sequence.

Once again you will be utilizing many of those principles of animation we covered within previous chapters, such as weight and balance, overlapping action, etc. The object is to experience animating two characters with different physiognomies and to see how they interact with each other while undertaking a simple physical task.

1. Use two very simple characters with different physical attributes: one could be tall, the other short; one old, the other quite young.
2. Keep the animation simple; do not get involved in overcomplicated actions at this stage.
3. Plan the animation out in one shot. Do not use cut-aways or close-ups.
4. The first character should be struggling to carry a heavy object.
5. The second character sees the first and moves towards him to help.
6. The object is passed onto the second character, who appears to be the stronger of the two.
7. The second character manages the object far more easily.
8. The exact nature of the object and final outcome of the sequence is left up to you.
9. As before, use neither dialogue nor soundtrack.
10. Make thumbnail drawings to map out the action.
11. Make the animation in the same manner set out in the previous exercise.

Some thoughts on possible actions

- Perhaps the first character collapses after passing on the object and the second character shows off his superior strength.

- Perhaps the second character slaps the first one on the back after taking the heavy object.

- Perhaps the characters drop the object and it lands on the toe of the stronger figure.

PLANNING A SCENE

A well-crafted scene containing a good animated performance is not something that happens by accident. It demands structure and planning. To ensure that the scene you are animating meets the intended aims and is in line with your storyboard and animatic, you need to carefully plan the animation performance and stage the action correctly. This will ensure the pacing of the film is correct and avoid any continuity errors. It will make the most of your characters and afford you the opportunity to fully explore dramatic content. You need to locate your characters within the environment properly, and establish where they will appear on screen throughout the scene. You also need to locate the action and drama within the sequence appropriately before you commence animation. This should allow the narrative to flow freely and in a natural manner. You will find it useful to have a copy of any voice track at hand as you make the animation. That way, you will be able to constantly refer to the voice performance and more fully appreciate all its nuances and exploit the voice artist's performance to the optimum effect. Don't allow the planning to restrict the performance. Thoughts will occur to you during the animation which may mean changing things slightly. This needs to be allowed for and there should be some leeway in the storyboard to accommodate this. If there was no structure to the film the narrative could become a rambling, incoherent and self-indulgent mess. If the structure is too rigid it could leave you missing the opportunity to fully exploit an excellent performance.

The six stages of planning a scene

1. *Think*. Don't just get down to the work, think it through first. It may sound obvious, but I have seen far too many pieces of animation that are simply going through the motions, a kind of animation by numbers, get character, place within

scene, check director's instructions and scene length, add animation = finished scene. The result is at best a lacklustre performance, at worst simply moving stuff around in time to predetermined points, wooden in the extreme.

2. *Aims*. Know what you and your characters are trying to achieve within the scene. Understand how this scene fits alongside the other scenes before and after within the sequence and how it fits within the dynamic flow of the movie. This is important not only to achieve the practical aspects of continuity throughout the animation, ensuring that if a character has a hat on his head at the end of one scene he also has it in place at the beginning of the next, but to ensure that the flow of the entire sequence is maintained.

3. *Objectives*. You should understand exactly what the scene must deliver. Establish if the character has to achieve certain objects, undertake certain tasks, and be at a certain emotional or spatial point within the movie? Identify those issues of continuity that must be considered as above by checking the scenes that precede and follow the one you are working on.

4. *Options*. Explore the options open to you. How will your character do what it needs to do? Even a simple action of getting out of a chair will have a number of variations. Establish which is the most appropriate for the scene; this is not always the most taxing or challenging. Remember, your animation must fit within the whole film; not every scene will offer the opportunity for you to showboat.

5. *Personality*. How is the personality of the character you are animating being expressed to the audience and is it in keeping with the character? Would the character you are animating behave in this way?

6. *Clarity*. Your audience must be able to see what you are trying to do not only in cinematic or graphic terms, but also in terms of the performance of your character, its objectives, motivation, shifting dynamic and relationship with other characters. What are you trying to say in this scene? Is it clear to you? If it isn't, it won't be clear to your audience either.

PROPS AND COSTUME

The use of props and the costume associated with a character's movement will not simply affect the movement of a character, but will often determine the action. We have looked at how

heavy objects will affect the action and balance of a character, but a certain prop may also affect the way a character performs. The transformation from fool to king may come about by simply placing a crown on a head. Crowned with a ringlet of gold, a character may change its entire persona, including the manner in which it carries its physiognomy. The character is no longer a cowering, servile fool, the butt of the jokes of lesser men, but now a noble, gracious and upright individual, worthy of a crown.

Props and costume can be used to enhance a mood and exaggerate characterization. They offer the opportunity for true character-based animation, business as Disney used to call it. Consider a young child wearing her mother's dress and shoes. What does she become, how does it alter the way she moves, even the way she speaks? There is a lot of business to be had from the simplest of props. Disney's Pluto manages to get into all kinds of bother with a simple piece of fly-paper, but manages to provide the material for a great piece of comedic animation in the process. Props do not need to be complicated. The manner in which a man could use a simple prop such as a hat can be very telling. Charlie Chaplin used his famous hat and cane to exactly that effect.

None of this can be learned in a vacuum. Observation is the key to the exploration and development of character-based animation, so I would urge you to get out and simply observe. Take a walk in the park, have a cup of tea at the café, and look at the different types of people and their individual

QUESTIONS TO ASK YOURSELF ABOUT ACTING IN ANIMATION

Q. What are your characters' aims?

Q. What are your characters' motives? What drives them?

Q. What are your characters feeling?

Q. What are your characters thinking?

Q. Do you *know* your characters?

Q. Do you empathize with your characters?

Q. Is the action naturalistic or stylized?

Q. Are your characters simply moving about in time to predetermined points on a time line or are they displaying personality and giving a performance?

actions you'll see there. It's surprising how their personalities start to become clear to you, how they are expressed even in the little things they do, even in their body language. And study film, not just animation but live action too, but don't let the footage just wash over you in waves. Deconstruct it, try to analyse what makes for a good performance.

This chapter really only skims across the subject of acting in animation and the issues covered here in a somewhat lightweight manner are worthy of an entire book on the subject. As far as I am aware, no such book written by a leading animator exists, though as a starting point you may wish to take a look at Ed Hooks's book on the subject, listed in Appendix 2: Further reading.

Chapter 4
Design

Colour Models

The individual colours of each character are identified by their colour values to ensure continuity throughout a production.

Good design is the foundation of every successful product. Animation is a product. Films don't just happen, they are crafted. Every element is planned out and designed, and the more elaborate the film, the more meticulous the design and planning.

BEFORE WE BEGIN

We need to establish exactly what we mean when we talk about design for animation. It would be a mistake to think that this is merely limited to designing funny cartoon characters. In the context covered by this chapter, we will be looking at the most obvious graphical design elements of character design, storyboards and backgrounds.

Design for animation does indeed involve character design, but beyond that it extends to backgrounds, sets, props, storyboards, animatics, cinematography and other non-graphic elements, such as sound, music, and scripting and characterization design, aspects that may be found in a writer's bible rather than an animator's bible. Each of these specific areas of design clearly contributes to the overall result. It can be argued that even animation timing can be classified and identified in terms of design. It is not only in the graphic quality of the animation that differentiates work such as Phil Malloy's and Erica Russell's. Design extends to the way in which each animator uses *time* as a design element, not simply using animation timing as a way of moving things around the screen but by creating an animation language. Animation timing as a design element is also clearly evident in computer games, where the playability of the game is of paramount importance. We often find that the separate actions of the characters within a computer game are subservient to the need for optimum game playability.

Design for animation is such an extensive subject encompassing so many different aspects of production that it is not possible to cover it fully here. So broad is the subject of design for animation that there is probably a need for separate volumes on each of the individual topics. The making of a successful animated film does not necessitate the use of stunningly beautiful and naturalistic animation. Great films can be made with a minimum of animation that depends on good scripts and first-rate design. UPA (United Productions of America) are testament to that. They formed as a direct result of the 1941 strike at the Disney studio and

began to make animation that was seen by many to be an artistic response to the ubiquitous Disney-style animation.

Much of UPA's output depended upon design and script-driven material, which resulted in what became known as limited animation. It may have been *limited* but it was anything but *limiting* and it provided a brand of animated movie-making that was fresh and innovative. UPA's version of Edgar Allen Poe's *Tell Tale Heart* was one such film. The strength of the design work, with its emphasis on neocubist backgrounds and film noir cinematography, make this a startlingly fresh film that cuts to the very heart of Poe's original work. Much more recently, Cartoon Network's *Samurai Jack* uses screen space design and cinematography to similar effect. The minimal use of animation does not detract from the stories, it enhances them and presents the narrative in a fresh and unusual way. The overall result is an animation that is reminiscent of the comic strip and graphic novel. The combination of strong design and limited animation allows the audience's attention to be focused on the story and highly original design. This creates a unique type of cartoon-based animation. Design for animation, like all other forms of design, should be appropriate to the production and meet a wide range of aesthetic and practical criteria, taking into account the purpose of the film, the methods of manufacture, its use and distribution.

Production

The entire production process of even a modest animated film will have an impact upon the final design. The methods adopted, the technology used in production, the type and amount of resources available (including staff), the production team and the level of skills available to them, and the production paradigms used by the production team will all have a bearing upon the design decisions made at the outset.

Style

It is important when designing for animation that the separate elements fit in with the overall styling of the film and that character design stays on message. Design must reflect the style. That is, the design must fit within the conceptual environment. Flat cartoon characters such as Ren and Stimpey would simply look out of place set against richly detailed and complex Disney-type backgrounds, and vice versa.

Audience

The differences between targeted audiences will determine design issues. Animation aimed at children will have the obvious limitations imposed upon it, though this may even extend to choice of colours, while animation aimed at an adult audience may utilize more abstract forms or contain material of an adult nature.

Distribution

The manner in which the animation is to be distributed may also have an impact on the design. Animation seen on the Web, TV, standard cinema or Imax will have a very different effect. A close-up that may be suitable for a small screen may prove to be alarmingly large for a cinema and almost impossible to read in Imax format.

Format and budget

The format of the animation must also be considered. Animation made for a TV series with a limited budget must take into account the reuse of animation, the separating of characters into constituent parts, limited lip-sync, etc. The design decisions for a series will have a major impact upon the profitability of the work. The simple addition of a patterned material on the costume of a character could have serious consequences for the budget. A patterned shirt takes longer to draw and colour than a plain one. Taken over a series of 26 × 25-minute episodes, this could add up to a lot more pencil mileage – which means money! For feature work the design is often more complex, as the budgets are usually much higher and allow for additional detailing. One-off films may not be subject to such design considerations and constraints, as there may be less opportunity to make economy-of-scale savings. There is still a very real need to consider design and set this against the resources and budget available.

STORYBOARDS

What is a storyboard and what is it for? A storyboard is a set of sequential images that sets out in visual terms, panel by panel, the progressive narrative of a film. Storyboards consist of a number of panels, each of which is representative of how the final animation will appear on screen. Storyboard panels provide a framework of separate images that create a sequential whole, reading from top left to bottom right, much like a comic strip, though the similarity is often overstated.

Unlike most comic strips, storyboards utilize a variety of cinematic devices and a range of shots that will be in the completed film to illustrate the narrative; a storyboard is a vital tool for all those within the production team. Producer, director, designer, animators, voice talent and editors will all find a use for the storyboard in their own particular part of the production process. In order to ensure that the full cinematic narrative is explained clearly to all the production crew, additional information regarding dialogue, sound, action, camera moves and sometimes even technical issues sits alongside the graphic representation.

It's at the storyboard stage that a script starts to become concrete; some have even argued that when the storyboard is finalized the film is complete. I would not support this view. It is true, however, that during a professional production it is normal practice that once a storyboard has been agreed upon and animation commences there are usually only few and minor alterations made to the storyline. Since animation is a very expensive process and reshooting is by and large out of the question, it is vital that the film works at the storyboard stage, with little or nothing left to chance. Some animators prefer to use the storyboard as a rough guide to the animation, allowing alterations to be made right throughout the production. While this looser approach to film making may enable the director and the animator to continuously develop the idea and make a creative input to the film through animated performances, it can also mean a lack of structure which could result in an uneconomic and inefficient use of time. This approach is something that is anathema to the professional production running on a tight budget up against an even tighter deadline. If the storyboard remains unresolved before production commences, it is more likely that expensive mistakes will be made. Time spent getting the storyboard right is time (and money) that will be saved at a later stage. The storyboard, and the animatic, will throw up difficult issues and highlight design problems that can be resolved before animators get to work, saving time and money. It is important that key members of the production crew are familiar with and have input to the storyboard; this will enable them to better assess the work involved and the resources required to accomplish a favourable result.

Very often, in the early days of animation, films had only the barest of outlines and animators made up the narrative as they went along. Perhaps this is why many of the animations

Figure 4.1 While the exact format of storyboards may vary slightly, they all have common elements within them. The template illustrated here shows how all the necessary information is included, not just a drawing of the proposed animation. The individual storyboard pages carry the production title and the storyboard page number to avoid possible confusion with other production or episodes. The scene and shot number are identified and a frame count for each scene/shot may also be included, though the actual animation timings will be slugged out on the corresponding dope sheets. The separate panels visually show the content of each shot, though there is often more than one panel per shot depending on the nature of the action. Dialogue, action and sound are indicated below each panel so as to link them to the graphic element.

of the 1920s look so clumsy and unstructured by today's standards. It wasn't long before audiences became more sophisticated and the sheer novelty factor of animation was no longer sufficient to captivate them. The need for a stronger narrative content became paramount and increasingly creating gag sketches for the films became the norm. As more and more gag sketch drawings were added over time, it eventually became customary to plan and draw out the entire film in this way. The storyboard was born.

Script first

Without a script it is difficult to create a storyboard. You need some kind of idea to work around, even if this is in a very basic format. The original idea may well change as the storyboard is

being developed. It may even be changed beyond all recognition or be thrown out altogether to be replaced by better ideas, but as a starting point it is very necessary. The idea and the script should not be so rigidly designed that changes cannot be made throughout the production. This will reduce the animators to mere technicians and deny them the opportunity to contribute their own particular brand of creativity through performance. A good performance will often enhance an idea way beyond what was originally expected or planned for. You must allow for this sudden inspiration but not be dependent upon it. Remember what John Lasseter said – script, script, script. Film is perhaps one of the most plastic of art forms; the work is subject to development from its concept to practically the moment it is screened.

Generally, there are three types of storyboard: thumbnail or rough storyboards; presentation storyboards; and working storyboards. Each has distinctive qualities and serves very different and particular purposes.

Thumbnail or rough storyboards

A thumbnail or rough storyboard serves the purpose of capturing an idea quickly. At this stage the flow of creative energy is high and the rough storyboard is often created at breakneck speed. The *idea* is paramount when creating thumbnail storyboards. Good ideas often come in fleeting moments and so must be captured quickly. It is important not to fixate on style or drawing *unless* the drawing style is the idea. The emphasis should be on the script and developing a cinematic narrative through the choice of shots and the pacing of the action. When developing character animation, the characters are often unrecognizable and may even be represented by little more than stick men. It's at this point that a rough working storyboard comes into its own. If the drawings are kept simple and the work is done quickly, it allows the ideas to begin to flow, one gag or situation being easily replaced by better ideas or funnier gags. It's important not to get bogged down at this stage with concern for the quality of drawing, that comes later; if the drawings are simple and there is little artistic investment in them, they are easily expendable. When making thumbnail boards you are likely to throw as many panels away as you use, though as you have invested little effort in the actual drawing of the board this is no hardship. A rough storyboard may be all that is needed for your animation. If you are making the work alone and do not

Thumbnail or Rough Storyboard

Figure 4.2 The drawings for this thumbnail storyboard are extremely rough, which enabled me to draw up an idea very quickly. I prefer to work with a pen at this stage, as it means that I cannot be tempted to make alterations to my drawings, sketching out the idea very quickly on sheets of A4 or A3 paper. This forms the basis for a presentation board. These rough drafts are for my purposes only; a client would never see such storyboards nor would they be used by a production crew. They are simply the first step in the storyboarding process.

have a client to satisfy, then there may be little point developing it beyond this stage, though it will still be of immense value to work out the animation shot by shot, even if it is with stick men. At least that way you will be sure your idea works before you commence animation.

Presentation storyboards

Presentation storyboards are usually made with the sole intention of formally presenting an idea to a client or an interested third party. This is usually done in order to get approval for a production. They are used by the producer, director and others to secure financing and in order to agree on a production budget. They are used to get money flowing out of a client or investor's pocket and into the production and, once out, keeping the money flowing out. This is not such a mercenary aim as it may at first seem; the clients or backers need to be reassured that their investment, and in some cases very large investment, is being used in a manner of which they approve (and can understand). It is often the only way of showing the backers, who are often non-artistic

Presentation Storyboard

PRODUCTION:
The Presentation in the Temple

Page: 1 of 8

Figure 4.3 Notice how, in these drawings, there is far more detail. While this may not be an exact representation of the final look of the film, it is usually fairly close. Colour is used to more closely represent the final animation. The client was able to approve the design of the film and production was able to continue to the next stage. When working in 3D stop-frame animation, presentation boards may sometimes consist of stills of the actual models placed in appropriate sets, though the cost of making those models in the first place may be prohibitive if finance has still not been secured. In such cases it is clearly acceptable to substitute drawings for these.

people, what the end result will be like. Presentation storyboards often have far fewer panels than working storyboards, though the panels are usually far more detailed, giving a much closer representation of the final look of the film. They also carry much less technical information, as this is usually irrelevant at this stage.

Working storyboards

These are used to help the director, animators, scriptwriter, background artists, etc. in making the film. They need to explain in visual terms the content, pacing and flow of the film, with a good indication as to the type of action the director is looking for. While they must make the aims of the director abundantly clear to all those involved, it is not necessary for the character designs to be accurate or the standard of draughtsmanship to be of the same high level as the finished animation.

There is a real need to communicate the exact nature of the animated production so that everyone knows what they are doing and that all the separate elements fit within the director's original plans. A working board is the template for the film and as such must accurately reflect the director's vision. A working board is not simply a series of graphic panels, it also contains such information as scene and sequence number, details of action, dialogue, sound and music; it may even include details of the scene length through a frame count, details of camera moves and other technical issues, and even detailed notes on animation timing, particularly if the animation has continuity implications or is synched to a specific sound.

Above all, it should be remembered that the only purpose of the working storyboard is to assist the crew in making the film; it should not be created as something separate from the film with a value beyond its worth. Remember, all storyboards are only the tools used to enable the production crew to get the film developed, financed and made. Storyboards are *not* the main aim of the film-maker, nor are they the end result of your efforts; your audience rarely gets to see them, so they should only be developed to a level that enables them to be used for their appropriate purpose.

ANIMATICS

Once the storyboard has been finalized and all the bad and sloppy ideas consigned to the waste-paper basket, it's time to

Figure 4.4 Drawing is far less important than an in-depth understanding of film grammar, which is essential when making a working storyboard.

see if the storyboard actually works as a film. To do this, animators make an animatic.

The animatic is a kind of movie that runs in sequence and is paced out in the same way as the final film, but unlike the final film the animatic consists not of animation, but only of the stills drawn up for your storyboard. The procedure for making animatics is quite simple. Each shot of the film is timed out with a stopwatch scene by scene. You can do this either by acting out the actions yourself or with others, or simply imagining how long the separate actions contained in the shots will take. If you are using dialogue it sometimes helps to read the script out aloud. The storyboard is then shot either on film or video to those timings (25 frames each second); the resulting footage is known as an animatic. An even simpler way to do this is to scan the individual images of your storyboard into a computer and import them into a desktop editing programme such as Premiere. The separate images can then be assigned a specific number of frames. Using Premiere it is easy to make adjustments to your animatic without having to reshoot the storyboard. You can even add camera moves and effects such as pans, zooms, dissolves, fade to black, etc. Importing your soundtrack also allows you to accurately synch your shots to soundtrack and/or music. Using such techniques it is possible to get a good idea if the animation is going to cut together well and make sense as a filmic narrative. As such, it is difficult to overemphasize the importance of the animatic. A lot of time, effort and money can be saved at this stage. If there are any problems with the way the film cuts together, it can often be easily rectified before animation begins.

Making the animatic is usually a job undertaken (or at least supervised) by the director. Many of the terms in animation have changed over the years and they do not all share the same common currency. You may often hear the term 'story reel' used instead of animatic. When the term story reel is used, the term animatic often refers to a sequence of rough, first-pass animation. To complicate things even further, the animatic is sometimes referred to as the 'Leica reel', named after the camera (Leica) that they used to shoot these on. This has mostly passed into disuse, but you do hear it from time to time. However, call it what you will, the principle remains the same.

CHARACTER DESIGN

> I think you have to know these fellows definitely before you can draw them. When you start to caricature a person, you can't do it without knowing the person.
>
> Walt Disney

The graphic elements of character design are only part of the design process. The director and the animators need to know what makes them tick just as much as how tall they are, how many fingers the character has or what colour their shoes are. In many studios, character design is not undertaken by any one particular artist or animator, a variety of individuals may have a hand in the creation of new characters.

In larger studios such as Pixar, the role of the designer is considered to be very important and it is likely that this will be an entirely separate job within a design team, consisting of concept artists, illustrators, storyboard artists, layout artists and animators. However, whether part of a big team or working as an individual, the one thing for sure is that anyone responsible for the development of the characters will shape the entire project and greatly affect the outcome of the end product.

As with live action film, the cast members are vital to the success or otherwise of the venture; they must be believable in both physical and psychological terms, and must operate convincingly not only on an individual level, but within the broader context of the film. There are some very famous examples of groups of characters working together to create a believable and captivating cast. Bugs and Daffy, Tom and Jerry, Baloo and Mowgli, Yogi Bear and Boo Boo, Woody and Buzz Lightyear, etc. As individuals appearing within the context of their cast they are very successful, but once taken out of that context or operating within a different type of cast demonstrating unsympathetic characteristics or design traits the resulting chemistry may be one that will be rejected as implausible by the audience. The actual drawing style used for each of the characters should be consistent with one another, otherwise they will not sit comfortably together on screen.

Character development

To develop a character fully it is necessary not only to have a clear understanding of their behavioural patterns, but to get under the skin of that character and really get to know what makes them tick. The way in which Daffy Duck behaves as a cowardly, greedy, megalomaniac, strutting hedonistically

around the screen, is convincing because the character is well conceived and completely understood and believed in by the designers. So convincing are the characteristics of this and other characters that it is quite possible (for the animators it is essential) to be able to predict the behaviour of such a character in almost any situation. We *know* how they would respond; they become real. To make completely convincing designs, it is vital that the artist has a good understanding of anatomy. In order to exaggerate, diminish or omit chosen physical characteristics to make a really first-class cartoon design of an animal, it is first necessary to have a clear understanding of that animal in real life, to know its proportions and its structure, and the way in which it moves. This obviously doesn't apply if the character is abstracted beyond the realms of realism; after all, Jerry doesn't behave much like a real mouse and Daffy doesn't move much like a real duck.

The animation bible

It is vitally important that, once the character designs have been completed and approved by the director, the producer and others within the design team, the designs are adhered to by the entire production crew. To this end, a design document is created to assist in this. The document, known as the animation bible, consists of separate sets of designs, known as model sheets (which can sometimes be very extensive, particularly for feature productions). The animation bible usually includes different types of designs sheets that enable the animators and others to stay 'on model' throughout the production, and also includes basic model sheets, construction sheet, height relation chart, action sheets illustrating a series of dynamic poses, a lip-sync guide and colour model guides. It is possible that the animation bible will also include actual test animation so the animators can keep on model with regards to the actual movements. There is little point going to great lengths developing a character and painstakingly drawing up a series of model sheets if the animators don't use them. Using these aids, it is possible for even a very extensive animation production made by scores of individual animators and technicians to look as though the animation has been created by a single hand. The result of animators and others (even within a very small crew) working in ways other than deemed by the development crew would be discontinuity and disharmony. Without model sheets, the designs could vary from scene to scene, the way the drawings were made could look different and the animation timing

could look like it was made by different people. In 3D computer animation it may also be beneficial to include illustrations and a detailed explanation of the functionality of the animation rigs, the particular constraints and appropriate use for each of the separate characters. The important thing to remember here is that these documents are done in order to assist the animators and to make their life easier, enabling them to concentrate on the job in hand – performance.

Will it animate?

There is a world of difference between drawings that make good illustrations and those designs that are suitable for character animation. The final test of a good design is summed up in one question: *will it animate?* No matter how attractive the drawings seem to be, if the design doesn't work in animation terms then it is unsuccessful and will need further development. This is not just a 2D classical animation issue, it extends to 3D stop-frame as well. A well-drawn design will not necessarily translate into a model that is capable of performing all the necessary actions and movements needed from it.

Model sheets

When considering the structure and the anatomy of the animated character, simplification is the order of the day. It is

Figure 4.5 The basic model sheet shows a character from all sides. This gives the animator a clear idea of the character's form and any details of costume. These designs give a clear indication of the overall structure and proportions of an animated character seen in 360 degrees. They are designed specifically for use by animators in order for them to gain a clear understanding of the individual character's 'three-dimensional' form.

necessary to break down a design into a form where it becomes possible to handle the character efficiently as animation. That's where model sheets come in. Generally, the use of model sheets for animators is restricted to 2D classical animation, as they create every frame of the animation from scratch each time. While the need for model sheets in 3D stop-frame animation or computer animation may not be seen as such a great issue for the animators, as they are working with prefabricated models, they will certainly benefit from those model sheets and action sheets that illustrate the range and type of actions that a character is capable of. This can only enhance the performance that an animator gives.

Model sheets should contain all the relevant visual information the animators need. There should be no ambiguity at all within the drawing or the poses. Model sheets should illustrate the character in a simple pose giving, within separate drawings, details of front, rear and side views. This is just as important and useful as showing the character in a series of dynamic poses. The model sheet should enable the animator to gain a good understanding of what the character looks like through 360 degrees. Model sheets should always be clear, with any additional information added as notation. They should also provide all the detailing of costume and in some circumstances it may be necessary to create more than one such model sheet for a character if, for instance, the character changes costume within the film.

Height relationship chart

If two or more characters are to be used in any sequence, a height relationship chart will be useful to ensure that issues of relative scale are addressed. There is nothing more disconcerting than seeing characters growing and shrinking throughout a film, and you need to avoid problems of this sort; believability will just jump out of the window.

Colour models

The use of colour is an important aspect of character design. It must be in keeping with the general design concept and fit comfortably with the rest of the design elements of the production. A multitude of psychedelic colours outlined by a heavy black line may not be what is required if the backgrounds are to be painted in delicate Chinese watercolour techniques. Colour must also be used with care

Height Relation Chart

Figure 4.6 The height relation chart places all the characters together in order that they are drawn to the right scale throughout the production.

when targeting a specific audience. Designs using bright primary colours may be appropriate for a pre-school TV series but unsuitable for a darker piece aimed at an adult audience.

The practical use of colour and the constraints upon production and distribution must also play a part in the design. Because the colouring of 2D classical animation can be a very major part of the production budget, the level of detailing and the number of colours used for a particular character must also be considered. The more colours you have and the more detailed a character is, the more costly the enterprise.

Colour model sheets are generally used by the department dealing with paint and trace to ensure that all the individuals that colour and shade the characters do so in line with the director's instructions. Again, this can involve creating many different versions of colour models to accommodate different costumes and different environments. A character dressed in the same clothing would look very different when seen in a brightly lit room than they would in an exterior moonlit scene or in the glow of a camp-fire. Digital paint and trace systems such as Animo, developed in 1992 by Cambridge Animation Systems, have replaced much of the work that was traditionally done on cels. Computer programs such as Animo are used not only to paint the artwork, but allow all manner of special effects to be achieved for a fraction of the cost and within a

Design 147

Colour Models

The individual colours of each character are identified by their colour values to ensure continuity throughout a production.

Figure 4.7 Colour models are usually used only by the trace and paint department in a 2D classical animation production. They are also useful when designing sets and backgrounds, so that incompatible colour schemes are avoided.

much tighter schedule than the traditional methods. They have done away with the need for messy paints and cels that were prone to scratching if mishandled, and required vast amounts of space to paint and leave to dry. This type of software also incorporates a system whereby all the camera work hitherto undertaken on a rostrum camera is built in to the programme, enabling a full range of camera moves and effects to be achieved. The work is then rendered and output directly to a range of formats, including formats for the Internet, doing away with the need to shoot the footage as a separate activity. While the high-end professional software may remain outside the reach of many of us, there is now a range of affordable animation-specific software available for amateur animators.

Figure 4.8 The construction sheet is used by animators making 2D classical animation and illustrates, in a step-by-step manner, how a character is drawn from simple primitive shapes through to its final complex form.

Construction sheets

A construction sheet is also a very helpful addition to the 2D classical animation bible. These model sheets demonstrate how the character is made up in the form of simplistic shapes, circles, ovals, etc. If a character is animated using good construction techniques, the animation drawings will keep their true proportions and have less likelihood of looking flat or going 'off model' and out of character. Construction sheets are created in order to take the animators and assistant animators through the actual sequential drawing of the characters in a step-by-step manner. Building the character up through a series of stages from simple primitive shapes through to fully detailed drawings of costume items ensures an efficient and economic use of the animator's time. Using construction sheets means the animator will spend far less time struggling with the individual drawings.

Action sheets

These are designed to give an understanding of the range of actions a specific character is likely to undertake, not only the typical poses which they make, but also the extremities of actions. Any peculiarities that a character may possess or actions that typify a particular character are sometimes included in these sheets. Such design sheets can be of immense value to all animators whichever discipline they are working within, as they provide a deeper insight into the character, not simply in how they move, but also their personality. Action sheets are often an ongoing design development. The series of design sheets may be added to from actual animation key drawings as the production develops. Updated action sheets will then be distributed to the

Character Action Sheet

Figure 4.9 Action sheets cover a wide range of poses, and aim to illustrate a character in action and displaying a variety of moods.

appropriate members of the production crew. There is little need for this on a short one-off film, as the animation crew is usually very small and the production schedule relatively short. For a TV series, however, it may be very useful to adopt this type of organic development of the action sheets, particularly if the designs of the characters themselves develop over time. There are good examples of how characters have developed; consider how the characters in *The Simpsons* have changed since the first series. Model sheets are working documents, they are not an end in themselves, and must be updated to reflect developments in the project. Using old model sheets would simply create problems in current productions.

Concept Art for 3D Stop-Frame Model

Images courtesy of Mary Murphy

Figure 4.10 Design for 3D stop-frame and computer animation must meet many of the same requirements as 2D classical animation. In these concept drawings, the detailing needed for the model can clearly be seen.

Lip-sync guides

Lip-sync guides can be a very useful addition to the animator's bible, particularly if the characters have peculiarities of design, unusual mouth structures or if the shapes made during speech are, for one reason or another, outside the norm. Lip-sync guides will also help if the production is being animated in different countries, where a number of languages are used by individuals within the production team. This proved to be invaluable during a production I was involved in where the pre-production was undertaken in Europe and the animation (including lip-sync) was being done in China. The separate mouth shapes were given numbers and the animators simply drew in the

Figure 4.11 The model sheet illustrated here, used as an armature plan, has much in common with a model sheet for 2D classical animation. In it, the character is placed in a very simple pose, allowing for ease of modelling. They are not used to explore the animation possibilities and capabilities of the model; these should have been established earlier in the development process. This is a simple blueprint for the actual construction of the puppet.

Figure 4.12 The final model.

appropriate mouth shape onto the characters at specific points throughout the film, determined by the director's notation that appeared on the dope sheets.

DESIGN CRITERIA

The criteria for designing for different types of animation may vary greatly and while each may have its distinctive elements, there are aspects that they have in common and must be taken into consideration.

- Your designs should demonstrate suitability for the concept. If you are making a horror movie it may not be appropriate to use pale, washed-out pastel colours for your backgrounds. The design for Tim Burton's *Nightmare Before Christmas* utilized classic horror stylization and lighting to great effect. In contrast, the TV series *Noddy* held true to the original Enid Blyton concept, simplicity and clarity of design with clean bright colours.

- Design should have empathy with the narrative of the film; this is evident even in abstract pieces. The abstract work of Clive Walley in his brilliant animated film *Dark Matter* as part of *Divertimenti* does not simply echo the sound narrative, it presents an interwoven whole. This film illustrates clearly Walley's approach to creative collaborations and design symbiosis.

- Design should always be determined by the suitability for the process – 2D classical animation, 3D stop-frame, computer animation, cut-out animation, etc. Each of these disciplines has its limitations, which need to be understood if you are designing for the medium. There is little point in designing a character for 2D animation by making its costume so complex that the drawing of it will exceed the budget.

- Design for computer animation should take into account the complexity of the character, as this will affect the time required for rendering, which will have an impact on budget. It is also true that design for computer games is often centred on polygon economy, as complex and high-polygon models will be handled more slowly by a games engine than a low-polygon model, which may in turn affect game play.

- The nature of the armature and complexity of model and materials should be considered when designing for stop-frame animation. The way certain materials behave will

have a profound effect on the design decisions, as will the physical size of models. These may have a knock-on effect and determine the size (and cost) of the set.

- The design must meet the practical requirements of production and be suitable for the specific needs of animated motion. If a character in a 3D stop-frame animation is expected to go through a series of complex and extreme actions, the design of the model and the engineering of its armature must enable the animator to complete these actions. The same is true for CG models. If they are constructed inappropriately the result may be that the model will 'cut through' itself in certain places.

- Design must take into account all processes and other people working within the production pipeline. What looks good on a drawing board does not necessarily mean that everyone will be happy with the design. A set of cityscape designs with high shots featuring the skyscrapers of New York may look spectacular in a presentation board and go down well in a presentation meeting, but be totally impractical in terms of set building. Pragmatic considerations should be given to the entire process, including the budget.

- Finally, when designing for any animation project you must ensure that others can understand and 'read' the designs in the manner intended and appropriate for the needs of the project. Design is not just about making beautiful or funny drawings, it's more fundamental than that. It is sometimes easy to forget that design is a form of communication and that communicating the *idea* is the most important factor, not just in animation but in all design.

The morgue

Those wishing to develop their skills and perhaps a career in one of the many design disciplines should begin collecting visual reference material of all kinds. A well-organized and extensive collection will be invaluable for those working in illustration, character design, storyboarding and layout or as a background artist. The famous animator Shamus Culhane termed such a collection of varied reference material a morgue. A collection can not only contain photographic reference of all kinds, but drawn images and graphic design as well. The subjects covered should be as wide as possible: humans, animals, machines, vehicles, architecture,

places, plants, etc. The trick to having a good morgue, as with so much in animation, is organization. If you catalogue it properly into various sections you should be able to find the relevant photograph or drawing quickly. You will obviously collect and file the kind of material according to your personal interests and its relevance to you and your practice. A comprehensive morgue will take years to put together, but rather than a task it should be seen as an enjoyable way of continuing your art education. It will also provide the much needed reference for the job in hand. The Internet is a valuable source of such material and search engines can usually direct you to the resources you need.

QUESTIONS TO ASK YOURSELF ABOUT DESIGN

Q. Do your designs communicate and support the central idea?
Q. Do your designs relate the narrative?
Q. Are the designs stylistically appropriate to the production?
Q. Are your designs practical? Will they perform in the way they should and do they work within the limitations of the medium?
Q. Are your characters' designs believable? Do they reflect the physical and psychological aspects of the character?
Q. Do the characters fit in with the rest of the design elements of the production?
Q. Will your characters animate?
Q. Can others use the design bible for practical production purposes?
Q. Are they suitable for your target audience?
Q. Are the designs efficient and do they fit within the production budget?

Chapter 5
Animals in Motion

Flying Bird Basic Cycle

1 — Wings in up position
2
3 — Downbeat
4 — Drag on upper surface of wings
5
6
7 — Drag on underside of wings
8 — Wings fold inwards slightly
9 — Wings in down position
10
11 — Upbeat
12

The animal kingdom is hugely complex, offering almost infinite possibilities and challenges for the animator. Nature fills in all the blanks, from the largest whale to the smallest bug; if there's a gap in the ecological market, nature meets it.

BEFORE WE BEGIN

It's through direct and detailed action analysis, either in the flesh or on video, that you will gain a more in-depth knowledge of the motion of animals. You don't need to concentrate on the wild or the exotic to develop these analytical skills. The average domestic cat or dog will provide enough fascinating material for serious study. The difficulties of animating animals with four legs are considerable, but like the walk cycle we covered earlier, the process can be broken down into its basic components, resulting in a fairly straightforward problem. All the principles that we have looked at so far still apply, and once you have practised a little with the earlier exercises you should find these much less daunting. Having said that, the realistic animation of animals is a difficult matter and requires much practice and patience, so don't get too despondent if your first efforts fall short of your goals; you will get there, but it will take time.

This chapter can only cover very limited examples of animals in motion. A whole volume dedicated to this one subject alone couldn't possibly cover all the variables of the animal kingdom. The actions of mammals, amphibians, insects and birds would take a lifetime to study in detail, and as we don't have time to do that right now, I have purposely limited this chapter to cover a single four-legged animal – a horse – and the action of a bird about the size and shape of a pigeon. With these examples I aim to cover some of the basic principles as applied to animal locomotion.

In addition to studying the movement of animals from life, you may wish to study the work of Eadweard Muybridge and Jules Marey. While Muybridge began his work during the latter part of the nineteenth century, his work became and remains a standard text for those (animators included) interested in studying animals and people in motion. His volumes of photographs are still available today and will invariably help your understanding of animals in motion; I recommend them to all my students. However, I would urge that you use the Muybridge photographs as a guide only. This kind of material, no matter how good, is no substitute for direct personal observation and analysis. Marey's work is

perhaps a little less well known. A contemporary of Muybridge, he not only recorded animal motion through photography, he developed a number of interesting devices to graphically record locomotion and movement. We have already seen how motion capture and rotoscoping have been used to good effect in *Lord of the Rings*, and it is now common for motion capture to be used as a way of providing reference, and in some cases a substitute, for more traditional hands-on approaches to making animation. This approach is most notable in the computer games industry.

FOUR LEGS

While we are already limited to the various actions of a horse, I have decided to concentrate on the actions of the 'average' horse (if such a thing exists), as even horses vary a great deal. A little Shetland pony will move in a very different way to a thoroughbred racehorse or the slow powerful action of a shire horse or the exaggerated actions of a horse trained in dressage. In the examples covered we will look at the walk, the trot and the run, though there are many other separate actions we could look at in detail. These actions have been chosen to give you a general feel for the type of animation we can expect from such an animal. The exercises should be challenging enough to extend your practice and develop your skills. The principles of the specific movements we will cover will be much the same for most four-legged animals, though there are some very obvious exceptions. The manner in which a camel walks is the same in principle to the action of a horse; however, it runs in a very different manner to a horse. Unlike the horse, the camel when running (an action that in camels is known as pacing) alternatively throws its front right and rear right legs forward, and then the front left and rear left legs forward together. The sequence of movement of the horse's legs during a run involves a diagonal action, which we will cover in some detail.

Before we get too involved in making animation, we should take a little time to familiarize ourselves with the physiognomy of the horse.

The structure and proportion

The structure is broken down in such a way as to create a much simplified form for ease of construction and for our animation purposes. I have omitted muscle structure or any other internal structures, though I have included the main

Animals in motion 159

Horse Basic Structure

Construct the horse from basic shapes to give volume, to show the pivot points at the joints and to maintain proportions

Skeletal structure Simplified structure

Keep the structure simple when beginning to animate

Figure 5.1 The main aspects of the structure; the head shape, body, fore and hind legs have been illustrated in a fairly simplistic manner. The skeletal structure, while much simplified, may still be too detailed for the purpose of the exercise. The overall proportions of this horse are a little over 2.5 head lengths high (from ground to shoulder) and around 2.5 head lengths long (from breast to rear end). You will notice that the length of the neck and head are not taken into account in this measurement. This makes the overall structure of the horse almost square. The distance between the ground and the underside of the horse is approximately half the distance between the ground and the horse's shoulder. While this is not an accurate measurement, it does offer a good working guide.

bones, joints, and skull and chest cavity, albeit in a *very* simplified manner, not intended to represent even the general shape of the separate structures. Additional details are added to the outline of the horse, such as the tail and ears, simply to indicate form.

The proportions of four-legged animals will vary greatly, depending not only upon species, but also on the breed, gender and age of the animal. Using the length of the head as a measurement guide, you can begin to define the various distances between the different aspects of the horse's structure.

If you are drawing the animation you should make construction drawings of your animation. These drawings clearly show the structure of the figure in terms of primitive shapes; they help to keep the proportions consistent throughout the animation and they also help to concentrate

Basic Horse Construction

Figure 5.2 In this drawing I have identified the main joints of the horse and body bulk in terms of primitive shapes: circles, ellipses and cylinders. While the proportions are reasonably accurate, this drawing is obviously not intended to be anatomically correct. When animating a figure it helps if you strip it down to the basic elements. Once you have got this working, you can then go back and add more detail. On top of this basic structure I have drawn a little more detail to add form, though this is also limited. Notice that I have used different colours to illustrate various aspects of the horse. This is so when I make a line test of my animation it is easier to keep track of the separate legs and to make more accurate analysis of the movement. The animation is less likely to become a jumble of indistinguishable lines. You will find that once 2D animation is blocked in with colour, a figure appears to be more solid and the animation is 'read' more clearly.

the mind on animating the structure of a figure and *not* on drawing issues that can result in distractions by creating unnecessary surface details.

If you are animating using one of the many 3D CG packages, I suggest for these exercises that you keep the modelling simple. Use primitive shapes for the structure wherever possible; this will not only keep the polygon count lower on your model, enabling faster rendering times, but it will concentrate your efforts on animation, not on unnecessary modelling details.

Making models for stop-frame animation often includes the use of rather elaborate materials and textures, though for the purpose of developing animation skills only it really doesn't have to be such a complex matter. Rather like the other two disciplines, you may wish to build a model that has little or no detail and consists of quite a primitive armature. The one thing you will have to look out for is fixing your model securely to the surface of the animation table, either with pins or magnets, in order to maintain the balance of your model.

Animals in motion 161

Basic CG Horse Construction

Animating using simple shapes enables the animator to concentrate on the movement without the distraction of added detail.
It also allows the software to work more efficiently as it does not need to process unnecessary textures or lighting at this stage.

Images courtesy of Gareth Cavanagh and Good Egg Productions

Figure 5.3 Notice how the general structure and the proportions of this CG horse are well defined and yet there is little detail to distract. Some animators prefer to make the separate limbs different colours in order to assist in modelling and to make the identification and selection of the limbs easier during animation.

Basic 3D Model Horse Construction

Even using such a simple model as the one illustrated, constructed from balsa wood and using twisted wire joints, should enable the animator to get to grips with the basics of animation and achieve fairly naturalistic movements.

Image courtesy of Mary Murphy

Figure 5.4 While professional armatures are engineered to a high specification, you can make a fairly simple model out of twisted wire and wood for very little cost. Also notice that there is no material covering the basic structure; once again this is to ensure that you concentrate your efforts on the primary and secondary aspects of animation and don't get involved with the details of tertiary movement.

The walk

The walk pattern of a quadruped usually begins by a movement of the hind legs thrusting the animal forward, resulting in a forward movement of a front leg to support the animal and maintain balance as it moves forward. The principle of the controlled fall remains the same as in the bipedal action; the weight of the animal is thrown forward and a leg is swung forward and outstretched to a position

Horse Walk Cycle

1 Back Right swings forward Front Right lifts

2 Back Right down Front Right swings forward

3 Front Right down Back Left lifts

4 Back Left swings forward Front Left lifts

5 Back Left about to go down Front Left swings forward

6 Back Left down Front Left about to go down Back Right about to lift

Figure 5.5 The sequence of the strides is such that there is an easily identifiable diagonal and forward and rear movement. While the start of the sequence may vary depending upon the animal's position, we can track the sequence by identifying in which order the separate feet make contact with the ground. For our purposes we will look at the order of footfalls and the order in which feet are lifted from the ground. We will start with the front left foot making contact with the ground. *Stage 1*. The front left foot makes contact and the front right foot is raised from the ground. *Stage 2*. The back right foot makes contact and the front right foot swings forward. *Stage 3*. The front right foot makes contact with the ground and the back left foot is raised from the ground. *Stage 4*. The front left foot is raised from the ground. *Stage 5*. The back left foot swings forward and is about to make contact with the ground, the front left foot swings forward. *Stage 6*. The back left foot makes contact with the ground, the left front foot is about to make contact and the back right foot is about to lift from ground. Written down here it looks quite complex, though the drawings will give you a much clearer idea of the sequence. One way to see this is to imagine that a rear leg swinging forward through the passing position 'kicks' the front leg of the same side of the animal out of the way, making contact with the ground *after* the front leg has risen. In this instance (though not in all cases), this results in a moment when both front and rear right (or left) legs are off the ground together at the same time. The slower the walk is, the less likely this is to occur, and there will be times when the rear right leg (or left) makes contact before the front right (or left) leg rises from the ground.

forward of the centre of balance in order to support the figure. Just as in the bipedal animation that we covered earlier, each of the individual legs demonstrates two distinct phases: the stride and the passing position. There then follows a sequence of alternating diagonal movements as it walks forward, sometimes supporting the horse on two feet, at others on three. Just as in the bipedal walk the action is mirrored, the right and left sides demonstrating the same type of action. The sequence of footfalls in a walk is such that the feet land separately one after the other; none of the feet land simultaneously, so if we listened to a quadruped walk we would discern all four feet as separate beats.

There is a degree of lateral movement in both the hips and the shoulders throughout the walk, demonstrating a slight movement in the direction of the supporting leg. As the opposite legs (i.e. front right, rear left) support the animal, a noticeable twist in the body occurs. This movement can be very noticeable in such animals as large cats, particularly when they are stalking prey and they adopt a more squat position, and the movement at the shoulders appears more pronounced. As with a bipedal walk, you will also notice that the hips are lifted slightly during the passing position and are lower through the stride.

ANIMATION EXERCISE 5.1 – BASIC WALK CYCLE

In order to further develop animation skills built up over the first few chapters, you could try the following short animated exercises of a four-legged animal going through a series of basic actions. While the exact nature of the action is left to your discretion, they should be based around the creation of a walk cycle, a run cycle and a more elaborate sequence involving a walk. You should attempt to assimilate your first-hand research of four-legged animals and, through the creation of a series of animated sequences, replicate a realistic action.

Aims

The aim of this short exercise is to extend your understanding of animals in motion through research and analysis, and through animation, to develop an understanding of the basic principles as they apply to a four-legged walk cycle.

Objective

On completion of the exercise you should be able to create a short animated sequence of a basic four-legged walk that works within a repeatable animated cycle.

For this first exercise you should limit the character to moving in profile either from left to right or right to left. Don't concern yourself with the difficulties of perspective animation at

this stage. Concentrate your efforts on the animation, not on design. Keep the drawings simple with a minimum of detail, rough but clear rather than cleaned up to a high level of finish. Concentrate your efforts on getting the legs and body right first; the secondary action of the head and neck can be added afterwards. Initially you should ignore the horse's mane and tail; these can be added later once the primary and secondary animation is complete and you are happy with the results.

1. You should begin by analysing the manner in which an animal with four legs walks. Take a look at a dog or cat then go back and have a look at the examples illustrated here.

2. You should make the animation using the key-frame or pose-to-pose method; that way you can break it down into basic positions before adding your inbetweens. You may find it easier to animate the front and back legs separately and then bring them together in a single drawing once you have figured out the movement for each pair.

3. You may find it easier to start with the front pair of legs, as the knee joints move in a similar manner to a biped and your experience in making a human walk will come in handy here. Make your first key drawing of the first stride position.

4. Make a similar drawing with the opposite legs thrown forward or backwards as appropriate, so that if in drawing 1 the front right leg is in a backwards position in this drawing it will be the front left leg that is in this position.

5. Use these two stride keys to make the first passing position drawing.

6. Now you have the first passing position drawing you can now make a similar drawing as with the stride. If in your first passing position the left leg was the supporting leg, simply make that the right leg in this drawing. You should now have two stride drawings and two passing position drawings.

7. Work out the animation timings as discussed in earlier chapters; remember to include slow outs and ins to create variable timings.

8. Go through the same process with the back legs, making keys of the stride and passing position, taking care to ensure that the structure of the leg is correct.

9. The timing of both pairs of legs *must* be the same and include the same number of drawings, otherwise the two sets of legs will be out of sync.

10. Redraw the key drawings for the two sets of legs together onto separate pieces of paper, making sure you get the sequence right. You will find that if you draw the separate legs in a different colour you will more easily be able to differentiate them, making animation simpler. You can make a good rule-of-thumb judgement on the sequence of movements of front and back legs by remembering that when one set of legs describes a stride, the other will be describing a passing position.

11. Remember that the animation should work as a cycle.

12. Line test your work, making careful critical analysis before you go on to make any alterations.

13. If the keys work, you can now complete the animation by making the inbetweens according to your animation timing breakdowns.

14. If the animation doesn't work, don't go over it immediately as you can learn just as much from your mistakes as you can from getting things right first time. It's not good enough just to get your animation 'right', you must understand *why* it is right so you can repeat the process time and again. This comes from thorough analysis of your work.

The trot

During the trot we can see that at some points the number of feet on the ground is now two or none. The big difference between a walk and trot or a run is that within the walk there is

Horse Trot Cycle

1 Right Rear and Left Front up

2 Suspended phase

3 Right Rear and Left Front contact

4 Passing position

5 Left Rear and Right Front up

6 Suspended phase

Figure 5.6 For the purpose of illustration we will look at the order in which feet make contact with the ground, the passing position and the suspended phase. We will start with the front left and right rear feet making contact with the ground. *Stage 1*. The front right and back left feet make contact while the front left and back right feet swing forward. *Stage 2*. The suspended phase is where all four feet are off the ground. *Stage 3*. The front left and back right feet make contact while the front right and back left feet swing forward. *Stage 4*. Passing position – the front right and back left feet swing forward passing the supporting legs. *Stage 5*. The front right and back left feet are extended forward and are about the make contact. *Stage 6*. Suspended phase.

always at least one foot on the ground; within the trot or the run there is a suspended phase where all the feet are off the ground. The sequence of footfalls in a trot is such that two of the feet make contact with the ground simultaneously in a series of synchronized events. The result of a quadruped trot is that we would hear the feet making contact as three distinct beats, not four as with the walk. The sequence of movements is structured around the synchronized movement of diagonal sets of front and rear legs. Simply put, the front right leg works in coordination with the rear left leg, while the front left leg works together with the rear left leg. Two of the four would make contact together, swing forward through the passing position

Horse Run Cycle

1
Front Left swings forward

2
Right Rear up Left Front about to go down

3
Left Front contact all others up

4
Suspended phase

5
Right Rear contact all others swing forward

6
Front Left swings forward Front Right contact

Figure 5.7 For the purpose of illustration we will look at the order in which feet make contact with the ground, the passing position and the suspended phase. Notice that both back and front legs have a leading leg – that is, the one that makes contact with the ground shortly before its front or back partner. You may also notice that the leading legs are both on the same side of the animal; in this instance it is the right side. We will start our cycle with the front left and back right feet making contact with the ground. *Stage 1.* There are three feet on the ground; both back feet are well planted on the ground and the front right foot has just made contact. *Stage 2.* The back right foot is lifted from the ground and the front right swings forward. *Stage 3.* The front right foot makes contact (in this example this is the leading front leg), the back left and front right legs are lifted from the ground together. *Stage 4.* Suspended phase. The front right foot is lifted from the ground and both rear feet move through the passing position. *Stage 5.* The back right foot makes contact. *Stage 6.* The back left foot makes contact shortly after the back right foot (the back right foot is the leading back leg in this example), followed shortly afterwards by the front right leg (the leading front leg).

together and together propel the animal forward, resulting in both legs leaving the ground simultaneously. The second 'pair' would land one slightly after the other. As a point of interest, it was to verify the theory of the suspended phase of a running horse during which all four feet leave the ground simultaneously that formed the subject of Muybridge's first experiments with sequential photography. Using the horse Occident, belonging to Leland Stanford, a wealthy American businessman and former governor of California, Muybridge conducted some of his earliest experiments in sequential photography and was able to confirm earlier beliefs that a horse did indeed have all four feet off the ground during a run.

The run

Rather like the trot, the run involves a suspended phase within the cycle where all four legs are off the ground at once. However, unlike the trot, the legs do not operate as simple synchronized diagonal pairs, the pattern of movement changes from a pair of legs working in synchronization to a sequence that involves the rear legs working together (though not simultaneously) as a pair of thrusting limbs with the front legs working together, with one or the other being the leading leg. The sequence of footfalls during a run would result in us hearing four distinct sounds, though not evenly spaced.

ANIMATION EXERCISE 5.2 – BASIC RUN CYCLE

Using the same approach to the animation as in the walk cycle, you could now try to animate a horse running. Keep the drawings simple with no detail and limit the animation to a profile view; this will make things a lot easier. Make the keys first, work out your animation timings and shoot a line test. Once you are satisfied with that, you can go on to complete the inbetweens. Remember to make this into a cycle so that you can loop the animation on playback.

ANIMATION EXERCISE 5.3 – ADVANCED ACTION

For a more advanced exercise you could try to animate a series of actions that link together to form a whole sequence.

1. Begin by drawing a standing horse and animating it from a standing start into your previously completed walk cycle.
2. From the walk cycle you could try to animate the horse walking in a complete 360-degree turn.

3. Link the turn animation to the cycle animation.
4. Animate the horse coming to a halt.

This is not an easy exercise and you will need to take a great deal of care linking the separate elements together in order to make it believable. Once again you should keep your drawing simple, constructing the figure from basic shapes and omitting any unnecessary detail such as facial details, mane or tail. These can always be added later.

QUESTIONS TO ASK YOURSELF ABOUT A FOUR-LEGGED ANIMAL IN MOTION

Q. Have you established a form created from primitive shapes that will allow you to achieve your animation simply without undue detail?
Q. Do you have a clear idea of what you are trying to achieve?
Q. Do the separate pairs of legs have the same timing? Will they be synchronized?
Q. Is the apparent weight of the animal reflected in the nature of its overlapping action?
Q. Have you taken into account the secondary animation in the head and neck movements?
Q. Is the sequence of leg movements correct? Does the animal look balanced throughout the sequence?
Q. Does the overall animation have varying dynamic properties running through it?

BIRDS IN FLIGHT

There are hundreds of different types of birds in the world, many of them with very distinctive actions that are determined by their size and physiognomy, the environment they live in and their habits. Hawks and eagles soar, swifts and swallows swoop, geese slowly and methodically beat their wings, and hummingbirds hover. (Interestingly there is a limit on the size hummingbirds can be – about the size of a blackbird, determined by the nature of the wing action. Any larger and the bird would not be able to beat its wings in the peculiar and distinctive figure-of-eight pattern sufficiently fast to keep it airborne.) Whatever the determining factors were for the development of flight in individual species of birds, the result is that they vary greatly, though generally the larger and heavier the bird, the slower the wing action. A wren flutters its wings so fast they appear as no more than a blur. A blackbird, being larger, has a much slower action, while a swan beats its wings in a very slow and measured way.

Flight cycles

At first glance the wing beats of a bird appear to be a simple upward and downward motion, but as you would imagine there is much more to it than that. Flight is determined by a wide variety of circumstances other than the type of bird. Different stages of flight will produce different types of actions: take-off, powered flight, acceleration, cruising, gliding, hovering and landing. The nature of flight is also determined by a number of other factors – for instance, if the bird is hunting, or being hunted, if it's migrating, if it is displaying, either as a courtship ritual or as a defence mechanism. In very general terms the wing cycle can be seen to describe a kind of rowing or swimming action. The wing not only moves upwards and downwards, it also moves forwards on the down-stroke and backwards slightly on the up-stroke, with the wing folding slightly into the body. The downwards movement of the wing is typified by the wing being stretched to its full length to maximize thrust; this is what propels the bird forwards. The upward movement of the wing offers a lower profile and is designed to create minimum resistance and drag, therefore utilizing the maximum energy of the downward thrust to gain more efficient forward momentum. These are simplistic and *very* general statements and this type of subtle motion is sometimes imperceptible, while at others it is clearly evident. There are some very obvious exceptions to the above description, such as birds that use air currents to soar.

The albatross, for instance, manages to accomplish forward motion with the minimum of wing movement by using the lift gained from the very small uplift from the surface of the ocean waves. Using this technique it is able to traverse enormous distances practically without a wing flap. The hummingbird also has a method of flight through a backwards and forwards movement of the wings, twisting them in such a way that they gain lift from both the forward *and* the backward actions.

As we have already established, the timing of a wing beat is determined by many variables, though the following timing will give some idea of the general dynamics that can be applied. The cycle of a beating wing has much in common with the flag cycle that was covered in an earlier chapter.

Flying Bird Basic Cycle

1. Wings in up position
2.
3. Downbeat
4. Drag on upper surface of wings
5. Wings in down position
6.
7. Drag on underside of wings
8. Wings fold inwards slightly
9.
10.
11. Upbeat
12.

Figure 5.8 The flight cycle illustrated here is a simplistic model of powered flight.

Figure 5.9 Notice how the movement of the end of the wing tips drags behind the main part of the wing. Once a change of direction occurs in the wing the wing tip will continue, for a short while, to move in the original direction.

Wing Action in Flight Cycle

Drag on upper surface of wings — Downbeat

Drag on lower surface of wings — Upbeat

While these illustrations and statements can only be used as guides, the exact nature of a bird in flight will be determined by the individual requirements of the animation; they are useful as a starting point and illustrate the general principles of a bird in flight.

ANIMATION EXERCISE 5.4 – BASIC FLIGHT CYCLE

Aims

The aim of this short exercise is to increase your understanding of animal locomotion and to develop an understanding of the basic principles and animation timing as they apply to a flight cycle.

Objective

On completion of the exercise you should be able to create a short animated cycle of a bird in flight that demonstrates variable dynamics and includes the basic principles of animation.

Ignore any unnecessary details on the bird, keep the drawing simple and construct the bird from simple shapes.

1. Begin by studying the examples given here, then take a look at birds in flight for yourself.

2. Use key-frame or pose-to-pose animation techniques; this will make it easier to build your basic animation before going on to create the animation timing and adding inbetweens.

3. Start by making the two most extreme positions, the upbeat extreme and the downbeat extreme.

4. Using these, you should then make the two main animation breakdowns: the one that fits between the up-stroke and the down-stroke (model 1) and the one that fits between the down-stroke and the up-stroke (model 2). Note that these drawings, while generally in the same position, will demonstrate very different properties. The drag affecting the tips of the wings in model 1 will create an upturn in the primary feathers. In model 2, the drag will cause a downturn in the primary feathers.

5. Once you have these drawings, you should create your animation timing breakdowns before creating your inbetweens. Remember to create variable dynamics within the cycle; take time to consider where the action will be faster and where it will be slower. Also remember that the animation should work as a cycle.

6. Rather than testing the animation keys before inbetweening as suggested with the four-legged walk cycle, wait until you have completed all your drawings. As you should have some experience now of creating animation with variable timings, this should give you more confidence in your ability to undertake animation without constant checking. Eventually you will find yourself making key pose tests to check only the more difficult sequences before completing your inbetweens.

7. After shooting your animation, make thorough analysis of your work before making any corrections and reshooting.

Timing a Flight Cycle

Figure 5.10 Notice that at the top and bottom of the wing beats the movement is noticeably slower. There is considerable drag on the wing tips, resulting in a degree of overlapping action; when the wing is being powered downwards at the shoulder the wing tips may still be moving upwards. The tips of the primary feathers only begin to move down once the force from the shoulder has transferred through to the wing tips.

Take-off

During take-off the action of the bird will often be far more vigorous than at other stages of flight, as the bird needs to gain momentum. Various birds need to adopt different strategies in order to take to the air. Ground-feeding birds such as sparrows and pigeons jump into the air to gain momentum, while swans need to take off from water by running along until enough speed is gained in order to achieve lift-off. Air-feeding birds such as swallows don't land on the ground, so they simply drop from their perch (often a telegraph wire) in order to gain the necessary lift from the air moving across their wings. Birds that roost and make their nests on cliffs simply launch themselves from their rocky perches into the air to pick up the air currents. As we have seen earlier, the effort needed to overcome inertia and gain movement is greater than the energy required to keep the momentum going.

Animals in motion 173

Bird Construction

Figure 5.11 Different birds can be very different in structure. Keep the design of your bird simple with no unnecessary detail; by including the construction shapes, you will be more easily able to animate it.

Figure 5.12 The bird in this illustration is taking off from the ground and needs to exert a great deal of effort to take to the air. Its first action is to quickly crouch down as an anticipation movement of the jump. As it does this, it spreads its wings outwards in readiness for the downwards thrust of the wing. As it leaps into the air its legs are fully extended and it completes the first of the downward sweeps of the wings. On the down thrust, the wings are spread to their widest to achieve the maximum thrust. The bird quickly raises its wings to the vertical position, folding them in to reduce air resistance and drag in readiness for the second downwards sweep; as it does this it brings its legs back towards the body. Notice how extreme the wing movements are during this phase; the wing tips practically touch one another at the upper and lower extremities of the wing beat.

Figure 5.13 In this illustration the bird is landing on the ground, which means that it can neither use gravity nor the particular qualities of its environment to assist it. As a first stage in landing, the bird angles its tail downwards and spreads out its tail feathers to increase drag, rather like the flaps on the wing of an aircraft. At the same time, it spreads its wings out fully and angles them in such a manner as to increase drag. The bird then changes its angle of approach from the horizontal position to a more vertical attitude, yet again increasing surface drag, keeping the wings outstretched. It also extends its legs in preparation for the landing and to increase drag. As a final measure, the bird increases the angle of approach to a more upright position and begins to beat its wings in a forward motion to create a kind of reverse thrust. Once again it folds its wings on the backbeat to reduce any amount of forward thrust this action would otherwise incur. The bird finally stretches out its legs in front of it, makes contact with the ground and uses the cushioning effect of its legs to bring it to a halt.

Landing

On landing a bird needs to do almost exactly the opposite of the take-off; it needs to lose air speed. This can also entail a good deal of effort on its behalf. Some birds use the environment to slow themselves down, while others use gravity. Some birds have become adapted to such specialist environments that they cannot land in situations outside of that environment. A swan, for instance, can only land on water. When it comes in to land, it reduces its air speed by extending its wings fully and lowering its legs to increase drag, then as it nears the water's surface it swings its legs to a forward position and, using them almost like water skis, uses the friction with the water to bring it to a rather graceful stop. Some birds, when coming to land on a perch, cliff or wire, will approach the landing site by flying below the desired spot and at the last moment move upwards, using their weight and the effect of gravity to lose momentum, timing it perfectly. All birds are not so graceful. The blue-footed booby is an elegant flyer, though somewhat less graceful when landing. It uses a strategy that resembles nothing more than a slightly controlled crash landing.

ANIMATION EXERCISE 5.5 – TAKE-OFF AND LANDING

Aims

The aim of these two short exercises is to extend your understanding of the motion of a bird in flight.

Objective

On completion of these exercises you should be able to create short animations that link together to form a cohesive sequence.

Take-off

1. Begin by animating the bird taking off. Start by drawing a bird in a standing position and using a combination of pose-to-pose and straight-ahead techniques, animating the bird leaving the ground and entering the steady flight cycle.
2. Use one of your animation keys from your previous flight cycle as the link drawing between this sequence and the flight sequence.
3. Use key drawings for the initial pose, the anticipation and the jump from the ground. From there on, you should try to use straight-ahead techniques to give the animation more spontaneity and vigour.

4. Link the take-off animation to the cycle animation by utilizing a key drawing from the flight cycle and inbetween to it.

5. Test your animation and analyse before making any corrections.

Landing

1. Begin by choosing one of your animation keys from your flight cycle. This will be the first drawing of the landing sequence. Once again, try utilizing both key-frame and straight-ahead animation within this sequence.

2. Make the first drawing of the bird in the landing sequence and use this as a second key drawing. You will be inbetweening from the flight cycle drawing to this first landing sequence key, which will create the link animation.

3. From here you should try to animate the bird straight ahead into its final touchdown position, its wings and tail spread wide and its feet just about to make contact with the ground.

4. Make a number of key drawings illustrating the bird's final resting position and the previous squash and follow-through drawings.

5. Using these key drawings you can then create animation breakdowns for the pose-to-pose sequence before inbetweening.

6. Once the sequence is complete, you should line test your animation.

7. Analyse thoroughly before making any alterations and reshooting.

QUESTIONS TO ASK YOURSELF ABOUT BIRDS IN FLIGHT

Q. Does the level of movement within the wings reflect the type of locomotion the bird is undertaking? Is it too busy? Is it busy enough?

Q. Does the animation reflect the appropriate size and weight of the bird?

Q. Does the bird demonstrate follow-through and drag on the wing tips?

Q. Do the wings illustrate a downward thrust and a movement to create a reduction in drag on the upward movement?

Q. Have you included a little squash and stretch and follow-through on the landing?

Q. Does the bird's body move slightly in a contrary direction to the thrust of the wings during flight?

Q. Does the overall animation have varying dynamic properties running through it?

Q. Is the effect of drag apparent throughout the sequence?

Chapter 6
Sound Synchronization

Simple and Complex Mouth Shapes

All too often, sound is considered by students studying animation only as an afterthought, but a film without sound or with an unconsidered soundtrack is a pale shadow of what it could be. Sound adds light, colour, texture and movement. We see these things with our ears.

BEFORE WE BEGIN

How important do you consider the soundtrack to be within a film? On one hand, you may find that the images dominate a film, leaving the soundtrack to simply fill in the gaps to no real effect other than to obliterate the silence. At the other extreme, the soundtrack may be the fundamental aspect of the film, relegating the visuals to mere illustrations, nothing more than animated wallpaper. Between the two of these rather extreme standpoints there is room for a wide range of interrelationships between sound and vision, and this relationship of sound and vision can be a complex one. A good film score can enhance the visuals to such a degree as to turn mediocre footage into something very special; a poor one can kill an otherwise good piece of animation stone dead. Indeed, a good soundtrack, sensitively used with good animation, can turn a good film into a great one. More than that, it can enhance mediocre animation to the extent where the final product is not just acceptable but a film of true quality. The soundtrack can completely alter the mood and meaning of a piece of film and, because of this, a great deal of care should be taken when creating or commissioning music and voice tracks. Even during the silent era of cinema, public screenings were accompanied by musicians that played along to the film, setting the mood and enhancing the pacing of the film. This mixture of sound and vision was nothing new to film; it was in fact carrying on a tradition that goes back centuries. The earliest known examples of shadow puppets were used as a form of entertainment, depicting folk tales and the exploits of the gods within a spirit world. In Java, to accompany such a performance, a Gamalang (Gamalan) orchestra would add a musical element to the performance, enhancing the experience with mood and drama. Animated films of all kinds use soundtracks to enhance the final result; it is far from being just a matter of adding a comical noise over the top of a Roadrunner sequence. Such diverse artists as Tex Avery (*Little Rural Riding Hood*) and Oscar Fischinger (*Motion Painting*), and more recently John Kricfalusi (*Ren and Stimpey*) and Clive Walley (*Quartet*), understand very well the power and importance of a good soundtrack. Music has always had

a major role to play in animation. Popular music and light classical was used in both Disney's *Silly Symphonies* and Warner Brothers' *Merry Melodies*. The Fleischer brothers, however, sometimes used a fusion of popular blues and jazz in their films, most notably in their version of *Snow White*, in which Cab Calloway turns in a wonderful performance of 'St James Infirmary Blues' in the guise of a ghostly walrus-type character. The first animation to use a synchronized soundtrack, *Steamboat Willie*, came from the Disney studios and was first shown in November 1928 to great public acclaim. The recording of sound and music was done 'live' in front of a projection of the film. While this was a rather hit and miss method and was developed much further on later films, it did lay down the foundations for very precise synchronization found in these early Disney films. While the production methods of creating synchronized sound to images have come a long way since then, becoming easier and more efficient with the developments in recording facility technologies and methods, it is a tribute to the creativity and ingenuity of those early film-makers that they managed to achieve such high standards. Finally, it is worth noting at the outset that this chapter will not be covering sound design, as this is an extensive craft skill in its own right; it will restrict its scope to sound synchronization and the creation of those devices to assist the animator in achieving lip-sync.

BAR CHARTS

In order to achieve frame-accurate synchronization of sound and image, it is necessary to analyse in some detail the soundtrack and then make documentation of this in a way that those within the production team can use as a technical aid. The analysis is achieved and a graphic record made of the various sounds and dialogue through the use of a bar chart. A bar chart is a way of making notation of sounds, music and dialogue in a systematic manner. These can then be matched accurately to specific frames of film or video, which then form synchronization points for animators to work to. The creation of bar charts is usually the responsibility of the director and the editor.

Soundtracks have until relatively recently been recorded on magnetic tape (MagTrack), very much like film in that it has sprocket holes along one side that allow for it to be synchronized with film stock. The soundtrack would then be analysed and edited using a picture sync machine (Pic Sync) or

Bar Chart Template

Figure 6.1 While individual bar chart designs may vary slightly, the points remain roughly the same. At the top of our chart we can see there is room to identify the production. There is also room to identify the sheet number. This is important as the bar charts for an entire production may extend over very many sheets. The three main rows running the length of the bar chart are there to identify Action, Dialogue and Music or Sound. You can see that at the top and bottom of the bar chart there are two smaller additional rows split into sections. Each of these sections represents a frame of film or video. The bar chart is also divided vertically at points along its length. This denotes seconds of video. Note that for each of these sections there are 25 separate divisions in the upper and lower rows, as there are 25 frames of video to every second of footage. If this was a bar chart to be used for film, this may be divided into 24 separate divisions as there are 24 frames per second (fps) in film. An alternative that you may come across divides the vertical splits into 16 separate divisions. This division accounts for the actual film footage; there are 16 frames of 35 mm film to each foot of film. As digital technology is becoming far more prominent, the division is normally 25 fps.

a flatbed editing machine (Steenbeck). The soundtrack was only transferred onto the final film print once the film had been edited and after the soundtrack had been mixed onto a single master MagTrack tape. With the advent of video technology this editing and sound analysis process was done on a video editing suite or Beta video recorder. The tape or MagTrack could be scrubbed backwards and forwards manually across the playback head, which allowed for very accurate analysis of a voice track. With the development of digital technology there are now many examples of non-linear editing software that offer sound synchronization facilities and some even purport to offer accurate lip-sync facilities. All non-linear editing facilities

such as Avid, Final Cut Pro and Premiere offer the kind of scrub capabilities that were available for tape, and while some of them even include a graphical representation of the soundtrack in wave form, some editors still prefer to use analogue-based technology to break down the soundtrack. Some believe that this allows them to scrub videotape backwards and forwards across the playback head more accurately than digital editing suites, and makes it easier to identify and make notation of the separate sound elements within the dialogue. The majority of sound breakdown is now done digitally, and it does indeed provide a very easy and convenient way of analysing and editing sound and voice tracks.

Soundtracks are usually separated out into four distinct areas: voice, music, effects and atmosphere. Each of these requires a separate approach when they are analysed. How a soundtrack is broken down and to what degree depends on the amount of detail you require to illustrate the action. Lip-sync needs to be broken down very carefully in order for it to work successfully, whereas a music or effects track may need only a rough

Figure 6.2 Notice on the soundtrack that the dialogue is written in the normal fashion and then broken down phonetically within the frame spaces.

indication of a beat or a rhythm and its place in relation to the footage. An atmosphere track may only need to be identified as having a start or end position, and then only if you are animating to it, though this is not usually the case. Essentially, breaking down a music track is the same as breaking down a voice track, and with both types of sound it is necessary first to establish the extent to which you need the breakdown completing – which elements will you need to include, which ones can you ignore. There is little or no point in breaking down dialogue for lip-sync if the character is out of shot or their mouth is obscured in some way. It may be a simple matter of establishing when the soundtrack starts and when it ends; more likely is that you will need to register, perhaps frame accurately, with certain aspects of the soundtrack. The first thing you need to do is establish where the music or sound starts; this will be done by using the frame count on whatever software or technology you are using – they all have them. Mark this start point down on your bar chart. Ensure that the zero point of the frame count is at the very beginning of the sequence and that it corresponds with the zero count on your bar charts. Next you should establish the end point of the part of the soundtrack you are interested in breaking down and mark this on your bar chart also. You have now established how long the piece runs and where it appears within the film.

Once you have established the start and finish points of the dialogue track, you can now go back to the beginning and find the start point of each word within the dialogue you wish to break down and mark these on the bar chart. You may prefer to break down each subsequent word in detail or do as before and find the start and end positions using the time code, marking these points on the bar chart before going back and analysing the separate words in even more detail. The words are identified phonetically on the bar chart and represent sounds rather than correct spelling, as it is the sounds that the animator will be animating to, not the spelling.

Breaking down a soundtrack or piece of music uses essentially the same process, though the individual sounds need to be illustrated in a manner that differentiates them. It may be important to establish the beat and the rhythm of the piece, in which case I would identify the rhythm before going on to the other instruments. Subsequently, if the music needs to be further broken down note by note, then the individual nature of each sound must be indicated on the bar chart

Figure 6.3 Notice how the duration of the word is established; some of the sounds only appear for one frame while others last longer. The straight lines denote the extent the individual sound continues for; the wavy lines denote silences between words. You will also note that these often do not occur, as one word runs into another in ordinary speech.

using a series of marks. As no codified system exists for such abstract sounds, you will have to make up your own. Sounds that have a sharp attack and little or no decay may have a relatively short duration, say two or three frames, such as a drum beat. To illustrate this type of sound I have used a simple dot or circle. For other sounds such as strings that may have a less pronounced attack and a very long decay I use a wobbly line. It works for me!

A very detailed analysis of the soundtrack will entail the soundtrack being wound backwards and forwards to determine the exact position of the individual sounds, carefully listening for the attack and decay of the sounds.

The bar chart is used to break down the film in its entirety from beginning to end, unlike dope sheets, which only cover the individual shots or scenes. The exact positions of the cuts, the dialogue, soundtrack, spot effects, camera moves, fades, dissolves, etc. are determined at this point. This is done once the storyboard has been completed and an animatic shot made.

Once the final length of each of the individual scenes within the film has been determined and the dialogue has been broken down onto bar charts, the information is then transcribed onto dope sheets for each of the scenes. These are usually included in individual scene folders ready for the animator to begin work. They enable the animators to see clearly exactly what is required of them for each scene.

Sound synchronization 187

Figure 6.4 The separate marks indicate the individual sounds within the soundtrack. These can either be instruments or separate spot effects. It is normal practice for many of the spot sound effects to be added after the animation has been completed, negating the need to identify them on the bar chart or dope sheet, though, as ever, there are occasional exceptions to this.

Figure 6.5 In this illustration we can see how the individual scenes are identified and marked on the bar chart. The decision on the timing of the individual scenes is made by the director, and is usually determined by the storyboard and only completed once the animatic is approved by the producer. Note that the vertical split on the far right of the top table has the same numerical value as the first on the lower table. Also, the first vertical split of each subsequent page has the same numerical value as the last split on the previous page; so if we end page 1 on a split at 4 seconds, we *must* start page 2 on 4 seconds, otherwise we will have mysteriously 'gained' a second. It's important to remember that the first vertical split on the first bar chart in a sequence of bar charts *must* begin with the numerical value 0.

Bar Chart
Dialogue Transcribed to Dope Sheet

Figure 6.6 This illustrates how the information is taken from the bar chart and transcribed to dope sheets in order that individual animators can work on their sequences. The transcription must be totally accurate or this will result in the lip-sync being incorrect.

DELIVERING DIALOGUE AND CARRYING NARRATIVE

Care should be taken when planning to animate dialogue. Animating lip-sync should be far more than a technical issue of sound synchronization; it is an opportunity to perform. As such, delivering dialogue should be in keeping with the character and the whole tenet of the film. Lip-sync is not only affected by a character's physical qualities, but their psychological make-up too. An angry individual is more likely to talk through gritted teeth, for instance, than someone who is happy-go-lucky.

The progression of the narrative is fundamental to storytelling, and an animator's performance, including lip-sync, is all part of that process.

To assist animators in creating lip-sync, they often receive from the director or editor a copy of the soundtrack itself, along with the dope sheets or bar charts, for each individual scene. The voice track is usually supplied on audiotape, in order for the animators to hear exactly how the dialogue is being delivered, so they can get a handle on the acting. In this regard, the *recording* of the voice performance is the key element. The dope sheet or bar chart can only identify *when* the words are spoken; it's *how* they are spoken that is important to the performance and this can only be acquired from a recording of the voice artists.

LIP SYNCHRONIZATION

All lip-sync is not the same, as with any design issue the style of lip-sync, complex and naturalistic or simplistic and abstract, must be appropriate to the project. While there are clear guides that can be used in order to create technically 'correct' lip-sync, the notion of lip-sync style is wrapped up entirely in the nature of the project. To successfully make a convincing piece of complex, naturalistic lip-sync is no easy matter and to gain the necessary skills will take practice. In this instance, poor or inappropriate lip-sync will not only stand out like a sore thumb, but can be a major distraction from otherwise first-class animation. Alternatively, simple design may call for simple lip-sync and, while the principles remain the same, the application of those principles will be very different.

Mouth shapes

We can break down a range of the separate phonetics and create a fairly limited number of mouth shapes needed for

Simple and Complex Mouth Shapes

Figure 6.7 The lip-sync should reflect the nature of the project; the more complex the project and design, the more opportunity for elaborate lip-sync. The design of the character will determine the nature of the lip-sync you will be able to do. Complex and full lip-sync may look completely at odds with a simple design, while more complex and naturalistic design may look strange if it is accompanied by simplistic lip-sync.

successful lip-sync. This system works quite well for most types of animation and can be used as a rule of thumb, though there are one or two things you need to watch out for. It is a common mistake of the inexperienced animator to overanimate everything, which results in the mouth being incredibly busy. Let's look at lip-sync for the word 'banana' as a short exercise.

Sound synchronization 191

Head Construction - Naturalistic Design

Figure 6.8 The construction of the head determines the nature of the lip-sync. Notice how the bottom jaw is hinged, creating a downward movement of the jaw while the rest of the skull remains static. The amount of flexibility that the lips and mouth have determines the range of options open to the animator.

Lip-sync
Abstract Mouth Shapes

Exaggeration of mouth and head shapes becomes possible with more abstract 'cartoon' designs

Figure 6.9 The design in this example determines the nature of the lip-sync, just as it did with the earlier example, though in this case the laws of nature may be broken. While there are a range of options still open to the animator, these are determined and limited by design constraints.

Figure 6.10 The lip-sync guide outlines the collection of mouth shapes needed for a complete phonetic range.

Lip-sync Guide

M, B, P

J, R, CH, G

S, Z, X, K
N, D, T

EE, A

AH, AY

U, OH

OO

TH

V, F

L

These simplistic shapes should be used as a guide to the phonetics only (the sounds you hear not the words as they appear written down). There are also no inbetweens in the illustrations shown. The exact nature of the mouth shape will be determined by the character design, what the character is saying and how he is saying it.

Now go to a mirror and look at yourself carefully as you repeat the word 'banana'.

Very fast dialogue or a garbled voice track may require much less animation than you may at first think for a successful result. If you try to accentuate the sounds too much, in this instance you will get very hammy and overacted lip-sync. There should be no need to make inbetweens of the tongue position, even if it can be seen in the open mouth. It moves so quickly that illustrating any such movement will simply result in making the animation look too busy.

As another short exercise you should try saying the following phrase in various ways while observing your mouth movements in the mirror:

'Good morning, Pete. Nice day. Fancy a cup of tea?'

Lip Synchronization
Banana # 1

In this example every separate element of the word is illustrated

The action is over-animated and appears to be too busy

B A N

A N A

Figure 6.11 If we use the guide to illustrate *every* separate element of the word, we end up with a repetition of mouth movements, giving us: **B,A,N,A,N,A**.

Take a good close look as you deliver the dialogue; notice how little your mouth moves.

> Start by saying this in your normal voice with an even tone.
> Now say it louder in an exaggerated bright and cheerful manner.
> Now say it very quietly, almost furtively, like you are telling someone a secret.
> Now say it angrily, almost through gritted teeth.
> Now say it slowly in a tired manner.
> Now say it very quickly, as quickly as you can so the words run into one another and become almost garbled.
> Now say it as though you were drunk; slur your words and allow them to almost become one long word.

Notice how each of the examples is very different from one another. Not only has the timing changed, but the level of actual movement of the mouth and lips varies greatly.

Lip-synchronization
Banana # 2

In this example there is very little mouth movement though the main aspects are hit. The Vowel 'B' and the Consonant 'A'

The action is not over-animated, is not over busy and will not distract from any other action

B A NANA

Figure 6.12 We can still use the guide illustrated, but we can now see that much of the word is formed by the movement of the tongue and that there is in fact very little movement of the mouth. There are really only two mouth shapes evident in the entire word, the closed mouth shape at the beginning to accentuate the 'B' sound and an open mouth shape for the rest of the word, and we are left with: **B,A,n,a,n,a**. Through observation we have managed to simplify the mouth movements to animate how we *make* the sound of the word, *not* how the word is spelt and *not* the individual sounds themselves.

Lip-sync

G U D M OR NIN
Good Morning

P EE T F A NS EE
 Pete Fancy

A K U P A
A Cuppa?

Figure 6.13 Using the guide illustrated here, the phrase looks like this. I have omitted inbetweens in parts to create more 'snap' between certain sounds.

Sound synchronization 195

Lip-sync Frame Accurate

The shape of the mouth matches the phonetic of the sound, in this case 'f'.

The number of the drawing, p15 is on the same frame as this sound occurs making the lip-sync frame accurate.

Figure 6.14 Lip-sync – frame accurate. The breakdown here specifically covers the word 'funny' from the phrase 'I suppose you think that's funny?' It calls for the 'f' sound in funny to be on one frame only, as the closed mouth shape with teeth pressed against the lips is preceded and followed by open shapes. The 'f' becomes very important, but could be missed by the audience.

The approach you take to the accuracy of your lip-sync and the timing of dialogue must be tempered by practicalities. If, for example, you break down a voice track and animate to it *precisely*, you may find that there are mouth shapes that are important to a particular sound but occur so quickly that the audience will miss it and it will not look right, even though (according to your bar chart) it is in sync. In these instances you may have to 'illustrate' the sound for one or two frames longer, though you should ensure that the mouth shape occurs *before* the sound is heard, not after. This is important. You can be early with your drawings but never late. That is, a

Lip-sync - Early

The drawing p15 now occurs two frames prior to the sound, making the lip-sync frame inaccurate.

Figure 6.15 Lip-sync – early. Extending the duration of the 'f' sound to two or even three frames will give the sound more emphasis. In this instance the additional 'f' frames have been added before the sound is heard in preparation for it.

Lip-sync - Late

The drawing p15 now occurs two frames after the sound.
This also makes the lip-sync frame inaccurate, though this will now result in a noticeable mistake.

Figure 6.16 Lip-sync – late. In this example the 'f' sound is extended after the initial sync point, which delays the sound and makes the 'u' sound in funny arrive late. The result of this is that we are hearing the sound before we see the animation associated with it, which looks very odd and wrong. In short, you will get good results if you are 'spot on' with the sync of image and sound; be 'early' with the image to add emphasis to a sound and never be 'late' with the animation.

particular mouth shape can occur a few frames before the sound. The exact number of frames can vary in normal speech by one or two, but the more exaggerated the sound, the longer this *may* be. For a scream or a loud shout, the mouth shape may occur up to eight or ten frames early. Remember: if it looks right, it is right.

Body-sync

Sometimes animators can achieve much of what they intend by synchronizing the action of the entire body to the dialogue. If done to excess or with insensitivity, it can result in overacting, a hammy performance and a kind of pantomime action. However, if this is done well it can create added drama and a clear rationale and emphasis of *what* is being said. Some people call this an accent or attitude; I call it 'body-sync'. It gives the animation a sense of purpose; your characters look like they *intend* to be saying the words and mean them, and they are not just reading the lines given to them. Body-sync should be done before the lip-sync is undertaken, and as a result of seeing the rough test of your animation synced up to the voice track, you may decide that this alone is almost enough to carry the dialogue and that much less emphasis is therefore placed on the actual lip-sync. Allow the body action of your characters an opportunity to deliver the dialogue.

It may often be appropriate to prioritize the physical action over the spoken word, allowing the body-sync to dominate, but such an approach to body-sync and lip-sync is obviously not always appropriate. There will be times when little movement is required of your character, but very clear and precise lip-sync is called for. Although some level of body action to support the dialogue is vital, keeping the figure completely still will kill your animation and no amount of accurate lip-sync will help it then. The pose is vital, rather than the action or movement of the character; don't be tempted to overanimate, as this can only result in overacting.

ANIMATION EXERCISE 6.1 – LIP-SYNC

Aims

The aim of this short exercise is to extend your understanding of sound synchronization, to explore the use of lip-sync and see how meaning can change through animation.

Objective

On completion of the exercise you should be able to complete a short sequence of animated lip-sync.

In this exercise you should attempt to complete a short animated sequence using two separate characters. Even though this is only a short exercise you should avoid the mundane

or obvious. Remember that even a simple exercise can be turned into a lively and interesting sequence that demonstrates your animation and creative skills, and be of great interest to a prospective employer.

Once again you will be utilizing many of those principles of animation we covered in previous chapters, such as weight and balance, overlapping action, etc. The object is not only to create a piece of synchronized dialogue, but to investigate how meaning can be changed depending upon your animation.

1. Create a short piece of dialogue with the scope for two distinct interpretations and then make a recording. Convert this to a WAV file and import to the appropriate editing software.
2. Break down the soundtrack onto bar charts as described earlier.
3. For the two pieces of animation you should use the same simple character in order to see that the change in meaning comes from the delivery of the dialogue and not the design of the character.
4. Animate just the head and shoulders of the character, ensuring that the mouth is clearly seen at all times.
5. Keep the animation simple; do not get involved in overcomplicated actions at this stage.
6. Plan the animation out in one shot. Do not use cut-aways or close-ups.
7. Consider the level of body-sync you use for each of the pieces.
8. Experiment with the timing of dialogue; try delivering the mouth shapes a little earlier in one piece of animation than the other (though only in parts) to see how this affects synchronization.

ANIMATION EXERCISE 6.2 – SOUND SYNCHRONIZATION

Aims

The aim of this exercise is to extend your understanding of sound synchronization, and to become familiar with the techniques used for breaking down a soundtrack using bar charts.

Objective

On completion of the exercise you should be able to break down a soundtrack utilizing the appropriate documentation and complete a short sequence of synchronized animation.

1. You should choose a short soundtrack of around 10 seconds.
2. Using bar charts and the appropriate software, analyse the soundtrack as described earlier in this chapter.

3. Use your own visual coding to differentiate between various sounds by marking down on the bar charts the separate elements of the sound. You will be using this information to time your animation to.

4. You should take careful note of the general mood and pace of the soundtrack. Isolate individual sounds/instruments and their patterns within the piece. Listen for the attack and decay of the sounds, and listen carefully to the beats, indicating on the bar chart *exactly* on which frame these occur. For this exercise there is no need to transcribe this info onto dope sheets – you should work from your bar charts only.

5. You should then animate the whole soundtrack based on your bar charts. How you choose to animate it is left up to you. Don't overcomplicate things for this exercise. You may wish to keep things simple by animating abstract shapes. Remember, this is an exercise in sound synchronization, not full-on character animation. That can wait.

6. Don't bother to make a storyboard. Just go with the flow based on your responses to the soundtrack.

7. Your animation should take the form of a single scene, as it may concentrate your efforts rather than getting distracted with other editing issues.

8. Avoid getting involved in heavy camera work, such as pans, tracks, mixes or fades. Keep your animation as simple as possible, concentrating on the synchronization of sound and image. Remember, this is a simple exercise *not* a major animation project.

QUESTIONS TO ASK YOURSELF ABOUT SOUND SYNCHRONIZATION

Q. Are you using the appropriate bar charts and dope sheets?
Q. Have you ensured that the dialogue has been accurately transferred from bar chart to dope sheet?
Q. Do you know what aspects of the soundtrack you are trying to break down and analyse?
Q. Are you limiting the analysis and breakdown to what you need for animation?
Q. Is the lip-sync in keeping with the design of the animation?
Q. Is the lip-sync in keeping with the character?
Q. Are you using a recording of the voice track to work from?
Q. What are the key points in the dialogue that you are trying to get across?
Q. Have you animated the appropriate body-sync? Does it enhance and not detract from the voice track?

Chapter 7
Technical

Character Layout

Character layouts may include a number of images
that show the actions in some detail.

Animation drawings taken from *'Sad Animators'*

Technology may be central to what we do as film-makers and animators, but it is only there as a means to an end – to tell stories, to amaze, to make people laugh and cry, and to inform and educate. But it does mean that we can tell more fantastical stories and in doing so make the impossible tangible and add just a little more sparkle to our everyday experience.

BEFORE WE BEGIN

The technical issues dealing with animation production (other than the ones directly related to animation and animation timing) are very extensive and cover cameras, lights and lighting, modelling, editing, sound recording, sound editing, 2D compositing, filming, film and TV formats, file compression storage, management and retrieval, image compression, computer modelling, and output formats for screening and distribution, all or some of which may be of interest to you. However, they are far too numerous to cover in any single volume on the subject and so it is the intention of this book to concentrate on those issues around animation timing. Other technical aspects of animation production are dealt with in a very general manner, though I have set out a number of recommended sources of additional specialist information that will complement this book. While some deal with aspects of production that are relevant to all types of animation, others are more specialist and only you can decide which are appropriate to your work and ongoing practice. None of the information covered in this book is intended to be software specific, though I cannot avoid giving examples that may cover certain programs.

DOPE SHEETS

What are dope sheets and what are they for?

It is important that the decisions directors, animators and others make about the individual shots within a film are recorded in an established and common fashion that all members of the production team can understand. The dope sheet is one of the tools an animator uses for this purpose. It carries all the relevant information about a particular piece of animation within a particular shot. Dope sheets (information sheets, sometimes called X-sheets or exposure sheets) were developed for animators working in 2D classical animation, and while similar tools are used by computer animators and 3D stop-frame animators we will be mostly concentrating on the traditional dope sheet. Animators

Figure 7.1 While the exact style of dope sheets may vary slightly they will share common elements, and once you are familiar with them moving from one style to the other is not an issue. The template I have illustrated here shows what all the different aspects of the dope sheet are for. At the very top, alongside the production company's logo, you will see room for the Production Title and episode number. The main part of the dope sheet is divided with horizontal lines into rows. Each one of these rows represents a single frame of film. You will notice that every 25th line is slightly

working in 3D stop-frame may prefer to use bar charts (see Chapter 6) and those working in CG animation will have access to built-in systems for recording information on animation timing on the time line that includes key-frame information options. In addition to the built-in dope sheets, computer animators may also wish to work from bar charts for that information not included on a time line, such as the director's notes to the animators. While certain aspects of the dope sheet are specifically intended for use during the 2D classical animation process, the principle that underlies their use applies equally to all forms of animation, and as such they are of use to *all* animators. Whichever discipline you are practising, this information is necessary if you are to track and properly record your animation in line with the director's instructions.

As animators create the animation they are not simply making a series of sequential images, they are dealing with those issues of animation timing that we covered in Chapter 1. The timing of your animation is vital, as it is timing that not only determines the speed things move at, but also shapes the animated performance. Without the timing you are simply left with a series of drawings. Dope sheets are a way of recording the many decisions the director has made about

Figure 7.1 (contd) heavier than the others. This is to indicate 1 second of video. Remember that there are 25 frames to each second of video. Other dope sheets are designed to be used with 35 mm or 16 mm film, in which case the heavier lines denote footage not seconds. In the case of 35 mm film, every 16 frames the line is heavier as there are 16 frames to every foot of 35 mm film. In the case of 16 mm film this is every 40 frames as there are 40 frames to each foot of 16 mm film. From left to right the elements are: *Action/sync*. This is where detailed information of the soundtrack is written. A frame-by-frame phonetic breakdown of dialogue appears here in order that animators may register *frame-accurate* animated lip-sync to the voice track. This is usually accompanied by a more general indication of the dialogue. Music and spot effects are also placed in this column if needed. The voice track information is transcribed from the bar charts (more detailed breakdown of the film in total) that are prepared by the director. This column is also used to give an indication of the action required by each of the characters or objects and where it is to appear in the scene. This may also, on occasions, need to be frame accurate. *Frame numbers*. Mostly used as a guide by the camera operator to ensure that errors do not occur during filming. *Animation*. This is covered in a series of numbered columns, normally around six, sometimes more, in this case 12. Each separate column is used to display individual animation drawings that are placed one over the other to make the necessary composite to complete each frame of the film. The cel positioned nearest to the background is indicated in column no. 1, the cel that is to be placed immediately on top of the first cel is indicated in column no. 2 and so on. *Background*. The background number is placed in this column. If this column does not exist (as in this case), the background is indicated in column 1. Sometimes, within a single scene, there may be two or more backgrounds required or additional overlays and underlays. These will usually be indicated in separate columns, with the position dependent upon where the animation appears in relation to the background elements. Any dissolves or transitions between the separate background elements are indicated in this column with additional notes in the Camera column. *Camera*. The column on the far right carries the instructions for the camera operator. This will include all manner of camera effects, such as fades, mixes, pans, tracks, etc. It will also carry information about the field size and position onscreen of the animation.

the narrative and the animator has made about the timing of the animation *as it relates to the contents of the shot*. This is a very important point. Dope sheets are a detailed record of all aspects of a particular shot, outlining length of shot, content of shot, acting, sound, camera moves, special effects and dialogue. They are a vital part of the production process, enabling important information to be passed on through the production pipeline to all members of the production team in order for them to undertake their specific tasks as they relate to a particular shot. Each separate shot normally carries its own individual dope sheet or series of dope sheets. The scene's dope sheets should always accompany the animation drawings of the relevant shot right throughout the production pipeline in order to avoid any errors: from leaving the director, through animation, inbetweening, trace and paint department, animation checker and finally the camera operator. It will be necessary for some individuals involved in the various processes to add information to the dope sheet as it moves through production.

In the case of the 2D classical animator, the dope sheet is filled out *at the same time* as the animation is made. This is important. The creation of the animation drawings for each of the separate elements and their individual animation timings, and the manner in which they relate to one another, are more easily tracked and recorded if these are transferred to the dope sheet at the time the animation drawings are being created. This not only avoids mistakes, it enables any alterations to key drawings or timing to be entered onto the dope sheet as and when they are made. If the dope sheet is on the animator's desk as he animates, he can see at a glance the director's instructions and the details of the soundtrack, and number the individual animation drawings accordingly. This is very important when trying to be frame accurate for lip-sync. It is then possible to keep an eye on how the scene is progressing time wise; if there is enough time left within the scene to complete a desired action and if a specific timing of an action will work with other elements within the scene, be these drawings, dialogue, soundtrack, action, etc.

Correct doping not only reminds the animator what happens and when, it clearly identifies this to other members of the production team further along the production pipeline. Getting this wrong can be a very costly process. Mistakes at

Figure 7.2 You can see on this example that the timing of the animation involves drawings split over many levels; this will sometimes denote a single character that has been split into separate levels, either for economic reasons or for practical considerations of timing, matching to backgrounds or other characters. Lip-sync is often split away from the main character in such a case. The animation is usually made separately and then the lip-sync added once the animation has been tested and approved.

this stage may mean that animation needs to be reshot or that additional animation needs to be made or even, heaven forbid, animation already completed is surplus to requirements. In any case this would prove to be expensive. It is therefore worth taking time over your dope sheets. Make sure that all the information is included and set out in a clear and simple manner. Any additional information you need people to be aware of should be included as notes at the top of the dope sheet. Don't leave anything to chance. State the obvious, rather that than miss something out that results in added expense.

Creating animation timings

So you have made your key frames for a particular action. It is at this point the animator will decide if the animation is to be shot on single frames (ones), two frames (twos) or more. Remember that animation on video is seen at a rate of 25 fps (frames per second), so the number of frames you choose to shoot your animation on will determine how quickly (and smoothly) your animation will appear. Shooting your animation on ones will give the smoothest result but is time-consuming to make. Shooting on twos will be a lot more economical and only slightly less smooth, and is perfectly acceptable in most situations. Shooting on threes will give you a slight jerkiness to the action, though this may be an acceptable economy, while shooting on fours will result in a very definite staccato action, not a good option for most animation. A lot of commercial animation is shot on twos (two frames per drawing), as this is a relatively economic way of making animation (half the number of drawings than making a drawing for each frame) that results in fairly smooth action. Remember, the more frames you choose to shoot of each of your separate drawings or individual positions of the model, the jerkier the movement and stiffer the action will appear. So shooting on ones (one frame for each drawing/position) is smoother than shooting on twos (two frames for each drawing/position), which is smoother than shooting on threes, which is smoother than…. Get the idea?

Animators need a way of recording the timing they are using with the drawings. We have already covered how animators decide on the timing of the drawings they make as they create the animation. Once the animator has completed the rough keys and determined the animation timing, this can be transcribed to the dope sheet before the inbetweens are made. The separate levels of animation can be checked

against one another to ensure that everything happens in the correct order and at the correct moment. It is then possible to determine if the animation fits in with the director's instruction in the Action column. If it doesn't, alterations can be made before the inbetweens are made.

Alterations to animation timings

Alterations may be made to the animation that does not require additional drawings, simply a shifting of the order they appear in or in moving them earlier or later within a sequence. You may find that you need to make more key drawings if the sequence is too short or take some out if the sequence is too long. While this is more likely to happen if you are working on a scene of a strictly fixed length, working with the dope sheets as you make the animation will reduce the likelihood of this occurring. Such amendments only affect where the animation appears within the sequence (on the dope sheet), though other alterations that you make to your *animation timings* as a result of testing the action should be recorded on both your key drawings *and* your dope sheet. This should be done before reshooting either your key pose test animation or the final rough animation; this will avoid confusion later on.

Most of the animation you undertake will be shot on two frames, though there are times when you will need to shoot individual drawings or positions for longer periods. These are called holds.

Holds

Holding the image still between actions is an economic way in which to make animation and means that the animator does not have to produce new images or move the model for every single frame exposed. The use of the held drawing was first introduced as a way of producing economic footage. After all, if you can hold on a drawing for a couple of seconds you have achieved the same amount of footage as if you had done the animation on every single frame, saving a lot of effort, time and money. This approach to animation came to be known as 'limited animation' and was much used in the early days of cinematic animation in the first quarter of the twentieth century, when budgets were minimal and schedules were very tight. However, on the downside this method generally makes the held position or key frame more noticeable, which may not be the desired effect some animators require. While the technique began as a simple

Figure 7.3 The held drawings are identified on the dope sheet and carry a line through the required number of frames until the next drawing appears to replace it. You will notice that other elements of the animation are still active while the held drawing is current. Inserting held drawings in this manner often masks the fact that drawings are static.

In this example drawings B1 to B9 run sequentially for two frames each.

Drawing B10 is shot for 16 frames effectively 'holding' the image static for that period.

The Hold Drawings

The held drawing or held pose can be used to good effect within both cartoon animation and more naturalistic actions.

Held drawings or poses should be strong and clear. Held drawings are usually key frame drawings.

Held drawings may be used within dynamic actions or more passive movements.

Held poses may be used over many frames or just a few.

Good use of positive and negative space in the pose is essential to add clarity and make the image more easily 'read' by your audience.

Animation drawings taken from 'Sad Animators'

Figure 7.4 A 'held' drawing needs to be a key drawing and, while all key drawings should be strong, the pose of a held drawing is more important as your audience has more time to scrutinize it.

technique for creating a crude sort of phrasing in animation, the use of the 'hold' need not look too much like low-budget limited animation; in the right hands it can become a stylized form of animation that is perfectly acceptable. Tex Avery took the basic principle of the held drawing and developed the

technique to highlight rather than hide its properties. He would create exaggerated drawings of his characters – bulging eyes, gaping mouths, wagging tongues, even to the point of dismembering all its limbs – and hold on these drawings for extended periods. Far from looking like a crude shortcut, he created a distinctive style that remains much imitated to this day. Throughout the 1940s, he created a whole new cartoon language all of his own in such wonderful films as *Red Hot Riding Hood* (1943), *North West Hounded Police* (1946) and *King Sized Canary* (1947), and once again demonstrated that animation, even low-budget animation, can be fresh and exciting. Later, the Hanna Barbera studio became experts at this type of limited animation, specifically for television budgets throughout the 1960s.

Moving holds

In nature a figure seldom comes to a complete rest, and to achieve a more naturalistic movement the use of holds may be inappropriate and a series of actions interspersed by stillness may make the holds more noticeable than you would like. To overcome this problem, the animator should create what is termed a 'moving' hold. This is a technique whereby a key frame is created in the usual manner, but once the action reaches its final key position (see section on key frames), it continues to move in small increments, either in the same direction of the last movement (stretching) or in the opposite direction (retracting). Effectively, you are holding the pose but keeping the movement going. If done with sensitivity, this refined action will keep the animation 'alive'. However, you must be careful not to give your animation timing uniform spacing during the moving hold. This will result in typical computer animation 'oiliness', an unnatural smoothness that has been a common mistake in computer animation, though thankfully this is becoming less common. In the past it has been the practice of some less experienced animators to set the key frames and let the computer handle the movement in between these, giving a very unnatural 'floatiness' to the work.

Staggered doping

The use of staggered doping can be very effective in creating substantial amounts of action through a limited number of drawings. Consider the action of a ruler bent under tension and then being released. The result would be a rapid though decreasing to and fro action, ending in the ruler coming to rest in an almost straight line. To animate all of this action as

Technical 213

Figure 7.5 The moving hold is not evident as such on the dope sheet. The drawings are numbered in exactly the same manner as any other.

Figure 7.6 The moving hold drawings usually only demonstrate a slight difference in position, though the timing within the moving hold displays a dynamic, usually slowing towards the most extreme drawing.

The Moving Hold

The moving hold keeps the action alive without making unnecessary or distracting animation.

When the animation is the centre of attention the moving hold prevents the action coming to a complete stop. Secondary actions may often result in an animation drawing being held.

Animation drawings taken from 'The Life of Fish'

Figure 7.7 You will notice how the drawings within this action seem to have an unnatural timing breakdown that would result in a very uniform motion if shot in sequential order. The numbering of the drawings in this way is for the purpose of inbetweening only. This ensures that the minimum of drawings are used and that they are in the right position. You need to check these drawings against the doping of the action to perceive the dynamic of the action.

Staggered Doping

Key drawings

Inbetween actions

The animation timings are straight forward. The staggered animation action is achieved through doping.

it moves backwards and forwards through many cycles could take scores of drawings, though by using staggered doping the same drawings can be used over and over again to achieve the same effect.

Repeat animation

Repeat animation is another very obvious device for creating more footage from a limited number of drawings. A walk cycle or flag, for instance, may be made up of a limited number of drawings, though if shot correctly and repeated this can create a limitless amount of action. It is also possible for certain actions

Technical 215

Figure 7.8 The way these few drawings are doped produces the action required. This minimizes the number of actual drawings you need to make. Check the order in which these drawings appear on the dope sheet to create a dynamic within this fast action. This is a good example of how a little forethought and consideration to doping your animation can save you an awful lot of work.

Figure 7.9 In this particular action of an arm striking an anvil with a hammer, the downwards action may be reversed to create a believable though simplistic cycle. More elaborate actions of this nature would involve the use of overlapping action and follow-through. The more excessive use of overlapping action to achieve a 'naturalistic' action would probably negate the use of a reverse action. Notice that in the animation of the car wheels there are far fewer drawings, but it still illustrates the point well. More drawings could be added to this cycle, though the effect would be to slow the rotation down. If only two drawings were used it would result in a flickering to and fro between one position and the other of the wheel texture, and the illusion of rotation would be totally lost.

Technical 217

Repeat Animation

Doping of door animation is simply reversed to create the open and close actions

Repeat animation of flag works with drawing of flag pole

The doping of the anvil animation is reversed and repeated. Notice the holds and omissions throughout the action.

Simple repeat animation of car wheels works with held drawing of car

A1	D1	F1	P1	W1	C1	
	2	2		2		
	3	3		3		
A4	4	4		W1		
	5	5		2		
	6	6		3		
A7	7	7		W1		
	D8	8		2		
A6	7	F1		3		
5	6	2		W1		
4	5	3		2		
3	4	4		3		
2	3	5		W1		
A1	2	6		2		
	D1	7		3		
A4	2	8		W1		
5	3	F1		2		
6	4	2		3		

Figure 7.10 To achieve the reverse action, the doping of the action needs to be reversed. The example on the far right is the animation of the action of the hammer striking the anvil. Notice also how the action involves a small hold at the top of the action and elements of staggered action by the omission of certain drawings at both the top and the bottom of the action. The door animation is represented by drawings denoted with a letter D. The flag cycle animation (F) sits on top of a level representing a flagpole (P). Likewise, the wheels of the car (W) sit on top of the car level, represented by the letter C.

Random Doping
The Boil

Random doping may be used to create a 'boil' in artwork that is heavily textured or animation drawings that have uneven lines.

The 'boil' helps to keep the drawings and action alive when the animation comes to a hold.

Animation drawing *'Funny Bugs'*

Animation drawing *'Elephant'*

Production still *'The Life of Fish'*

Production art *'Knit One'*

Figure 7.11 The drawings used in a boil are key drawings and, while the pose remains the same, the separate drawings differ in order to keep the line alive and to avoid a sudden kick in the animation as the hold becomes apparent. A minimum of three drawings will create the effect of a boil. Using two drawings will create a kind of flicker.

to simply be reversed. Shooting the animation backwards as well as forwards may result in an economy of work.

Random doping

The use of random doping can also create interesting effects. We have seen how the use of a held drawing can be a very

economic way of making animation, and if the animation is a typical cartoon type there will be little difference between a 'held' drawing and one within a moving sequence. If, however, you work in a more expressive manner and the individual drawings are very distinctive, then you will find that the use of the held drawing will create a very noticeable and undesirable kick in your animation as it stops dead. A more expressive form of drawn animation need not be a problem and the kicks in the animation can be avoided. The way around this is to create what is know as a boil. By making several separate drawings (three is usually enough) of the one pose used for the held position and by shooting them in a random manner, the line and any rendering will continue to move even though the pose remains static. The work of Joanna Quinn is a good example of how this technique helps to achieve a vivacity and energy throughout, due to the very liveliness of the line work. The children's TV series *Rhubarb and Custard* by Bob Godfrey made a virtue of the wobbly line, while *The Snowman* managed to emulate the original rendered colour pencil drawings of Raymond Briggs by using this method.

There are a great many variations on doping, far too many to go into here, each of them specific to the individual action. You will no doubt develop your own approach to doping and animation timing as you gain more experience as an animator. The ones outlined above are just a few of the standard uses of doping.

Dope sheets are available from a number of animation suppliers.

Figure 7.12 When the animation comes to a stop, the drawings used for the hold continue to keep the pose alive. However, if the individual drawings used for the boil were shot in a strict repeated sequence – 1, 2, 3, 1, 2, 3, etc. – the result would be a definite repeat action, which could be very distracting. If the animation is shot in a more random manner – 1, 2, 3, 2, 3, 1, 2, 1, 3, 2, etc. – the repeat within the boil would be less obvious. It stands to reason that the more drawings used for the boil the less likely it is that the hold will be noticed, as the line itself remains 'alive'.

QUESTIONS TO ASK YOURSELF ABOUT DOPE SHEETS

Q. Does the dope sheet identify clearly what scene or sequence it refers to?

Q. Is the doping clear? Can other people read and understand it?

Q. Does the animation match with the direction given by the director?

Q. Is the sound synchronization and lip-sync in registration with the drawings?

Q. Are all the instructions on the dope sheet, including the camera instruction and field size, given clearly?

Q. Are all the separate elements identified on the correct levels?

Q. Are the backgrounds and overlays identified?

Q. Is the use of reused animation identified, including the scenes where they can be found?

LINE TESTS

Before animators commit their 2D work to film or before it goes for trace and paint, which is an expensive business, they need to be as sure as they can that the animation is working in the way they planned it and that the timing is right. To achieve this, they often make a test of the animation drawings by shooting them on video; these are known as line tests or pencil tests. The animation is shot, as near as possible, in the same way as the finished animation will appear, giving a clear indication to the animator, the director and anyone else on the production crew if the sequence is working in the way they had planned. Often, these tests do not include camera moves, as these are difficult and time-consuming to do, and such tests sometimes only cover certain aspects of the final animation. Experienced animators may decide to skip the use of line tests for certain simple actions if they are confident that the animation will work anyway. While the use of line tests can save the time and effort of reanimating sequences after they have been through paint and trace, the line tests themselves take time and the decision to test the work in this way is dependent on the budget – and the skill of the animator.

In the days before the development of such sophisticated video equipment, all animation tests were shot on film, usually on black and white reversal film to save expense. They were then viewed on a small projector known as a Moviola. This device allowed the viewing of film through a very small and poorly illuminated screen. In the early days at the Disney studios, one such machine was tucked away in a small dark corner under the stairs with barely enough room for two or three people to view the animation at any one time. The animators named this the sweatbox, probably due to the rather warm conditions under which they had to work, but maybe because of the stress induced by having Disney look over their shoulders as they viewed the work for the first time. The name stuck, and even after the Disney studios had grown to such a size that the pencil tests were viewed in a purpose-built viewing cinema, the viewing of the animation in this form became known as sweatbox sessions. The animators may have had a better environment in which to view their animation but it is doubtful, taking into account Disney's reputation, his forthright manner and acerbic wit, if they felt any less discomfort. The sweatbox was well named.

Computer animators normally make their work using stripped down versions of their models with no texture mapping or lighting. Without such details the computer can handle the animation more quickly and play back the animation in real time. This enables animators to more quickly assess the animation *as they are making it*, which is a far more efficient way of creating animation than having to stop and make separate tests of the work. Records of the animation in flick-book form can then be seen and approved by the director before the more costly process of rendering animation *after* texturing and lighting and placing the models into an elaborate CG environment. Unfortunately for animators working in stop-frame animation, the equivalents of pencil test or line test animation are not possible.

LAYOUTS AND FIELD GUIDES

When setting up a shot to be animated it is important to frame it correctly; getting this wrong can ruin the best animation. The framing and choice of camera angle is something that the director will do during the storyboard and layout stage of the project. This decision is then conveyed to the animator through the use of layouts and field guides.

What are layouts?

When making 3D stop-frame animation, the action is framed when the shot is set up simply by looking through the camera. The same method is used in computer animation, though in this case the camera is a virtual one. In 2D classical animation, all the framing needs to be planned before the animator begins work, as this will be shot as a separate activity only after the animation is completed. This framing of the action is done through creating layouts. Layouts are drawn up by a layout artist following the instructions of the director and based upon the shot designs in the storyboard, and are used to determine the content of the shot, backgrounds, foregrounds, the action within the shot and any camera moves. Figures may move through the shot and interrelate with other characters and/or their environment, and all of these things will determine the manner in which the shot is set up. To properly frame the shot, a layout artist must use a device called a field guide, sometimes referred to as a graticule.

What are field guides and graticules?

The field guide or graticule is a device for accurately measuring and dividing the size of the screen into sections called fields. There are two general sizes that animators work with, 12 fields and 15 fields. Regardless of the actual size of the field, the aspect ratio of each of the fields remains the same, 4:3. The measurements are based on the width measurements of increments of 1 inch. Therefore, an eight-field guide will be 8 inches wide while a seven-field guide will be 7 inches wide. While it is a very common format, there are many exceptions to the 4:3 aspect ratio used for traditional TV proportions, such as widescreen or high-definition TV, which is 16:9.

Even though you may take a great deal of care to frame your animation correctly, you must take into account that part of the image will be lost. The recording of an image on video or film to a specific field size is no assurance that the playback or projection will be *exactly* the same size. Always leave room within the frame to accommodate cut-off. You will always lose a little from the edges of the frame; in the case of video this is known as TV cut-off. Allow around a field and a half on a 12-field setting as a safe area; the safe area for titles is even tighter again.

One major benefit of computer animation is that it enables the animator to animate the camera in the same manner as any other object within the scene. This can be very liberating

Figure 7.13 The field guide or graticule standard sizes are 12 fields and 15 fields. These in turn break down the frame into a number of framing possibilities, from 1 to 12 and from 1 to 15 respectively, though the exact framing of these does not need to be centred.

Technical 223

Animation Layouts

Background Layout

Character Layout

Field Guide

Composite of all elements

Background

Final screen image
Images taken from *'The Last Supper'*

Figure 7.14 The layout is used to determine the framing of the shot and its content throughout the sequence. This is determined by the director, who uses a field guide or graticule to establish the exact framing. In this instance the framing is offset slightly, though the aspect ratio always remains 4:3. The field guide is drawn up by the layout artist and used as a guide for animators in order that they place the action correctly within the scene.

Character Layout

Character layouts may include a number of images
that show the actions in some detail.

Animation drawings taken from *'Sad Animators'*

Figure 7.15 Separate layouts, character layouts, are sometimes made that show the exact position of the characters at key moments throughout the sequence as an additional guide to animators. All these separate elements – layouts, field guides, character layouts and backgrounds – all carry the same information regarding the scene and sequence number for the animation. In this example you can also see how the camera move is set out in a separate field guide. The start and end positions are identified along with the field sizes of each of these positions. The animation needs to be planned to happen at the same moment and the same place that the camera is covering. Getting this wrong can result in very costly time animation being framed incorrectly and appearing on the wrong part of the screen or, worse, not on screen at all.

for 3D stop-frame animators used to locked-off cameras or for 2D animators facing the additional expense of camera moves. However, the problem with such a free roving camera is that this has often resulted in animators overusing camera moves, creating the ubiquitous 'fly-through' shot. Thankfully, this is becoming a thing of the past and animators are relying much more on their cinematic skills and using the animated camera as simply another tool.

Camera moves

In 2D classical animation, all the camera moves need to be planned beforehand. Establish what is going to be seen, how

Technical 225

Animation Background

Animation layout drawing

Animation drawing sitting on the finished background
Artwork taken from *'Sad Animators'*

Figure 7.16 The finished background is made by the background artist using the accurate layout. Animators do not generally use the background to register their work to, but work from the original layout. Great care is taken that these two are the same in every regard to ensure that correct registration of artwork is achieved.

wide or tight the shot is, establishing the nature of the camera move, the distance travelled and the speed of the camera move (the speed of this is determined by how many frames you shoot to cover the distance of the move). All of this

information is identified and noted on the dope sheet in the 'Camera' column. With the use of computer technology, the exact camera move can be worked out within the computer, borrowing much of the same approach that computer animators have had from the beginning. This has created a good deal of flexibility, enabling animators to make final decisions on camera moves once the animation and backgrounds have been scanned separately. This approach largely negates the need to work out the exact speed of a camera move frame by frame before the work is scanned and composited with other elements, as was the case when shooting on film under a rostrum camera.

QUESTIONS TO ASK YOURSELF ABOUT LAYOUTS

Q. Are the layouts clear and easily read by both the animator and the background artist?

Q. Are the sequence or scene numbers and production title identified on each of the layouts?

Q. Are the design and framing of the shot in keeping with the storyboard?

Q. Do the characters fit to the backgrounds and are any match lines identified?

Q. Are separate overlays or underlays identified?

Q. Is the layout accompanied by a field guide identifying the framing of the shot and any camera moves such as track-ins or pans?

FORMATS

Recording formats

The way in which you work will, in some small measure, depend upon the chosen format you are working in. Working in some formats will prove to be cheaper than others, while others may prove to be more convenient. The way in which you will be distributing or viewing your work and the purpose for which it is being made will also determine your choice. Broadcasters may require different formats from those distributing work on the Web, and some animation festivals still prefer to receive animation on film.

Video or film?

This can be a very personal preference. Some animators still enjoy the physical aspect of working with film, though this usually entails a very different approach to recording and

processing images, sound synchronization, editing footage, and final output and distribution. When choosing equipment expense is often a major consideration, so you will need to balance one against the other to determine which is the best option for you. Be sure to shop around for the best deal and check out second-hand equipment; some people are very quick to upgrade, making very decent pieces of kit available at a fraction of the original asking price. The specification of software and hardware is always changing, as is the development of new software, so to recommend specifics here would be useless as they would probably be out of date by the time the book went to print. The best approach to choosing equipment is to regularly review the trade press, of which there is an enormous amount, covering all aspects of video and digital media production, specifically for animation. A few useful websites are listed in the appendix section.

There are many film formats available to the animator, ranging from Super 8 mm, 16 mm, Super 16 mm, to 35 mm. Larger 70 mm format film requires such specialist equipment that it is simply out of most individuals' reach. Most professional animation shot on film uses 35 mm. Generally, the larger the format, the better quality the image, as it is being projected from a larger original frame size, which makes for better resolution, though the speed of film and associated graininess also has a major impact upon quality. Some film-makers do not like to use digital media specifically because of the lack of film grain. The use of film and the appropriate film equipment is covered extensively in Susannah Shaw's book *Stop Motion: Craft Skills for Model Animation*.

There are a bewildering range of video formats available that include VHS, SVHS, Betacam SP, Digi Beta, DV, DVCam, DVCPro and HD. In order to make sense of this you will need to do a little research to find out which one is most suited to your needs. Again, the trade press is a good starting point. For much more detailed information on the range of video and digital formats, I have listed some useful websites in the Appendix section. A number of countries, most notably the USA and Japan, use the NTSC (National Television Standards Committee) video system, which is a system that records and plays back at 30 frames per second. European countries, Australia and China use the PAL (Phase Alternation by Line) system, which records and plays back at 25 frames a second. A third system, SECAM, is also a 25 frames a second record

and playback system, and is the standard used by a number of countries. The standard size format (that is, the proportionate frame size), established in 1936 in the UK, has an aspect ratio of 4:3, which matched the standard film projection frame size at that time. While film continued to develop and now has many different aspect ratios, video remained constant and it is only now moving towards a broader aspect ratio of 16:9. Much more detail regarding the technical issues of video can be found in the excellent book *Cinematography, Theory and Practice* by Blain Brown.

A good way to get started making animation is to utilize digital cameras to input directly into the computer using programmes such as Adobe Premiere, which runs on a Mac or PC. While Premiere is predominantly a mid-priced desktop editing facility, it does have a frame capture facility that will enable you to shoot 3D stop-frame animation. There is also a useful blue screen facility, which automatically creates mattes as a series of alpha channels that allow you to set your animation against different backgrounds. There are a number of more specific pieces of software for recording 3D animation available, one of which is Stop Motion Pro. This has a number of very useful tools, is reasonably intuitive and has a very useful onionskinning facility, allowing animators to see the previous frames and making more precise animation possible.

For making 2D animation via a computer, the Animo system from Cambridge Animation Systems is the current industry standard, though much less expensive alternatives are available for the student and professional, such as Toon Boom and Flipbook from Digi Cel. These programmes enable you to create new artwork, scan existing artwork, paint it, place multiple elements against backgrounds, work out animation timings set against existing dope sheets, complete camera moves and effects, and render the final composite and output the work to a range of formats, including DVD, CD, videotape and the Web.

Editing your material will also depend on your approach, film or video. Editing film used to depend on the physical splicing and joining of sections of film stock using purpose-built film edit machines. However, film can also be transferred to video or a digital format, a process known as telecine. If this is undertaken before the editing process, it will enable the animator to use non-linear editing software such as Final Cut

Technical 229

Aspect Ratios

4:3

16:9

Production still taken from 'Watch the Skies'

Production still taken from 'Buddybodies'

Figure 7.17 The different aspect ratios are clear to see in this illustration.

Pro or Avid to cut the film together. Alternatively, the film can be edited in a more traditional physical manner before the final cut print is transferred to video or digital format for distribution. Non-linear editing is far and away the most popular method of editing; it is less cumbersome than film, mistakes can be easily rectified, multiple edits are easily and cheaply compiled and, as the process is digital, there is no loss of quality.

PRODUCTION PROCESSES

It is important at this point to cover certain aspects of production and production management. Space doesn't really allow for any more than a cursory glance at this very vital aspect of animation production. However, it is necessary that you are organized in your production if you are to work in an effective manner, meet deadlines *and* stay on budget.

Production management

Even the most modest of animation productions needs to be managed properly. A professional production demands

software, this process has become much more widespread. Such savings can make a great difference to the overall production costs; for animation studios it can mean the difference between making a profit and turning in a loss.

Using the system illustrated here, each of the fields is filled in once the task has been completed. This gives a clear indication of how much work has been done and how much is left to do on a daily basis throughout the production period. The column on the right-hand side is for any notes that need to be made during the production, such as the addition or subtraction of frames. Every animator will have their own preference as to the inclusion of the separate elements and the order in which they are placed, and this will be determined by the nature of the project, as the separate processes may be different each time. Production charts are not only useful for commercial productions; even animators making a short independent project would benefit from keeping their own production chart as a constantly updated reminder of their own schedule. That way they can monitor which scenes have been roughed out, which are in clean-up or ready for inbetweening, how many have been line tested, and how much work is left before the sequence is finished. For a freelance animator, a production chart is all important as a way of tracking the work, as payment for the work will nearly always be after completion of the animation and a good production chart will give you an idea of how the financial side is working out week by week. This is even more important if the animator is subcontracting out assistant or inbetweening work, for not only do they need to be paid, but any delay with their work will have a knock-on effect, which may upset your cash flow situation unless you have sufficient financial back-up. Proper tracking of a project can determine the animator's very survival as a freelance. You may wish to include a delivery date and an invoice column; this would be a reminder of when work was completed and the date on which the invoice was generated. To give even more detail it might be advisable to include the date on which you commenced the work and how much the job is worth; this can be done either scene by scene or as a complete sequence. You may find that the individual scenes have already been cost to a set price or you may be working to a footage rate, i.e. 1 foot of film (or second of film) = £ x. This kind of information will enable a weekly rate for animators, assistants and inbetweeners to be worked out.

Production schedules

Within any production studio the importance of a production schedule is difficult to overemphasize. Deadlines for the client are very real; they may have a broadcast or delivery date of their own, which cannot be moved. Unless you know the deadlines and milestones involved in a production it cannot be fully or realistically planned. Schedules can only be developed once the nature of the project and the resources available are established. A production schedule, along with the production budget, may shape the nature of the production and its production values; conversely, the production values and budget may determine the schedule. They are all interdependent elements of production management, and achieving a balance between them and focusing on the most pressing of these is vital to a production's success. Creating and sticking to a schedule can mean the difference between profit and loss. The production

Figure 7.19 Production schedules can be very elaborate affairs depending on the size of the production. This very simple example, created in Microsoft Office's Excel, shows how a small project can be broken down into tasks and tracked across time. Schedules need not be overcomplex and should reflect the intricacy of the project. Simple projects – simple schedules. Using more specialist production management software tracking resources for more complex projects involving many separate elements and large production crews linked to a series of milestones and individual production costs can become a relatively simple task.

manager will have a separate schedule outlining the individual schedules for recording artists, storyboarding, layout, animation, paint and trace, camera, processing, final edit, and the all-important delivery/air date. The production manager will also have their own version or versions of a production schedule outlining exactly when the backgrounds were commissioned, what date they are due back to the studio, a detailed breakdown of who has been allocated which animation sequence, who the assistant is and on what date the animation is due back in the studio. Obviously, not all of this is necessary for a small independent project, but if you are to complete the production within a certain time period you will need to undertake some form of scheduling.

Production folders

Animators should get into the habit of creating production folders for all their scenes. These should contain copies of all relevant material, such as layouts, overlays, underlays, character layouts, dope sheets and field keys. Once the animation is complete, each separate element of the animation – individual characters, separate character elements such as heads and arms, lip-sync, etc. – should have its own folder within the main scene folder. This need

Figure 7.20 Each scene needs to have its own production folder clearly labelled with production title and scene number. All the relevant documentation, such as dope sheet, layout and field guides, is kept within this folder. All the animation drawings for this scene are kept separately within this folder.

only be a sheet of paper folded in two with the drawing numbers written on the front. If a sequence of a character is numbered as A1–A57, for example, it would help if this was identified on the front of the folder, along with the scene number and the production title. This helps to keep all the various drawings in order, which is particularly useful when working on limited animation, where there are many separate elements involved within each scene. It also helps to identify the individual drawings that belong to a specific scene within a specific project. This is vital in a production that involves many scenes to avoid misplacing animation. This may seem like a bit of a bother, but it can save time and effort in trying to find all the relevant drawings within a scene if alterations or additions need to be made at some point.

Production budgets

The other main aspect of production management is the production budget. If you are simply making a film for your own enjoyment this need not be a very complex process, though it would benefit you to know at the outset how much the completed film will be costing you. For commercial productions this is vital. Get this wrong and no matter how

Figure 7.21 This is a very simple production budget that outlines the separate costs of each of the processes involved in a short, low-budget production. Notice how the animators have a daily rate; this is important for the production schedule as any overruns will potentially put the production over budget. Figures for each of the elements are omitted as these will vary greatly. Please note that this budget template is intended to be used as *a guide only*. This does not constitute any kind of formal or official document and in no way constitutes a contract.

creative you are or how well you animate the work you will be in for a hard time. This would tie in with both the production schedule and production chart, as the budget available will ultimately determine how long you can spend on a project and the amount of resources, including production crew, you can allocate to the film. As formulating a production budget is usually the work of the producers and the production accountant, most animators need not get involved. As finance and budgets are such complex and important areas, I have only touched on them here. There are a number of very good guides on putting together a production budget, which I have included in the appendix section.

There are a number of media production management and media resource management software packages available, though production management can easily be undertaken without this and little knowledge of standard spreadsheet software will enable you to achieve most of the things you will need even within a substantial production. For a more detailed text on production management for animation, you should look at *Producing Animation* by Catherine Winder and Zahra Dowlatabadi.

QUESTIONS TO ASK YOURSELF ABOUT PRODUCTION MANAGEMENT

Q. Is the project achievable?

Q. Have you identified all the resources you need for the project, including materials, equipment and production team?

Q. Have you drawn up a realistic production budget?

Q. Do you have sufficient resources to complete the production?

Q. Have you broken down your project into the separate tasks in the form of a production chart?

Q. Have you established a realistic and achievable deadline for the milestones within the production, and are these identified within the production schedule?

Q. Are each of the scenes timed out to comply with your animatic and are these organized into separate production folders?

Q. Are all your production crew aware of what they have to achieve and within which milestones and deadlines?

Q. Is all the relevant documentation in place to track the film in its entirety?

Appendices

The Double Take

Squash Stretch

APPENDIX 1: GLOSSARY

The following jargon buster is given to demystify terms and make things a little clearer.

Actions – Primary This term describes those actions that instigate a movement or are central and fundamental to an animation (also see *Secondary* and *Tertiary Actions*).

Actions – Secondary This term describes the actions that are influenced by primary actions and support a movement; they are often not central and fundamental to an animation (also see *Primary* and *Tertiary Actions*).

Actions – Tertiary This term describes those actions that occur as a result of primary and secondary actions. They do not normally support the movement nor are they central or fundamental to an animation (also see *Primary* and *Secondary Actions*).

Animatics See *Leica reel* and *Story reel*. This is a filmed version of a storyboard which gives an indication of the duration of the film and each sequence within it. The intention is to establish if a film cuts together in the desired manner, so any alterations can be made before animation begins. Sometimes this term is used to describe animation that is blocked out (usually computer animation).

Animation bible This consists of a series of documents, including designs, model sheets, style sheets and action poses, that give a thorough description of all aspects of the characters within a production. This is used by animators and others within the crew to keep the characters 'on model'.

Animo Industry standard digital paint and trace software.

Anticipation A movement, often small, that precedes and anticipates a greater action, usually in the opposite direction.

Bar charts Charts used to outline the action, sound and other key elements of an animated film.

Blocking out Rough animation, usually of key frames only, in 2D classical animation. In computer animation this may take the form of a figure being manipulated across the screen

in time to the bar chart or dope sheet. It will contain no animation other than the simplest of rough timing.

Blue screen The process of recording video footage against a flat backdrop consisting of a preselected colour (blue and green are the most common) in order to subsequently composite the footage against other video elements or artwork as background plates.

Body-sync The term refers to the synchronization of physical action to a piece of spoken dialogue undertaken by animators prior to lip-sync.

Boil The use of several drawings to create continuous movement in an otherwise still animation. It helps to keep the animation alive.

Character interaction The interrelationship of two or more characters on screen at any one time.

Cushions See *Slow in* and *Slow out*. The spacing of drawings of an object or character, usually at the beginning and end of an action, as it accelerates or decelerates throughout its motion.

Cycle animation Animation that is made to work in a seamless loop, often using a minimum of drawings.

Dailies See *Rushes*. The footage that is the result of the previous day's shoot. These are usually viewed by the director and others to ensure that there are no errors, that the quality is appropriate and that no reshoots are required.

Dope sheets See *X-Sheets*. These are the documents that outline the requirements of a particular scene by recording in detail the animation timing and any camera moves and effects in preparation for the shoot.

Drag The process whereby certain animated elements, usually ones that are not the primary source of movement, are delayed in their movement and only move or change direction due to the action of the primary source of animation. Drag can be seen in the action of the wing tips of a bird in flight.

Field guide or **Graticule** A field guide in this instance is the device for measuring and dividing the screen space. Using one of these, the layout artist is able to plan out and frame the shot prior to animation.

Field guides Guides drawn up by the layout artist to illustrate the framing of a specific shot to assist animators in planning out their animations. This may incorporate camera moves such as pans and zooms.

Follow-through The action within an animation whereby elements continue to move once the main course of movement has stopped. This can be seen on such elements as a horse's tail, which may continue to move and 'follow-through' once the horse has come to rest.

Flip book A way of making 2D animation using a small book, the pages of which are flipped one after the other to see the sequence in full. There are now some software packages that have a facility with the same name for viewing test computer animation before committing the work to a full render.

Frames per second (fps) This term describes the rate at which film, video or animation on the Web are recorded and played back.

Graticule See *Field guide*.

Inbetweens These are those additional animation drawings that are created to appear between key drawings. The number and precise placing of these drawings give the animation its timing.

Key frames See *Pose-to-pose animation*. The term relates to those frames that describe key points within the animated action.

Layouts Usually made for 2D animation, these are drawings that are made in preparation for animation, and describe the background of a scene, the field size, and the character's position within the environment and in relation to other characters.

Leica reel See *Animatic* and *Story reel*. This term was coined based on the make of the cameras usually used to create the animatic or Leica reel.

Line of action Used within 2D classical animation, the line of action denotes the primary dynamic thrust of a character's or object's action and it does not illustrate the secondary or tertiary movements. Usually limited to very strong, varied and fast actions, it is often used when creating key frames to capture the essence of the movement.

Line test See *Pencil test*. The line test is a way in which rough animation is tested then viewed and assessed by shooting onto video before completing and sending on to the next stage of production.

Lip-sync The precise synchronization of dialogue to animation.

Milestones Points within a production schedule when specific elements are expected to be completed by. Usually set by clients and the production management team.

Model sheets A set of documents that illustrate the exact design requirements for a specific character or group of characters. These often include design sheets outlining proportions, height relation, colour and poses.

Morgue This describes a collection of reference material made by creative individuals within a design team.

Motion capture The process whereby the physical movement of an actor or animal is recorded through an optical or electromagnetic capture device. This information is imported into a computer and the action copied onto 3D computer models, creating motion capture animation.

Onionskinning The process whereby a number of previously shot video frames or frames within a computer program can be viewed layered over one another in order to assist in placing a model or computer image for the current frame the animator is working on.

On model The process of producing characters throughout a production that comply exactly with the original designs.

Overlapping action The name given to a number of actions, usually within a single character, that start and end at

different times (they overlap) during a single movement, thereby creating variable timings throughout the animation.

Pacing This refers to the aspect of timing describing the overall pace of the film. Pacing refers to a number of related sequences and their varied tempos, and the way in which they relate to one another to create a changing dynamic profile.

Passing position This describes the phase of a walk cycle of a biped when a leg is lifted and swung forward, passing the opposite leg that supports the figure.

Path of action A guide used to control the motion of an animated element.

Pencil test See *Line test*. A process of testing rough 2D classical animation before completing and progressing through to final animation and paint and trace.

Persistence of vision This is the phenomenon whereby an image is retained momentarily on the retina of the eye. Estimated at one-tenth of a second, it is the process by which the illusion of movement is achieved by viewing separate still images quickly in sequence.

Phonetics The breaking down of dialogue into its constituent parts with regard to how the various elements sound. Phonetics is used to illustrate the pronunciation of speech regardless of spelling in order to create animated lip-sync.

Phrasing This refers to the aspect of the varied timing of separate movements within a single sequence to create a choreographed series of actions.

Pose-to-pose animation See *Key frames*. The term describes a method used in 2D classical animation whereby the main aspects of an animation are drawn out in a series of poses before the subsequent drawings are completed in between each of the poses.

Rushes See *Dailies*. This term originally described the uncut film footage delivered back from the processing labs in order that the director could view recently shot footage and assess ongoing work. It now refers to any recently shot footage for the purpose of review.

Slow in Animation timing that describes a decelerating action as the animation progresses more slowly 'into' a key frame.

Slow out Animation timing that describes a gradual acceleration of an action as the animation progresses 'out' of a key frame.

Slugging This describes the timing out of the storyboard prior to shooting an animatic; this way, individual shots can be timed accurately before animation begins. This also includes the spacing out of the dialogue and action within a storyboard in preparation to create an animatic.

Squash and stretch The principles of animation that describe the flexible nature of materials, objects and characters, used by animators to enhance the nature and dynamic of the movement.

Stop-frame animation Describes the process of animation using physical models. It is sometimes called model animation or 3D animation (as opposed to 2D drawn animation). However, the term 3D animation is now often used to describe the branch of computer animation that utilizes 3D geometry.

Storyboards These are the graphic representation of a sequence of film through a series of sequential separate panels. There are three different types of boards: thumbnails (or rough boards), working storyboards and presentation storyboards.

Story reel See *Animatics* and *Leica reel*. A term originating in the USA, it describes a filmed storyboard in conjunction with a basic soundtrack, created to indicate the progress of the narrative.

Stride The phase within a walk cycle that describes the position when the legs are the widest apart.

Sweatbox This is the name for the session when the director views for the first time the test animation for approval, together with the animators.

Takes An exaggerated action made by a character upon being surprised or frightened.

X-Sheets Another name for dope sheets, usually American.

APPENDIX 2: FURTHER READING

I have listed a number of texts that those making, planning or designing for animation may find useful for a variety of reasons. I have given a brief outline of the content of the book to assist individuals seeking additional information.

I must emphasize that these recommendations are my personal recommendations and as such may be limited and do not necessarily represent the views of others.

Practical guides

Halas, J. and Whitaker, H. (1981) *Timing for Animation*. Focal Press, Oxford.
Comments: *The* must-have book. If there was one book any student animator should own it's this one. Written in an accessible style, it covers all the principles of animation, with easy to understand examples and plenty of illustrations. It is a little old-fashioned perhaps, but it's none the worse for that. Affordable for most students, it is in my opinion *the* animator's bible.

Hooks, E. (2000) *Acting for Animators: A Complete Guide to Performance Animation*. Greenwood Press.
Comments: There are few books that cover this topic and no doubt animators will find it a useful addition to their collection. It is an easily accessible read, though I find that it could have dealt with the topics in a more in-depth manner. This is a minor criticism and I would recommend all animators to take a look at this volume.

Laybourn, K. (1998) *The Animation Book*. Three Rivers Press, New York.
Comments: A great book. This covers a lot of ground. Still a little old-fashioned, despite some updated information that covers aspects of computer animation. A very good addition to a collection, and a real must-have book for teachers of animation and those working in mixed media.

Shaw, S. (2004) *Stop Motion: Craft Skills for Model Animation*. Focal Press, Oxford.
Comments: An excellent book that covers all the essential basics of modelling and the preparation required to make 3D stop-motion animation, including materials and armatures. There are few, if any, books that deal with this subject in such a clear and concise manner, making it a very useful and most

welcome guide to this discipline which is otherwise poorly provided for. This is a vital book for the serious 3D animator.

Thomas, F. and Johnson, O. (1985) *The Illusion of Life*. Hyperion.
Comments: A brilliant book. Written by two of the masters of animation from the Disney stable, the book is in two distinct parts. The first covers the historic background of the Disney studio and some of its greatest animators. While this is interesting and informative, it is of little direct use to developing skills. The second, more practical part of the book is pure gold. This is also a must-have book for the serious animator.

Williams, R. (2001) *The Animator's Survival Kit*. Faber and Faber Ltd.
Comments: Another brilliant book. Written by a master animator and director with years of experience, including *Roger Rabbit* and the ill-fated *Cobbler and the Thief*, the book covers in plenty of detail all the principles of animation, explained clearly with loads of illustrations. Written in a very open and accessible style, it includes anecdotes from Williams' career that are much more than amusing stories, they are lessons in themselves. Computer animators should not be put off by the emphasis on drawn animation – the principles apply to your work too. A must-have book for serious animators.

White, T. (1986) *The Animator's Workbook*. Phaidon, Oxford.
Comments: This is a first-rate book, very clear and concise with good examples. Written by an award-winning animator, and its no nonsense approach will suit the student.

Winder, C. and Dowlatabadi, Z. (2001) *Producing Animation*. Focal Press, Oxford.
Comments: A first-rate book. A must-have for independent animators and serious animation students alike. If you only buy one book on production and production management, make it this one.

Subotnick, S. (2003) *Animation in the Home Digital Studio*. Focal Press, Oxford.
Comments: Excellent. It covers various aspects of production for the enthusiastic amateur and student.

Levison, L. (2001) *Filmmakers and Financing*. Focal Press, Oxford.
Comments: Very good. Students will find this an invaluable introduction to the world of finance. Written in an accessible manner, it makes a difficult and often scary aspect of production seem hardly scary at all.

Eisner, W. (1985) *Comics and Sequential Art*. Poorhouse Press, Florida.
Comments: A first-rate book for those wishing to develop the craft of storyboarding and sequential imaging.

Simon, M. (2003) *Producing Independent 2D Character Animation*. Focal Press, Oxford.
Comments: A very useful book that covers all aspects of production, giving good clear examples following the production of a single product.

Kuperberg, M. (2002) *A Guide to Computer Animation*. Focal Press, Oxford.
Comments: OK as an introduction, though students will have to dig deeper to find more specifics on software.

Brown, B. (2002) *Cinematography, Theory and Practice*. Focal Press, Oxford.
Comments: If you are looking for one book that will assist you with the techniques and principles of cinematography, look no further. A very useful book.

Culhane, S. (1988) *From Script to Screen*. Columbus, London.
Comments: Very lively in content, from one of the great classical animators. It seems a little dated in the way it is written, though the principles that are laid out here are timeless.

Scott, J. (2002) *How to Write for Animation*. The Overlook Press, New York.
Comments: Good. Represents about the only text specifically for animators, though is limited with examples taken from series production for children.

Theoretical

Wells, P. (1998) *Understanding Animation*. Routledge, London.
Comments: This is a very good text if you wish to get to grips with the contextualization of animation within media

production. Entertaining and well written with a light touch (a lamentably rare event with such books unfortunately).

Pilling, J., ed. (1997) *A Reader in Animation Studies*. John Libbey, London.
Comments: Another first-rate book that deals with a broad range of issues such as representation, audience and gender.

Historical

Maltin, L. (1987) *Of Mice and Magic*. De Capo, New York.
Comments: First rate, though limited in its scope, as it only covers cartoon animation in America.

Bendazzi, G. (1994) *One Hundred Years of Cartoon Animation*. John Libbey, London.
Comments: Quite a broad range of animation and animators covered. A good starting point for those interested in the history of animation, though a serious student will have to search a little further for detailed work on specific areas, studios or animators.

Jones, C. (1990) *Chuck Amuck*. Simon & Schuster, Sydney.
Comments: An excellent book. This is a brilliant read that inspires, informs and entertains. A personal account of one of the greatest animator's adventures in animation. It won't make you into a brilliant animator but it will make you wish you were one.

APPENDIX 3: FURTHER VIEWING

This listing represents my personal view of the very best of animation across a range of disciplines, but it is personal.

	Animator/film-maker	Title	Discipline
1.	Winsor McCay	*Girtie the Dinosaur*	2D classical animation
2.	Chuck Jones	*What's Opera Doc*	2D classical animation
3.	Tex Avery	*King Sized Canary*	2D classical animation
4.	Willis O'Brian	*King Kong*	3D stop-frame animation
5.	John Lasseter	*Luxo Jnr*	Computer animation
6.	Uri Norstein	*Hedgehog in the Fog*	Cut-out
7.	Bob Godfrey	*Karma Sutra Rides Again*	2D classical animation
8.	John Kricfalusi	*Son of Stimpey*	2D classical animation
9.	Ub Iwerks (Disney)	*Skeleton Dance*	2D classical animation
10.	Fredrick Back	*The Man Who Planted Trees*	Drawn animation
11.	Caroline Leaf	*The Two Sisters*	Scratch on film
12.	Jan Svankmajer	*Faust*	Pixellation
13.	Len Lye	*Rainbow Dance*	Mixed media
14.	Lotte Reiniger	*Prince Achmed*	Cut-out
15.	Clive Walley	*Divertimenti*	Paint on glass/mixed media
16.	Phil Maloy	*Cowboy's Revenge*	Drawn animation
17.	Joanna Quinn	*Girls Night Out*	2D classical animation
18.	Pixar	*Toy Story*	CGI
19.	Ladislaw Starewicz	*The Tale of the Fox*	2D classical animation
20.	Disney	*Pinocchio*	2D classical animation
21.	Zibigniew Rybczynski	*Tango*	Manipulated live footage
22.	Paul Driesen	*Tip Top*	2D classical animation
23.	Nick Park	*A Grand Day Out*	3D stop-frame animation
24.	Richard Condie	*The Big Snit*	2D classical animation
25.	Erica Russell	*Triangle*	Drawn animation
26.	Zagreb	*Ersatz*	2D classical animation
27.	Fleischer Brothers	*Betty Boop*	2D classical animation
28.	Otto Messmer	*Felix the Cat*	2D classical animation
29.	Peter Jackson	*Lord of the Rings*	CGI
30.	Geoff Dunbar	*Damion the Mower*	Drawn animation
31.	George Dunning	*Yellow Submarine*	2D classical animation
32.	Oscar Fischinger	*Allegreto*	Drawn animation
33.	Klasky Csupo	*Duckman*	2D classical animation
34.	Katsuhiro Otomo	*Akira*	2D classical animation
35.	Simon Pummel	*Secret Joy of Fallen Angels*	Mixed media
36.	The Brothers Quay	*Street of Crocodiles*	3D stop-frame animation
37.	Emile Cohl	*Fantasmagoria*	Proto animation
38.	Halas and Batchelor	*Animal Farm*	2D classical animation
39.	UPA	*Tell Tale Heart*	2D classical animation

Animator/film-maker	Title	Discipline
40. Richard Williams	*Roger Rabbit*	2D classical animation
41. Mark Baker	*Hill Farm*	2D classical animation
42. Ray Harryhausen	*Jason and the Argonauts*	3D stop-frame animation
43. Caroline Leaf	*The Owl and the Goose*	Sand on glass
44. Norman McClarren	*Boogie Doodle*	Scratch on film
45. Bill Plympton	*Your Face*	2D classical animation
46. Winsor McCay	*How a Mosquito Operates*	2D classical animation
47. Alex Alexief and Clair Parker	*Promenade*	Pin screen animation
48. Caroline Leaf	*The Street*	Paint on glass
49. Barry Purves	*Next*	3D stop-frame animation
50. Mario Cavalli	*Soho Square*	Mixed media

APPENDIX 4: USEFUL CONTACTS

The following represents only a very small sample of the many outlets and links for information on animation, suppliers of equipment, training, etc.

Suppliers

There are a number of suppliers providing a broad range of equipment and materials for the 'would-be' animator. The list below is far from exhaustive.

Paper People	www.paperpeople.co.uk
Chromacolour	www.chromacolour.co.uk
Cambridge Animation Systems	www.cambridgeanimation.com
CartoonSupplies.com	www.cartoonsupplies.com
Rocky Mountain Arts	www.vedaeyeland.com/anim.html
Lightfoot Limited	www.zyworld.com/drkatie/lightfootltd/index.html

Schools

There are very many institutions that offer a wide range of training and education opportunities for the student animator. The one piece of advice I would offer is for potential students to do their homework. Not every programme will be suited to the needs of every student. As part of your research, check the facilities, experience and qualification of the teaching staff and the curriculum.

University of the West of England	www.uwe.ac.uk
Bristol School of Animation	www.uwe.ac.uk/amd/bristolanimation/
University of Westminster	www.wmin.ac.uk/solape/item_admission.asp?ID=3862&wp=
Pontypridd College	www.pontypriddcollege.ac.uk
Bournemouth University	www.bournemouth.ac.uk/
NFTS (National Film and Television School)	www.nftsfilm-tv.ac.uk/
Surrey Institute	www.surrart.ac.uk/opportunities/undergrad/animation.html
University College Wales Newport	www.newport.ac.uk/courses/amd/ug/bahonsanimation.html

Animation studios

Listed below is a small sample of some of the more interesting studios making a variety of animation (apologies for the very many omissions).

Aardman Animation	www.aardman.com/
A Productions	www.aproductions.co.uk
Bolex Brothers	www.bolexbrothers.co.uk
Pixar	www.pixar.com
Atom Films	http://atomfilms.shockwave.com/af/home/
Siriol Productions	www.siriol-productions.com
Tippet Studios	www.tippett.com/
Cuppa Coffee Animation	www.cuppacoffee.com/

Wreckless Abandon Studios www.wrecklessabandon.com
Framestore www.framestore-cfc.com/

Other information

Listed below are links to sites that may be of use to professional and student animators alike.

3D Stop Motion Animation www.stopmotionanimation.com/
Animation World Network www.awn.com
Animation Magazine www.animationmagazine.net
Cinefex www.cinefex.com/home.html
Animation UK www.animationuk.com/
British Film Institute www.bfi.org.uk/
Video formats www.hut.fi/~iisakkil/videoformats.html#notes
Blue Screen Technology www.seanet.com/Users/bradford/bluscrn.html
Motion Capture www.visgraf.impa.br/Projects/mcapture/index.html
Stop Motion Pro www.stopmotionpro.com/
Toon Boom www.toonboomstudio.com/main/
Avid www.avid.com/index_fl.asp
Adobe Premiere www.adobe.com/products/premiere/main.html
Animo www.cambridgeanimation.com/index.htm
Final Cut Pro www.lafcpug.org/
Asset Management www.nxn-software.com/
Project Management www.microsoft.com/office/project/default.asp

Index

2D animation *see* Classical animation
3D animation *see* Stop-frame animation
360-degree design, 144–5

Abstract animation, 191
Acceleration, 15, 16
Accent, 197
Acting, 70–1, 105–27
 characterization, 109–15, 119–21
 interaction, 121–4
 props and costume, 125–6
 scene planning, 124–5
 temperament and pace, 115–19
Action sheets, 148–9
Actions, 69–70
 analysis, 157
 motivation and objectives, 112–13
 primary, 37–8, 40
 secondary, 38–9, 40
 tertiary, 39–40
Activity, 69
Aeroplane cycle exercise, 64–6
Alterations, 209
Analogue technology, 184
Anatomy, 143, 158–9
Animals, 46, 155–77
 flight, 168–77
 four legs, 158–68
Animated cameras, 222, 224
Animatics, 139, 141
'Animation bible', 143–4
Animo software, 146–7, 228
Anticipation, 98–103
Arcs and curves, 19, 50–5
Armature plans, 151, 152–3
Arms, 39, 48–9, 51
Aspect ratios, 222, 228
Atmosphere track, 185
Attitude, 197

Audience, 133, 146
Avery, Tex:
 holds, 211–12
 naturalistic animation, 8
 physical acting, 114
 soundtrack, 181
 squash and stretch, 22–3
 temperament and pace, 116
Avid software, 184, 229

Backgrounds, 225, 228
Balance, 73–5, 89–98, 99
Balloons, 35
Balls, 18, 20–1, 22, 30–4
Bambi, 114–15
Bar charts, 182–8, 205
Beauty and the Beast, 24
Believability, 107, 109–10, 143
Birds, 168–77
 exercise, 171
Blair, Preston, 53
Blanc, Mel, 111–12
Body language, 114
Body-sync, 197
Boils, 218
Bouncing, 18, 20–1, 22, 30–5
 exercise, 32–5
Brown, Blain, 228
Budget:
 agreeing, 137
 design implications, 133
 line test implications, 220
 production, 235–6
Bugs Bunny, 109

Camera moves, 224–6
Cast members, 142
 see also Characterization
Centre of gravity, 91, 94
Chaplin, Charlie, 99–100, 113, 126
Characterization, 109–15
 design, 142–52

Characterization (*contd*)
　exercise, 119–21
　interaction, 121–4
　props and costume, 126
　walking, 73
Charts:
　bar charts, 182–8, 205
　production charts, 230–2
Checklists:
　acting, 126
　animal motion, 168
　birds, 177
　design, 154
　dope sheets, 219
　drag, 49–50
　follow-through, 49–50
　layouts, 226
　overlapping action, 49–50
　production management, 236
　sound synchronisation, 199
　weight and balance, 98
Clarity, 125
Classical animation:
　camera moves, 224–6
　colour, 146
　cycle animation, 55
　dope sheets, 203, 206
　equipment and materials, 3
　keys and inbetweens, 27–8
　layouts, 221–6
　lines of action, 52
　model sheets, 145
　pose-to-pose animation, 26
　straight-ahead animation, 27
Clothing *see* Costume
Colour models, 145–7
Computer animation:
　bar charts, 205
　camera moves, 226
　cycle animation, 55
　design criteria, 152, 153
　documentation, 144
　dope sheets, 205
　line tests, 221
　model construction, 160, 161
　model sheets, 145
　recording, 228
Computer games:
　design criteria, 152

motion capture, 158
timing, 131
Concept art, 150
Consistency, 132, 142
Constant speed, 30
Constructed time, 5
Construction sheets, 148
Contacts, 251–2
Continuity, 125
Costume:
　acting, 125–6
　colouring, 146
　model sheets, 145
　overlapping action, 45, 47
　tertiary action, 40
Culhane, Shamus, 153
Curves and arcs, 19, 50–5
Cut-offs, 222
Cycle animation, 55–61
　drag, 47
　flag, 47, 56, 57–61, 214
　flight, 64–6, 169–72
　follow-through, 47
　interlocking cycles, 56
　overlapping action, 47
　wave, 55, 57
　see also Repeat animation;
　　Running; Walking

Daffy Duck, 113, 116
D'Arcy, Chevalier, 4
Dark Matter, 152
Design, 129–54
　animatics, 139–41
　characters, 142–52
　criteria, 152–4
　storyboards, 133–9
Dialogue:
　acting, 111–12
　key frames, 26
　sound synchronisation, 189
　timing, 195–6
　see also Lip-sync
Digital cameras, 228
Digital technology, 184
Director, 139, 141, 182
Disney studios, 131–2, 182, 220
Disney, Walt, 6, 142, 220

Distribution, 133
Documentation:
 'animation bible', 143–4
 dope sheets, 186, 188, 203–19
 production folders, 234–5
 soundtrack, 182–8
Dog ears, 46
Dope sheets, 186, 188, 203–19
Double takes, 103
Dowlatabadi, Zahra, 236
Drag, 35–6, 48–50, 170, 172
Drawing skills, 71, 101–2

'Ease in'/'ease out' actions, 28–9, 31–2
Editing, 141, 183–4, 228–9
Editor, 182
Educational institutions, 251
Efficiency, 26
Emotions *see* Acting
Empathy, 113
Energy, 18, 21, 116
 see also Kinetic energy
Equal and opposite actions, 15, 16, 97–8
Equipment and materials, 3–4, 182–4, 227
 see also Software
Exercises:
 advanced action, 167–8
 aeroplane cycle, 64–6
 bouncing balls, 32–4
 characterization, 119–21
 flag cycle, 58–61
 flight cycle, 171
 flip book, 8–14
 interaction of characters, 123–4
 lip-sync, 197–8
 run cycle, 89
 running, 167
 sound synchronization, 198–9
 take-off and landing, 176–7
 temperament and pace, 117–19
 walk cycle, 78–85, 163–5

Exposure sheets *see* Dope sheets

Faces:
 double takes, 103
 drag, 48
 squash and stretch, 23
 takes, 102
Falling objects, 17–18, 19, 21
Fantasia, 53
Field guides, 221–6
Figurative animation, 67–103
Film:
 formats, 227
 frames per second, 5
 versus video, 226–9
Final Cut Pro software, 184, 228–9
Fischinger, Oscar, 181
Flag cycle, 47, 56, 57–8, 214
 exercise, 58–61
Fleischer brothers, 182
Flexibility, 136
Flight *see* Birds
Flip book exercise, 8–14
Flipbook software, 228
'Fly-through' shots, 224
Follow-through, 35–6, 45–7, 49–50
Force, 21, 97–8
Formats, 133, 226–9
Fps *see* Frames per second
Frame counts, 185
Frames per drawing, 208
Frames per second (fps), 4–6, 141, 183
Freelancing, 232
Friction, 17, 48
Front view:
 running, 87
 walking, 77
Further reading, 245–8
Further viewing, 249–50

Gag sketches, 135
Galileo, 17, 18
Glossary, 239–44
Gollum, 109–10
Graticules *see* Field guides

Gravity, 16, 17, 18
 centre of, 91, 94

Hair, 46, 48–9
Hanna Barbera studio, 212
Height relationships, 145, 146
History of animation, 6, 134–5, 209
 further reading, 248
Holds, 209–12, 218–19
Horses, 158–68
Human figure, 73–4
 see also Figurative animation

Ideas:
 capturing, 136
 communicating, 153
Illusion of movement, 4–5
Impact, 21
Inbetweens, 27–32
 over-animation, 192
 walking, 76, 78
Inertia, 15, 29, 48, 172
Intended actions, 70, 103
Interaction of characters, 121–4
Interlocking cycles, 56
International production, 150, 152

Jogging, 87
 see also Running
Jones, Chuck, 109
Jurassic Park, 8, 109

Key-frame animation see Pose-to-pose animation
Key frames:
 holds, 209–12
 inbetweens, 27–32
 physical acting, 114
 running, 86
 throwing, 25, 95
 walking, 76
Kinetic energy, 18, 29
Kricfalusi, John, 50, 114, 181

Landing, 175–7
 exercise, 176–7
Lasseter, John, 110

Laws of motion, 11, 14–18, 50, 70
Layouts, 221–6
Leica reels see Storyboards
Lifting, 41–3, 91–4
Limited animation, 132, 209
Line tests, 220–1
Lines of action, 50–5
Lip-sync, 184, 186, 189–97
 dope sheets, 206
 exercise, 197–8
 guides, 150, 152
Living creatures, 36–45
 see also Animals
Lord of the Rings, 109–10

McLaren, Norman, 8
MagTrack (magnetic tape), 182–3
Management, 229–30, 236
Marey, Jules, 157–8
The Mask, 8, 23
Materials see Costume; Equipment and materials
Merry Melodies, 182
Model animation, 24, 41
Model sheets, 143–5, 151
 see also Structural models
Momentum, 15–16, 17, 29, 172
Morgues, 153–4
Morph, 116
Motion capture, 158
 see also Gollum
Motivation for actions, 70, 103, 112–13
Mouth shapes, 189–96
Movement:
 animals, 155–77
 categories of, 69–71
 illusion of, 4–5
Moving holds, 212, 213–14
Moviola projector, 220
Music, 181–2, 184–6
 synchronising, 141
Muybridge, Eadweard, 157, 167

National Television Standards Committee (NTSC), 227

Naturalistic animation, 7–8
 figurative animation, 67–103
 lines of action, 50
 lip-sync, 191
 pose-to-pose animation, 26
 squash and stretch, 23
Newton, Sir Isaac, 15–16
Nightmare Before Christmas, 152
Noddy, 152
Non-linear editing, 229–30
NTSC (National Television Standards Committee), 227

Objectives:
 actions, 112–13
 scene planning, 125
Observation, 72, 157
Onionskinning, 228
Over-animation, 190, 192–3, 197
Overlapping action, 35–45, 49–50
 flight cycle, 172

Pace, 115–19
 exercise, 117–19
Pacing, 12
Paint and trace software, 146–7
PAL (Phase Alternation by Line), 227
Pantomime, 113–14
Passing position, 75–8, 85–9
Passive characters, 122–3
Pencil tests *see* Line tests
Performance, 110–11
 see also Acting
Persistence of vision, 4
Personality *see* Acting
Perspective, 62–5
Phase Alternation by Line (PAL), 227
Phonetics, 185, 192
Phrasing, 13–14, 114–15
Physical acting, 113–14, 197
Pic Sync (picture synchronisation machine), 182
Planning scenes, 124–5

Pluto, 126
Polygon economy, 152, 160
Pose-to-pose animation, 24–32
 staggered timing, 37
Practical texts, 245–7
Pragmatics, 153
Premiere software, 141, 184, 228
Presentation storyboards, 137–9
Primary actions, 37–8, 40
Production:
 charts, 230–2
 design implications, 132
 processes, 229–36
Props, 125–6
Psychological acting, 114–15
Psychology of characters, 11, 70–1, 189
 see also Acting
Pulling, 98, 99
Pushing, 97–8

Quinn, Joanna, 219

Random doping, 218–19
Reference material, 153–4
Ren and Stimpey, 8, 50
Repeat animation, 214, 216–18
 see also Cycle animation
Resources, 133
Retina, 4
Retracting, 212
Rhubarb and Custard, 219
Rigidity, 23–4
Roadrunner, 22
Rotoscoping, 110, 158
Running, 39, 85–9, 166–7
 exercise, 89, 167

Samurai Jack, 132
Scale, 145
Scanning, 3, 226
Scenes:
 bar charts, 187
 dope sheets, 206
 planning, 124–5
Schedules, 233–4

Scripts, 135–6
 storyboard, 134
 versus performance, 110
SECAM system, 227–8
Second-hand equipment, 227
Secondary actions, 38–9, 40
Shadow puppets, 181
Shaw, Susannah, 227
Shots, 206
Silent characters, 112
Silent movies, 181
Silly Symphonies, 182
The Simpsons, 149
Slapstick, 114
'Slow in'/'slow out' actions, 28–9, 31–2
Slow motion, 5–6
Snow White, 115, 182
The Snowman, 219
Software:
 animatics, 141
 choosing, 227
 classical animation, 228
 editing, 184, 228–9
 paint and trace, 146–7
 recording, 228
 soundtrack synchronisation, 183–4
 stop-frame animation, 228
Sound effects, 184–5
Sound synchronisation, 179–99
 bar charts, 182–8
 dialogue and narrative, 189
 exercise, 198–9
 lip-sync, 189–98
Soundtrack *see* Music; Voice track
Spacing of images, 7, 8, 28
Speeded up action, 5–6
Sprinting, 88
 see also Running
Squash and stretch, 18, 22–4
Staggered doping, 212, 214, 215
Staggered timing, 36–7
Standing up, 44
Steamboat Willie, 182
Steenbeck editing machine, 183
Stock animation, 231–2

Stop-frame animation:
 concept art, 150
 design criteria, 152–3
 equipment and materials, 3
 layers of action, 41
 line tests, 221
 lines of action, 52
 model construction, 160, 161
 model sheets, 145, 151
 recording, 228
Stop Motion Pro software, 228
Story reels *see* Storyboards
Storyboards, 133–9
 pace, 115
 presentation, 137–9
 scene planning, 124
 thumbnail/rough, 136–7
 working, 139, 140
Storylines *see* Scripts
Straight-ahead animation, 24–7
Stretching, 212
 see also Squash and stretch
Stride, 75–8, 85–9
Structural models, 158–61, 173
 see also Model sheets
Studios, 251–2
Style:
 consistency, 132, 142
 design implications, 132
Subcontracting, 232
Suppliers, 251
'Sweatboxes', 220
Synchronisation:
 animal motion, 162–7
 lip-sync guides, 150, 152
 soundtrack, 141, 179–99

Take-off, 172, 174
 exercise, 176–7
Takes, 100–1, 102
Technical issues, 201–36
 dope sheets, 203–19
 formats, 226–9
 layouts and field guides, 221–6
 line tests, 220–1
 production processes, 229–36
Telecine process, 228

Television series, 149
Tell Tale Heart, 132
Temperament, 115–19
 exercise, 117–19
Terminator II, 7
Tertiary actions, 39–40
Test animation, 143
Theoretical texts, 247–8
Throwing, 25, 51, 93, 95–7, 100
Thumbnail storyboards, 136–7
Timing, 4–14
 alterations, 209
 computer games, 131
 design, 131
 dialogue, 195–6
 dope sheets, 205–7
 flight cycle, 169, 172
 frames per drawing, 208
 lifting, 94
 psychological acting, 114–15
 recording, 208–9
 running, 86
 staggered, 36–7
 variable, 28–32
 walking, 77
Tom and Jerry, 22
Toon Boom software, 228
Toy Story, 111
Trade press, 227
Trotting, 165–7
Turning:
 body, 37
 head, 52, 53

Unbalance, 75
UPA (United Productions of America), 131–2

Variable timing, 28–32
 see also Drag; Follow-through; Overlapping action
Video:
 formats, 227
 frames per second, 5
 versus film, 226–9
Villains, 115
Vision, persistence of, 4
Voice artists, 111–12, 189
Voice track:
 pace, 115
 scene planning, 124
 synchronising, 141

Walking, 13–14
 arm swing, 51
 drag, 49
 exercise, 78–85, 163–5
 figurative animation, 72–85
 front view, 77
 horses, 162–3
 keys and inbetweens, 76
 perspective, 63
 primary action, 37–8
 repeat animation, 214
 timing, 77
Walking With Dinosaurs, 109
Walley, Clive, 152, 181
Wave cycle, 55, 57
Weight, 89–98
Williams, Richard, 45
Winder, Catherine, 236
Wings *see* Birds
Working storyboards, 139, 140

X-sheets *see* Dope sheets